MW00785287

Wild
SHEEP
Country

Text by
VALERIUS GEIST

Photography by
MICHAEL H. FRANCIS

NorthWord
PRESS, INC

Box 1360, Minocqua, WI 54548

Library of Congress Cataloging-in-Publication Data

Geist, Valerius.
 Wild sheep country / by Valerius Geist; photography by Michael H. Francis
 p. cm.
 Includes bibliographical references (p.
 ISBN 1-55971-212-0 : $39.00
 1. Mountain sheep. I. Francis, Michael H. (Michael Harlowe).
 1953- . II. Title
 QL737.U53G456 1993
 599.73'58--dc20 93-17235
 CIP

Text copyright © 1993 NorthWord Press, Inc.
Photography copyright © 1993 Michael H. Francis

All rights reserved. No part of this work covered by the
copyright hereon may be reproduced or used in any form
or by any means–graphic, electronic, or mechanical,
including photocopying, recording,taping, or
information storage and retrieval systems–
without the prior written permission of the
copyright holder.

Designed by Bill Lundborg, Minneapolis, MN
Jacket Design by Patricia Bickner Linder
Edited by Greg Linder

Published by
NorthWord Press, Inc.
Box 1360
Minocqua, WI 54548

For a free catalog offering NorthWord's line of
nature books and gifts, call 1-800-336-5666.

ISBN 1-55971-212-0

Printed in Hong Kong through Palace Press,
San Francisco, CA

Valerius Geist is a professor and program director of environmental sciences on the Faculty of Environmental Design at the University of Calgary at Alberta, Canada.

Dr. Geist obtained a Ph.D. in zoology in 1966, specializing in ethology (the study of animal behavior), from the University of British Columbia, Vancouver. After a year of post-doctoral study in Germany with Konrad Lorenz, Dr. Geist took a position at the University of Calgary, where he became a founding member of the Faculty for Environmental Design as its first program director for environmental sciences. He has published one previous technical book (1971) and one popular book (1975) on his work with mountain sheep. In 1974, he co-edited a two-volume conference proceedings on the behavior of ungulates. Dr. Geist's book on the biological basis of health was published in 1978. He has served as a consultant or co-editor for numerous other books, including titles published by the National Geographic Society.

Dr. Geist's scientific work has been honored by the American Association for the Advancement of Science, the Wildlife Society, the Foundation for North American Wild Sheep, and other organizations.

In addition to his published technical works, Dr. Geist has contributed more than 150 popular articles to outdoor and natural history magazines. He is the wildlife columnist for *Western Sportsman* magazine, and he serves on the editorial boards of numerous scholarly journals.

Conservation has been a major focus of Dr. Geist's work. He acts as an expert witness in investigations pertaining to breaches of conservation legislation in Canada and the United States, in environmental impact assessments, and at public hearings. He serves on committees with the International Union for the Conservation of Nature, the Conseil International de la Chasse, Wildlife Habitat Canada, the World Wildlife Fund, Canadian Society of Zoologists, Alberta Society of Professional Biologists, the Canadian Committee for the International Biological Programme, the Frankfort Zoological Society, and others.

Valerius met his wife, Renate, when both were studying biology at the University of British Columbia. She teaches German, and is a translator with several published volumes to her credit. The Geists have three grown children, a daughter and two sons, and are now grandparents.

ABOUT THE PHOTOGRAPHER

Michael H. Francis, born in Maine, has spent the last 24 years as a resident of Montana. He is a graduate of Montana State University. Prior to becoming a full-time wildlife photographer, he worked seasonally in Yellowstone Park for 14 seasons.

Mike's photography has been internationally recognized for its beautiful and informative nature imagery. His work has been published by the National Geographic Society, the Nature Conservancy, the Audubon Society, the Wild Sheep Foundation, and *Field and Stream, Outdoor Life,* and *Natural History* magazines, among others. His previous titles for NorthWord Press include *Elk Country, Mule Deer Country, Yellowstone Wildlife, Glacier Park Wildlife,* and *Moose for Kids.*

Mike lives in Billings, Montana, with his wife Victoria and their daughters Elizabeth and Emily.

PHOTOGRAPHER'S ACKNOWLEDGMENTS

This project has been my most ambitious undertaking to date. Wild sheep live in some of the most rugged, inhospitable, yet beautiful terrain in North America. Add to that the fact that I wanted to include photos of Stone's, Dall's, Rocky Mountain, and desert sheep, and I ended up putting thousands of miles on my truck . . . from the Mexican border almost to the Arctic Circle.

Of course I couldn't have completed this project without the help, guidance, and support of many fine people.

First to thank on the list is my family: my wife Victoria and daughters Elizabeth and Emily. Needless to say, they spent quite a lot of time these past two years alone while I was in the field. I appreciate their understanding and support. My wife keeps reminding me that she married me ten years ago because she thought she'd spend lots of time hiking and camping in the out-of-doors. Unfortunately, she now spends most of her time in town.

To my mother and father, Derline and John Francis: As always, thanks for raising me to appreciate nature.

Photo: Brad Garfield

Thanks to my good friend Ron Shade, with whom I spent five weeks cooped up in a pick-up camper while exploring Canada and Alaska.

I'd also like to express my gratitude to the following for their invaluable help. The University of Arizona, especially Paul R. Krausman, Richard Etchberger, Mara E. Weisenberger, Darren Ray Peoples, and Gregory B. Carmichael. The Arizona Game and Fish Department, especially Stan Cunningham and Layne S. Hanna. The China Lake Naval Weapons Center, especially Jerry Boggs and Dallas D. Allen. Parks Canada-Jasper, especially Wes Bradford and Greg Horne. Badlands National Park, especially John Donaldson and Kevin Fox. Thanks also to Brad Garfield and Craig Phillips.

I'm pleased to be able to share with you some of the 12,000-plus photos I've taken in the past couple of years. Hopefully, between Dr. Geist's text and my photography, you'll get a feeling for the special animals called wild sheep, and for the places we call wild sheep country.

—*Michael H. Francis*

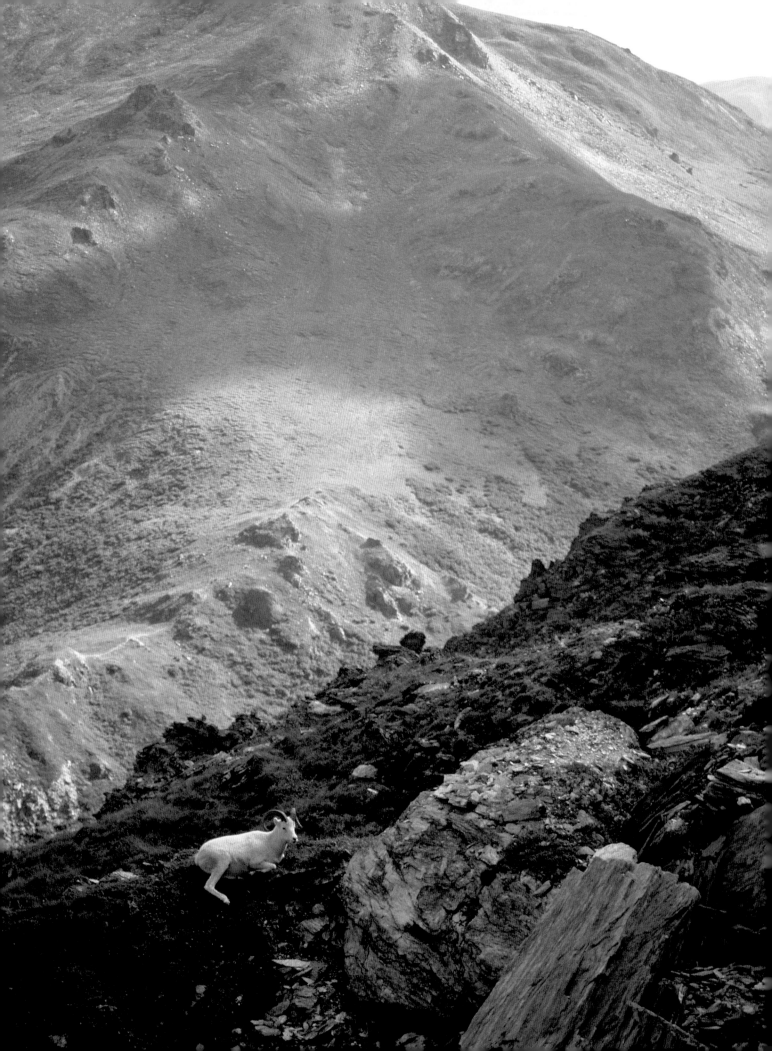

TABLE OF CONTENTS

11

PREFACE

19

HIGH ABOVE THE CLOUDS

37

MOUNTAIN SHEEP

61

GOATS AND SHEEP

73

HORNS

95

FOLLOW, FOLLOW LITTLE SHEEP

107

SHEEP TALK

125

THE RUTTING SEASON

143

TAME MOUNTAIN SHEEP

155

RENEWAL, SURVIVAL, DISPERSAL, DEATH

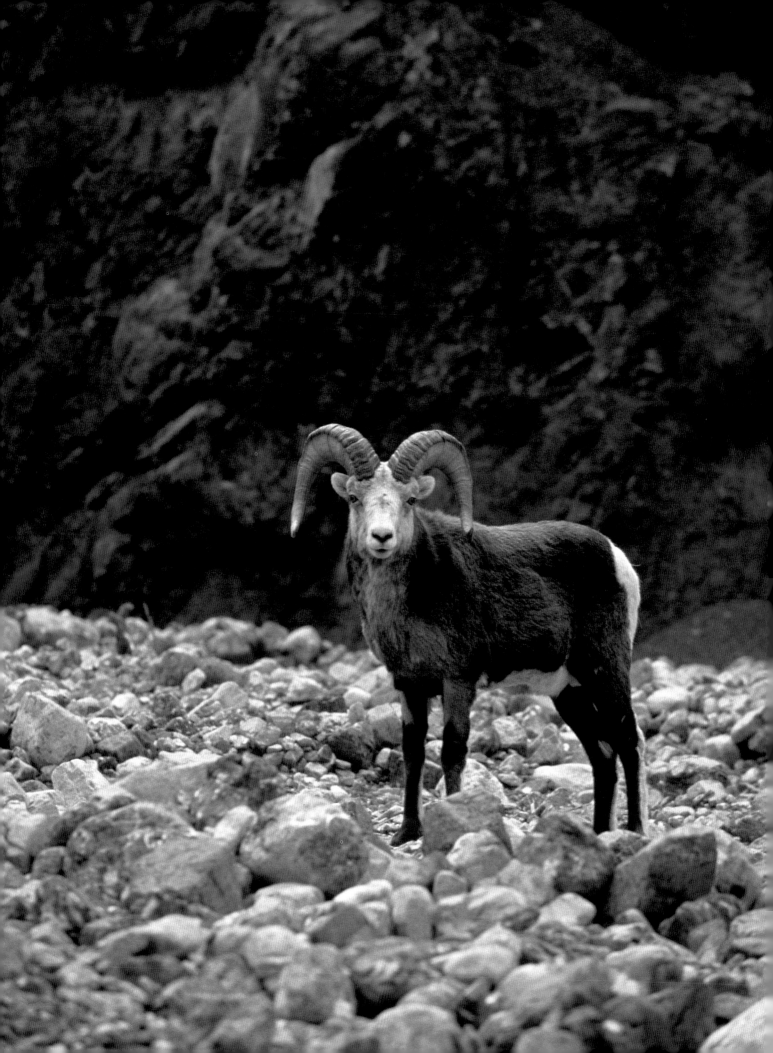

When I began my studies of mountain sheep, I hid and stalked to get close enough to watch. When I finished, the sheep were tame. They even followed me, unhesitatingly and trustingly, into areas that were strange to them. They played hide and seek with me at the timber's edge on the mountain, and on a few occasions even held me back physically, as if to restrain me from leaving, as if to retain me in their band. I had, unknowingly, embarked on a journey from paradise lost to paradise found. I had not anticipated that.

What I had anticipated was some modest scientific gain, some understanding of how mountain sheep lived, how they communicated, what they did over the course of the seasons, and maybe a few insights into how they came to be.

I was the first scientist to study Stone's sheep, the beautiful, dark, thinhorn sheep indigenous to northern British Columbia and the southern Yukon Territory of Canada. The sheep had been named in 1897 after the hunter and collector Andrew J. Stone of Missoula, Montana, who collected three specimens of black sheep in the Che-on-nee Mountains along the big Stikine River. He returned for a second time in 1902 to collect nine more, along with other specimens of large mammals. There was thus little known about Stone's sheep in 1961 when I began; in fact, there was not that much known about the social behavior of *any* of the North American wild sheep. However, the year I began field work, Ralph and Florence Welles published their observations on desert bighorns in Death Valley, California. Theirs was a pioneer study in animal behavior, as were others in that time, because the study of animal behavior as a scientific discipline was groping then for a theoretical foundation.

Not that there were no theories put forward in papers and books on animal behavior, or that there were not bitter debates between proponents of different theoretical visions. There were. The theorists that would emerge as the most influential were the ethologists, led by a "troika" of rather unlikely scientists, Niko Tinbergen of Oxford, Konrad Lorenz of the Max Planck Institute, and Karl von Frisch of Munich. Eventually, they were

A Stone's sheep ram *(Ovis dalli stonei)* from northern British Columbia, about seven years of age, in winter pelage. Stone's sheep are thinhorned sheep of the same species *(Ovis dalli)* as the white Dall's sheep of Alaska and the Yukon.

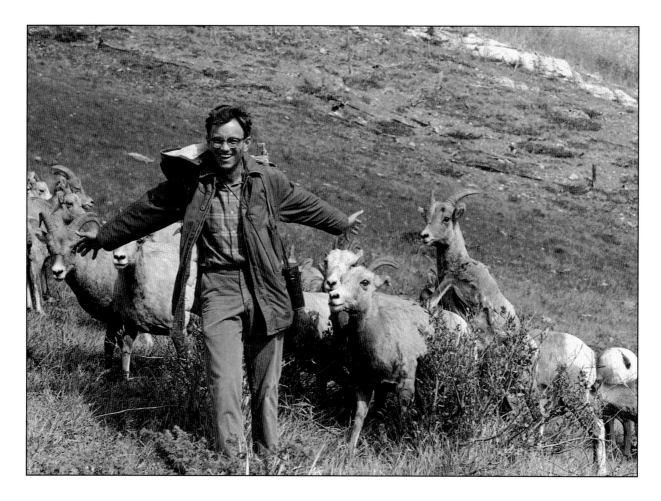

V. Geist with a band of bighorns—a nursery band with a few young rams sprinkled in. We knew each other very well, a prerequisite for an in-depth study of wild sheep social behavior. Only "brainy" creatures become this tame, and mountain sheep have a relatively large brain, as is expected in large mammals from highly seasonal, inclement environments.

honored with a Nobel Prize for their achievements. I had been influenced by the Finnish ethologist, Lars von Haartman, when he came to teach as a guest professor at the University of British Columbia in 1957. However, I had been infected by mountain sheep fever much earlier and had come to Vancouver to study under Ian McTaggart-Cowan, the famous Canadian zoologist.

The reasons I studied Stone's sheep were only in part scientific. My presence in the Spazisi Plateau was part of a greater scheme to put pressure on the government of the province to set a large area aside as, essentially, a university wilderness research reserve. The mover behind that scheme was the late Tommy Walker, an Englishman of aristocratic bearing who held a license to outfit hunters for big game in the area. A research reserve with a field station would be good for business, as it would limit and control access to the valuable big game populations.

Tommy's dream did not come to pass, but when the International Biological Programme came to be in the early '70s, there was an opportunity to create an ecological reserve out of my Stone's sheep study area. The movers were Ian McTaggart-Cowan, Vladimir Krajina, a famous plant ecologist, and myself. Gladys Lake Ecological Reserve became the largest ecological

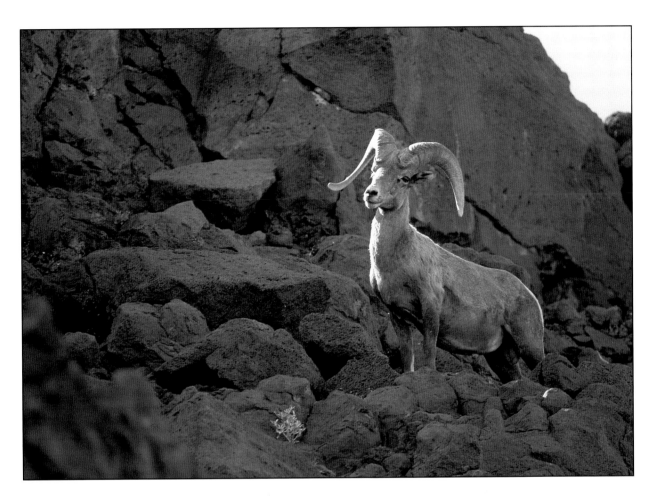

A desert bighorn ram *(Ovis canadensis nelsoni)* from northern Arizona, taken in June. Desert bighorns are usually small-bodied compared to bighorns from the Rockies, but they can live in a much harsher environment.

reserve in British Columbia. Better still, it forms the heart of the large Spazisi Plateau Wilderness Provincial Park, with strict controls on access to wildlife. I think Tommy Walker might have approved. In wildlife research and management, politics may not be far away!

I pined to see Stone's sheep, as I thought they lived in a dry, sunny land. In two preceding years, I had followed moose in Wells Gray Provincial Park, in the wetbelt of central British Columbia, and rain or sunshine, I had wound up soaked day in and day out. The willows and fireweed on the burns were either soaked in rain or dew. Little did I know that, on this count at least, we had made a false bet on the Stone's sheep. There was much rain on the Spazisi, with tall dwarf birches and willows faithfully holding the moisture.

Newlyweds, my wife Renate and I arrived at Gladys Lake on the 19th of June in 1961. Tommy had seen six rams on a cliff above the lake on a fly-past in February. He kept the mountain he called Sanctuary Mountain off-limits to his guides and hunters. He had seen sheep there periodically. We saw a large band of rams there on our first day out, but it was to be the last sighting until late in summer, for the rams moved out and we were busy building a cabin for the coming winter.

I stayed on alone for 22 months, as Renate's stay in the Spazisi was disrupted and finally cut

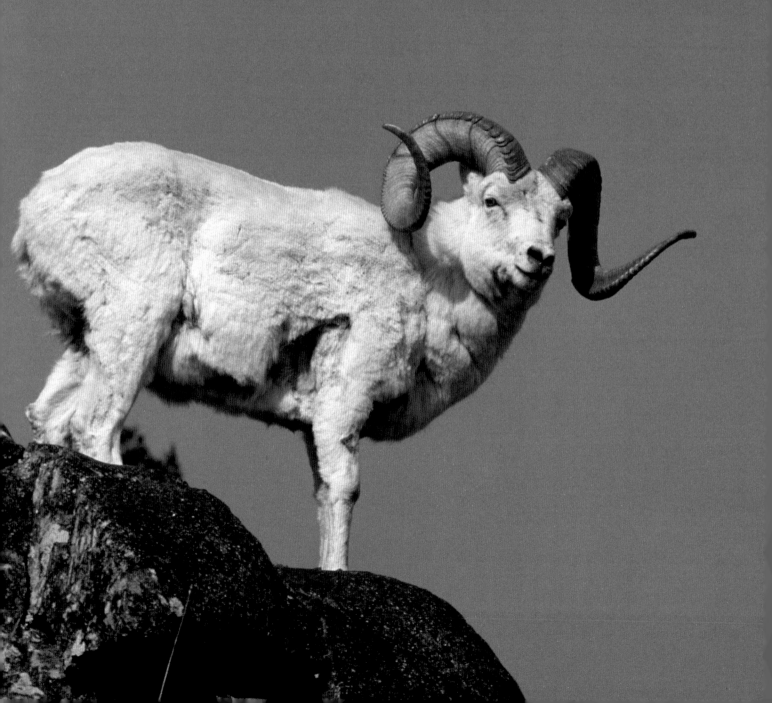

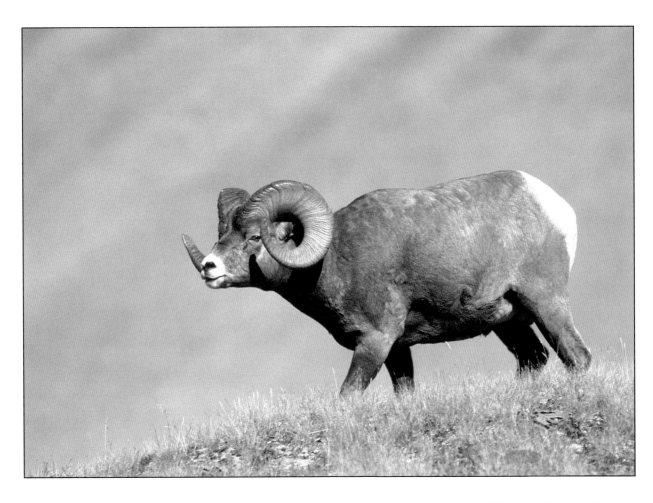

Rocky Mountain bighorn ram *(Ovis canadensis canadensis)* in the short fall or nuptial coat. This subspecies is normally the largest in body size. However, desert bighorn rams from high and cold mountains, such as in Baja California in Mexico, grow to nearly the same size.

A Dall's ram from the Yukon with an exceptionally large set of horns. He is fully matured and about to shed his winter coat.

short by several bouts of illness. After the Spazisi, Renate and I went to Banff National Park, where I studied bighorn sheep for two years; then on to study Dall's sheep in what would later become Kluane National Park in the Yukon. I wrote my dissertation in Vancouver, but my technical book about these studies (Mountain Sheep, University of Chicago Press, 1971) was written in Germany, where I was a post-doctoral student under Konrad Lorenz.

The science of animal behavior has come a long way since the innocence and wonder of our early days. We were doing low-tech science with binoculars and notebooks, but with exhilarating insights! After returning to Canada and starting a professor's career at the University of Calgary in 1968, mountain sheep, along with other animals,

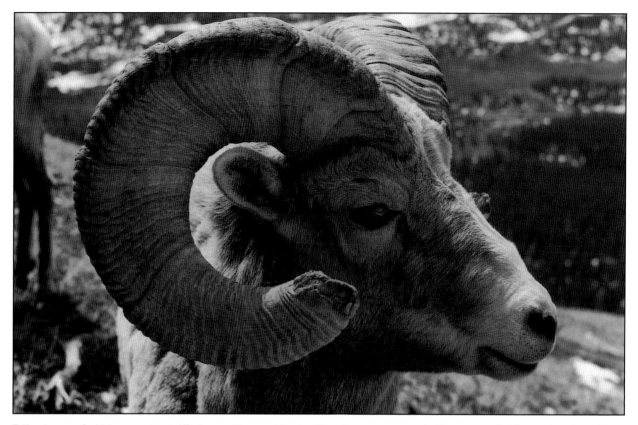

Telling the age of a bighorn ram is not difficult, except in very old males. Since the ram grows a set of horns a year but the new horn is stuck onto the old horn, all one needs to do is to count the number of horns it has grown. The first set of horns, those of the lamb, are so small and indistinct that, even if present, one skips to the next ring and begins counting at "two." That is, the horn grows from early summer until late fall, when the sex hormones turn on the rut and stop horn growth. The result is a big groove, an "age ring."

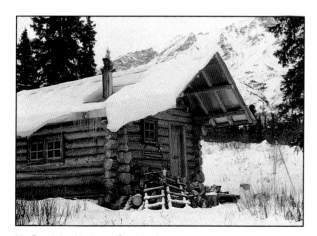

My Spazisi cabin in my Stone's sheep study area in northern British Columbia. I stayed here for almost two years, studying sheep and mountain goats from 1961 to 1963. My study area became a large ecological reserve, Gladys Lake Ecological Reserve, within which Stone's sheep are now protected.

continued to be a focus of my research. The doctoral work on bighorns by my students David Shackleton, Cris Shank, Brian Horejsi, and Marco Festa-Bianchet contributed much to an understanding of population differences and ecology.

However, not all of our concerns are reflected in this particular book, for we dealt with much applied science and wildlife conservation. We included heart rate telemetry on free-living mountain sheep to generate a rational basis for deciding what disturbed them and what did not. Dr. Bob MacArthur, Ray Stemp, and Denis Chabot pioneered here, and my friend Ron Johnston, Professor of Electrical Engineering, designed and built the radio transmitters we used in this research. It paid off, because wild mountain valleys and ranges were spared from destructive development. Strip mines for coal—each an eyesore if ever there was one—were rehabilitated to mountain sheep habitat in the pioneering effort of

Mrs. Beth MacCallum. Now these holes in the ground produce embarrassing numbers of bighorn sheep in Alberta.

We know how to effectively manage mountain sheep. However, we have not removed threats to their existence, the worst of which are livestock diseases. Our sheep, with their ancestral homes in Eastern Siberia, are—like native people—extremely sensitive to the parasites and pathogens of their Old World relatives. Once sheep die out in an area, recolonization is extremely slow, if it takes place at all. Just keeping North America's sensitive native fauna free of foreign diseases and genetic pollution will be a challenge in the years ahead. How, pray tell, does one separate the most sensitive of these species, such as bighorns, from livestock and escaped exotics . . . forever?

Our North American large mammals are unique in that they are poorly adapted to the land and to one another, creating a perfect situation in which to study adaptation. The animals are, after all, a mixture of recent Siberian immigrants such as the moose, elk, grizzly bear, timber wolf, and wolverine, plus some not-so-recent arrivals such as bighorns and mountain goats, and a few old, opportunistic survivors from the species-rich Ice Age fauna of North America, such as white-tailed and black-tailed deer, pronghorn buck, peccary, black bear, and coyote.

The Siberians are closely adapted to the ecological conditions of Ice Age Siberia, not to the climate and biota of North America. The ancient survivors, meanwhile, are specialists in exploiting fleeting opportunities in disturbed landscapes that are densely packed with ecological specialists. These ancients never had it so good as today. They are opposed only by "northerners" that are less adapted to compete for food rapidly removed by competitors. Instead, the Siberians are adapted to exploit sharply seasonal differences in food type and availability.

In addition, there are newly evolved forms such as mule deer, a unique hybrid species now quite different from its paternal (black-tailed deer) or maternal (white-tailed deer) species, and the bison, a species apparently shaped post-glacially and in good part by human hands.

Man, too, came from eastern Siberia. His ancient adaptation to Ice Age Siberia, a weakened immune system, was perfectly capable of dealing with the few parasites and pathogens that survived the cold, dryness, and dust. The system even dealt with American continents that were stripped of much of their species-rich large mammal fauna, and therefore of a host of diseases and parasites. However, the immune system proved detrimental once it encountered diseases born by Old World relatives adapted to southern climates in the post-Columbian area.

The collapse of a fauna, and the subsequent explosive colonization of "southern" continents by "northerners" is, historically, a unique situation. It may surprise readers to learn that, in all likelihood, human life here was quite impossible prior to the extinction of America's multitude of large, ecologically specialized herbivores and large predators. There was no uncontested food to exploit, and human hunters would quickly have become the hunted by carnivores that were far too large to oppose with the primitive weapons of late Stone Age man.

The study of Ice Age species such as our mountain sheep thus led us along trails full of unexpected scientific adventures. Some of these adventures are recounted in this book. I suspect there are many more surprises still to come, provided we retain our wild large mammals in their wild state. North America's past generations have done a good job of restoring the wildlife which, by the turn of their century, they had nearly exterminated. Let's hope that the current and future generations do as well.

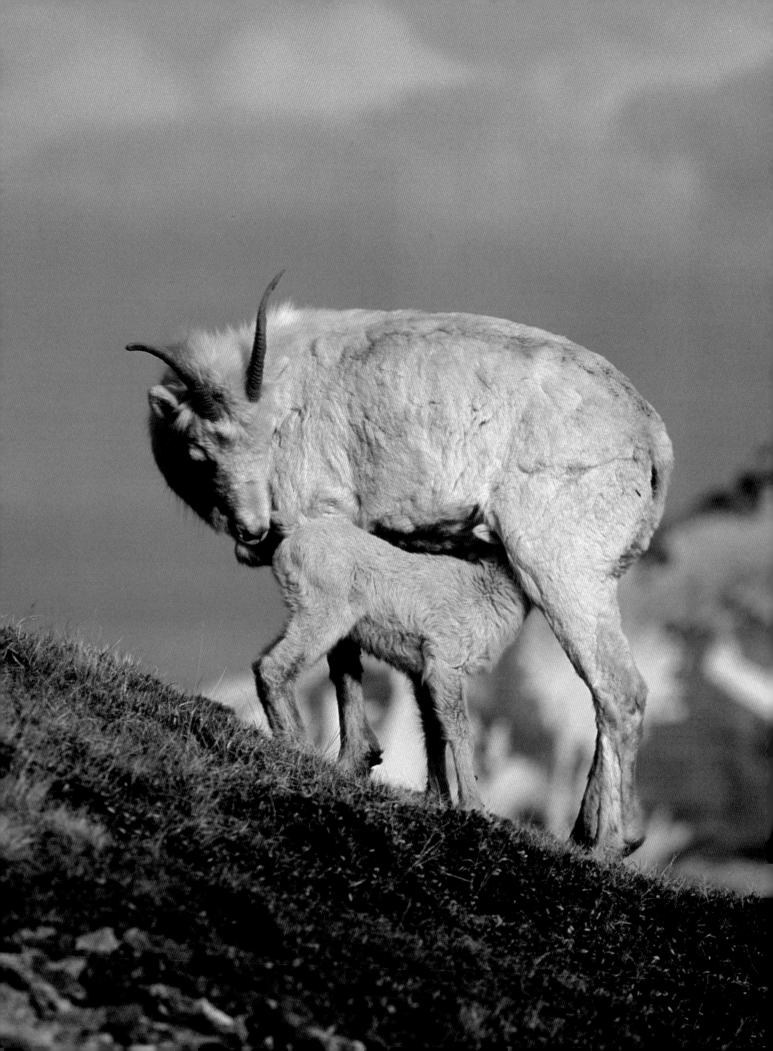

HIGH
ABOVE
THE
CLOUDS

Its eyes were large and bright. They looked out over a world they had not seen before, but they still understood its essential features. They correctly interpreted the chasm that dropped off from the cliff's ledge and fell precipitously to the scree slope and the sparsely grassed meadow below, to the stunted alpine firs lower still, to the waterfall and the rocky gorge that guided the meltwater to the valley below. The bright eyes scanned the distant spaces, where the valley floor tilted and soared into mountain peaks that rose row upon row to fade into the hazy blue distance.

The eyes scanned the near spaces and analyzed the shaggy shape of the large, moving object close by, and guided the little newborn's search for sustenance into a high, dark corner between thin pillars, where a soft udder and its warm, rich milk was hidden.

The eyes detected the eagle that scouted the tall cliff for prey, triggering fright and making the little lamb duck beneath its mother. The lamb's

Week-old lamb suckling. The ewe checks the identity of the lamb by the odor of the anal glands below its little tail. Ewes are very watchful mothers.

large, sensitive eyes would later guide it unerringly when it was foraging or escaping during the long winter nights, or above the Arctic Circle through months of continuous darkness.

 o o o

The mountain sheep's large eyes allow it to live in the Arctic along with caribou, in a realm where its distant cousin, the mountain goat, appears no longer able to follow. Though a cliff and mountain dweller much like the mountain sheep, the mountain goat does not go beyond the Arctic circle, and even on winter days it quits foraging on the vegetated slopes and appears eager to reach the safety of cliffs well before dusk. Mountain sheep, living on the same mountain, feed right on through dusk, while the goats hurry past to bed down before darkness.

 o o o

The deep chasm below the cliff's ledge simultaneously raised anxiety and meant deep comfort to the lamb. In times of danger, the large, bright eyes would direct the little creature toward the cliff as fast as its feet would carry it, and would do so for years to come—into adulthood and old age. The cliff meant security. Over millions of years of evolution, mountain sheep had learned they could avoid danger there. From the minute this

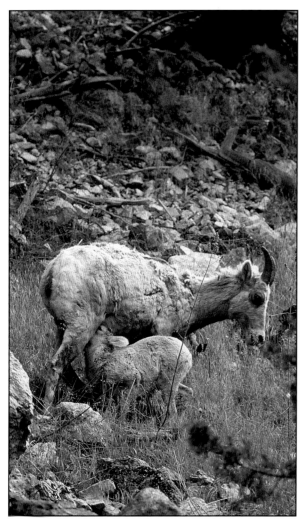

A ewe with lamb, producing abundant milk, delays the shedding and regrowth of her hair coat. Consequently, lamb-leading ewes look scruffy. The lambs are born in steep cliffs to protect them from bears, wolves, and coyotes. After birth, the ewe needs a few days with her lamb to ensure close maternal bonding before she joins other ewes with lambs.

newborn could wobble about on the birth ledge, its discerning eyes would also ensure that it would never get too close to the edge, and would never fall off.

The little bundle of big eyes, big-jointed legs, and large hooves was endowed by nature with an ability to survive and thrive in the cold, steep mountains, where glaciers and snowfields cap the peaks, where the winds are strong and cold, where clouds can quickly turn into snowstorms, where wolves patrol the ridges and are joined by wolverines, grizzly bears, and eagles whenever sheep, mountain goats, and elk or mountain caribou give birth.

<p style="text-align:center">o o o</p>

Predators and prey all look to their own advantage. The grizzly bear female, systematically combing the ridges and cliff edges for tasty lambs, kids, and calves, is herself in milk. She has two spunky cubs of her own to feed. She needs the nutrients found in the bodies of newborn sheep, goats, and elk to ensure her own success as a mother bear. The wolverine's hunger is no less real, and its capacities to find and catch newborn lambs are finely tuned. So are those of the eagle, which in soaring past had frightened the lamb into ducking under its watchful mother. The lamb's action had told the eagle to soar on by. It somehow understood that to attack this lamb was to waste time and effort on a fruitless and dangerous pursuit. As long as the ewe was watching, the eagle must bide its time and try again later or elsewhere.

As sinewy and tough as an eagle may be, an upward blow from the ewe's horns, powered by the female's stocky, muscular body, would turn a deadly eagle into a dead eagle. Wounded by the ewe's horns, an eagle would be reduced to a tumbling mass of broken bones with wings, tail, and talons flapping out of control. The eagle, of course, could not know that, but its instincts

ensured that it would not meet such a fate. It soared on, looking for better opportunities.

○ ○ ○

The world of the lamb held many dangers from the moment the newborn slipped from the warm body of its mother into the biting chill of the exposed, windy rock ledge. However, the lamb and its mother were endowed with survival strategies perfected by sheep of generations past, and so they endured the tests they faced daily, dealing with the dangers that the newborn was to meet throughout its life. They endured most of the dangers, at least, but nothing in their past had prepared them for modern times.

The newborn's chill was met with a quick burning of its store of fats, and heat surged through its body. The ewe licked off the birth fluids and birth membranes that stuck to the lamb. Her licking not only reduced heat loss by evaporation, it also thoroughly massaged the lamb, made it kick and struggle, and stimulated proper body function. The drying of the lamb's fur thus enhanced its insulation. Small though it was— about eight pounds—its weight was enough to significantly retard heat loss. But above all, it carried enough birth fat to ensure warmth in the critical first hour of its life, until it rose on wobbly legs and discovered that it could suckle the warm, life-giving mother's milk.

The ewe swallowed the birth fluids licked from the lamb's fur. It also chewed and swallowed the birth membranes and the afterbirth. This removed evidence that would otherwise be carried by the wind to the sharp noses of predators, announcing that a lamb had been born. The chewing also recycled precious proteins and vitamins the ewe needed for milk production and for her own depleted body.

○ ○ ○

The mountain sheep's pregnancy period, about 175 days, is nearly a month longer than that

Stone's yearling at dusk. Mountain sheep have excellent night vision and may feed well off protective cliffs at night.

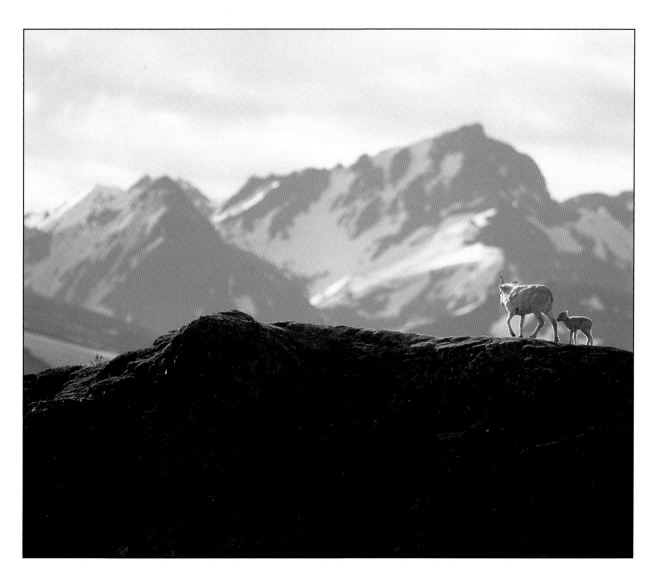

Cliffs are essential to mountain sheep security. In steep terrain, the surefooted sheep can thwart attacks by predators or can quickly withdraw from sight in the many nooks and crannies.

of its southern cousins in Asia. Its gestation is longer even than that of the much larger giant sheep, or argalis. Normally, bigger-bodied species have longer gestation periods, but this clearly does not apply to mountain sheep. In this respect, they resemble other large Ice Age ruminants that evolved in the long, dry, cold winters of northeastern Siberia. The extended gestation also applies to our elk, whose period of 245 days exceeds that of its southern relative, the red deer, by about a month. It applies to the musk oxen's gestation of 250 days or more, and to the caribou's 230 days—long pregnancy periods for the respective size and hereditary lineage of these species.

All of these ungulates give birth to young of relatively small body sizes, and all bear no more than one young at a time. This suggests that only small amounts of nutrients and energy are available to wintering females for fetal growth. Limited by meager forage costly to procure and difficult to digest, and constrained by the high cost of searching for food and keeping warm, the females have little energy and nutrients to spare beyond what is needed for their own daily maintenance. There is too little to spare to grow large young, let alone to allow the luxury of growing twins. Fortunately, life in cold climates makes encounters with predators less common, and the diversity of predator species is much more limited here than in warm

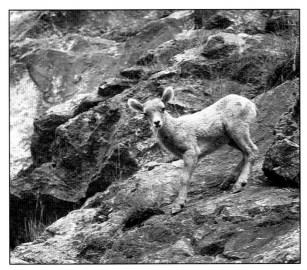

Lambs are born rock acrobats. They are capable of following their mothers along the steepest cliffs within a few hours of birth.

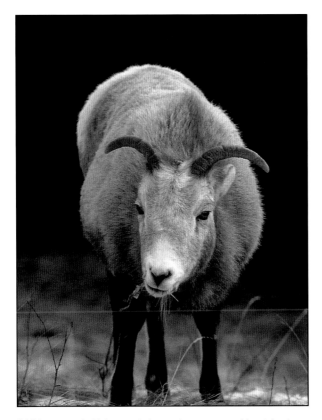

A bighorn ewe in February during early pregnancy. Mountain sheep are unusual among sheep and goats, in that they have a relatively long gestation period. Gestation lasts about 175 days compared to about 150 days for most sheep and goat species. This may be an adaptation to long winters.

climates. This in turn allows, on average, successful reproduction at a birth size that would be inadequate in warm, especially tropical, regions.

 o o o

Costly as a pregnancy might be in the long, icy winters, its hardship pales when compared with the cost of producing milk. The female is metabolically scheduled so that birth coincides with the flush of abundant nutritious forage in spring, when she also uses her last body stores for producing milk. She raids her skeleton for minerals, surrenders the last of her body fat for energy and vitamins, and drains her muscles and organs for protein. She becomes emaciated. Her skeleton grows light and fragile, and she delays shedding her worn, bleached winter coat for a new, shiny one. She must take chances on her own security and expend precious energy visiting distant mineral licks, in order to ingest inorganic salts that are not readily available in the spring forage.

After several weeks of producing abundant milk, the female begins to rebuild her own body, but she does so later than sheep not burdened with reproduction. With advancing age, she will rebuild imperfectly. Old ewes may have thin-boned skulls, occasionally marked by openings where dissolved bone was not replaced. These old ewes chance breaking a horn when they butt heads with a young ram, or busting a leg during a fall. Early summer is the season that brings broken legs for mountain sheep.

 o o o

Mineral licks are very important to mountain sheep. The licks supply essential metabolic salts

Overleaf: A bighorn ewe and her day-old lamb, moving in the protective landscape of the badlands of South Dakota. Bighorns formerly inhabited most of the western badlands, but they fell victim to market hunting at the turn of the century. These bighorns were reintroduced from a Pike's Peak population.

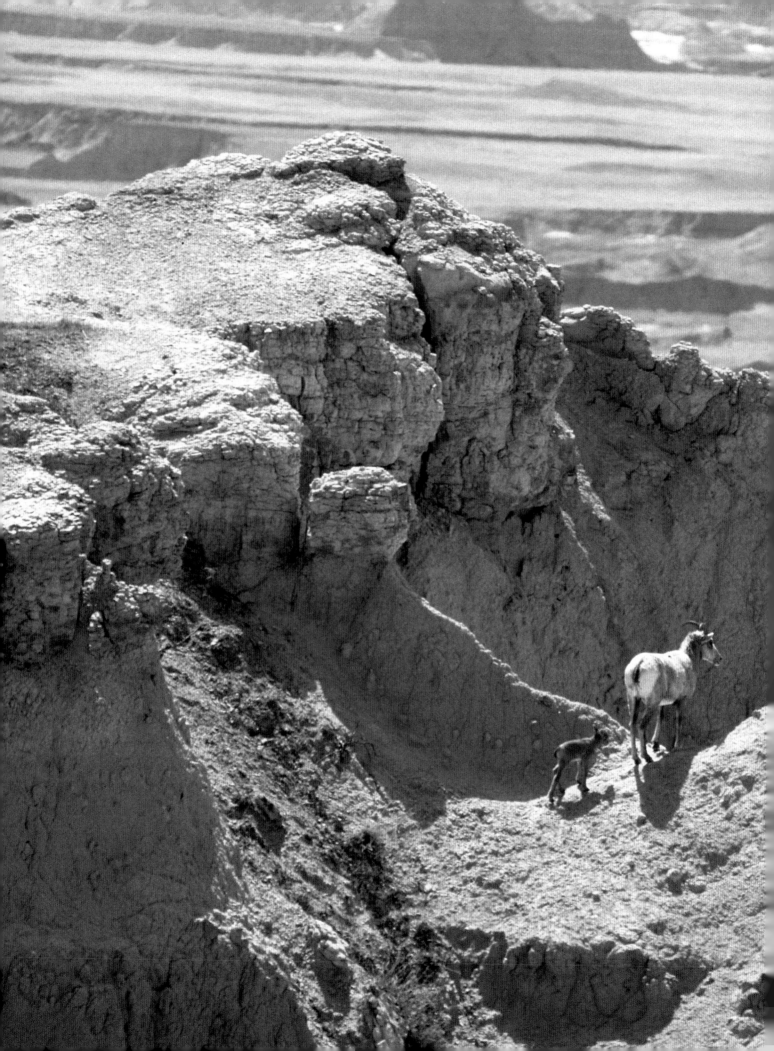

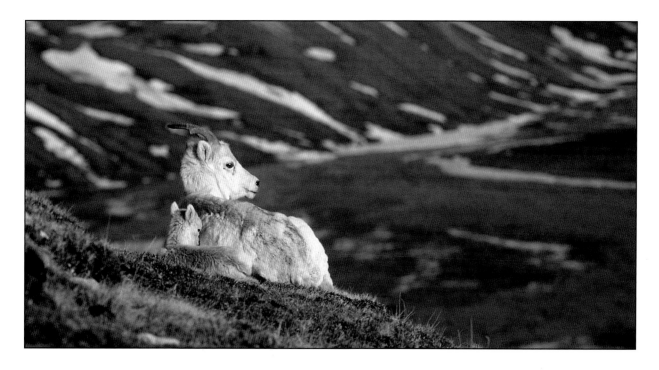

The baby sheep snuggles close to its mother during periods of rest. Lambs rest a little more than their mothers, and seek out the ewe for protection.

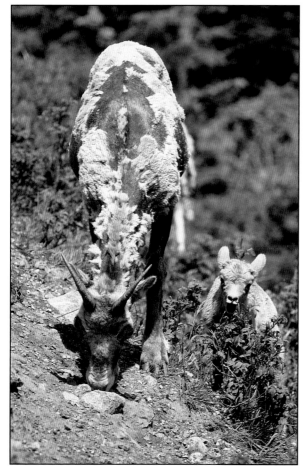

The ewe pays a price for nurturing her lamb. The cost of milk production delays the restoration of the ewe's emaciated body and hair coat. Only when lambs reduce suckling in late summer do the ewes catch up, so they can restore the body before winter.

lacking in the early growth of plants, and they also provide inorganic sulfur. With the aid of their rumen bacteria, sheep use the sulfur to synthesize rare, sulfur-bearing amino acids. The amino acids, cysteine and methionine, are vital for the growth of connective tissues, hair, and horns.

The time when the mountain sheep's hair regrows, in early summer, is also the time when it visits mineral licks. In fact, in the MacKenzie Mountains of far northern Canada, Dall's sheep ewes center their summer activities on mineral licks. That's how important the licks are to the existence of northern sheep. Where mineral licks are plentiful, sheep exhibit high reproductive success, large body size, and vigorous behavior—in part a consequence of abundant mineral wealth in the form of magnesium sulfate, calcium sulfate, and other sulfates.

o o o

The bright-eyed little lamb on the narrow ledge of the towering cliffs above the valley was about to embark on the great adventure of life.

Within a day, it was surprisingly strong on its legs; it began to bounce around its resting mother. Soon it would jump flea-like through the cliffs, in long hops up and across walls as if defying gravity. It would jump even on top of its traveling mother and tumble down, learning quickly not to choose such uncertain footing. Within a few days, it would meet other lambs and join them to sprint and bounce between and under adults. It would try to entice yearlings into butting contests, though to no avail. And through these athletic activities, the lamb's thick-jointed limbs and generous-sized hooves would come into their own. The big hooves would soon get a solid grip on the rocks, and the big joints would absorb the energy of those long downhill jumps.

But today the lamb narrowly evaded the attack of the grizzly bear female and fled with its dam into the safety of another cliff. Its half-sister, born the preceding year, had not been so lucky. The ewe had returned for three days to the spot where her baby had been killed, bleating and searching for the lost child. Thereafter, the painful milk pressure in her udder had subsided, and she had rejoined other ewes of her clan and followed them about. That "vacation" from lamb-rearing may have been responsible for her superior body

Mineral licks are vitally important to mountain sheep females during summer, when heavy demands are placed on their metabolism by milk production, the restoration of their skeletons, and the growth of hair and hooves. Many minerals play vital physiological roles. Organic sulfur, for example, is turned into cysteine and methionine by bacteria in the sheep's rumen. The two substances thus created are amino acids vital to the growth of connective tissue, hair, and horn.

condition and the large, well-developed lamb she bore this year.

⚬ ⚬ ⚬

The female clan residing here was made up of females related to one another by maternal descent. They were mothers, daughters, aunts, cousins, grandmothers, even a great-grandmother. The clan arose because of the proclivity of young females to stay within their maternal home range. Their brothers leave for other ranges, following large-horned rams to their distant seasonal abodes. Only occasionally does a young female leave or a strange young female visit the clan and stay. The ewes normally remain on their accustomed ranges, with young females accepting the home ranges of their mothers and intimately learning the areas by following the adult females on their daily routines.

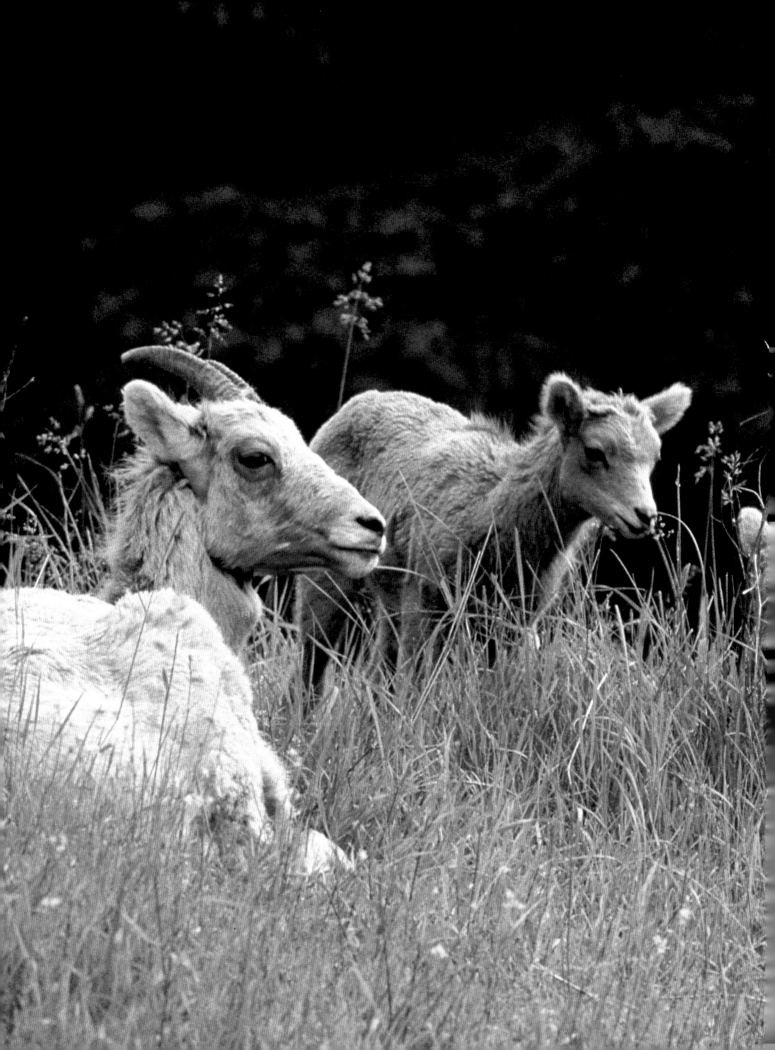

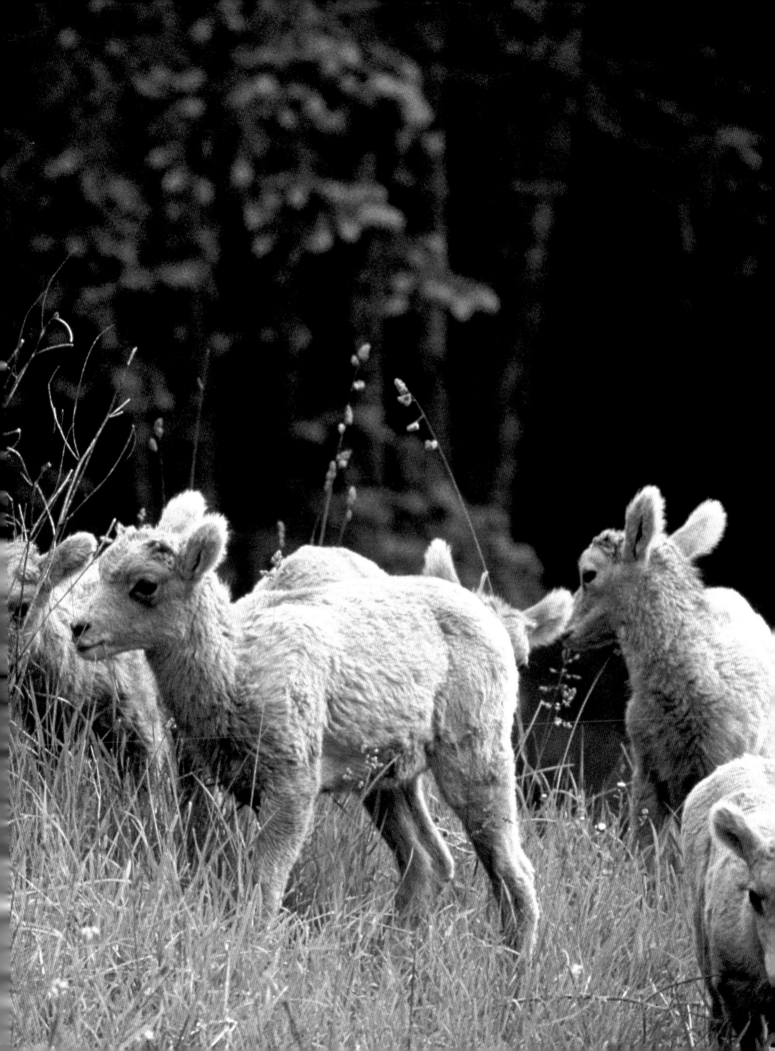

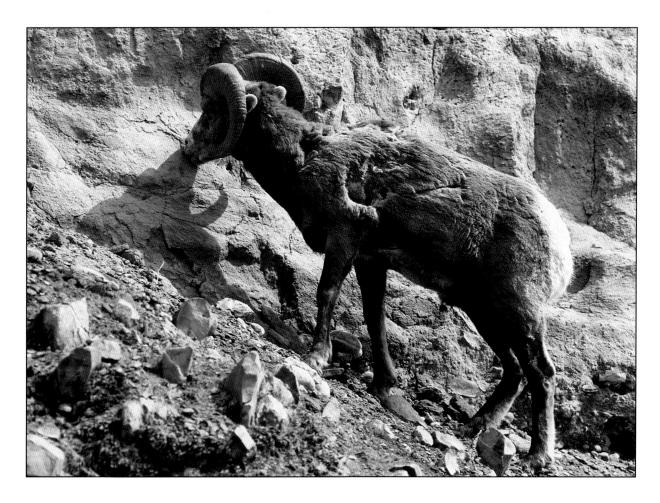

At hair-shedding time, rams visit mineral licks most frequently. When the physiological demands of growing a large body and horns and depositing layers of fat lessen, then rams visit the mineral licks much less frequently.

Rams visit the female clan home range during the breeding season in early winter. Since one large ram does most of the breeding within any one year, the little lamb met within its clan many half-brothers and half-sisters. Those meetings took place about seven days after its birth.

As luck would have it, the lamb was the very first to come down from the birth cliff and meet other sheep. These others were plainly fascinated by the bright-eyed little bundle. They stared intently at this, the "first" lamb of the year. They crowded in, stretching their snouts toward it and sniffing. The lamb, a little frightened, bounced close to and then underneath its mother. However, the yearlings, the two-year olds, and particularly a barren old ewe, all crowded in. The lamb's mother butted them, but they were not discouraged. The crowd was enthralled. The mother ewe turned and ran from the herd, and the lamb ran after her. But the barren old ewe would not desist. Ducking low over the ground, her snout extended toward the lamb, the old ewe ran as fast as she could after the mother and child, following them into the cliffs before returning to the crowd of yearlings below.

o o o

Old barren ewes are like that. For a few brief weeks in spring, when a new crop of lambs is being born, they become caring nannies for yearlings that have grown increasingly independent of

Lambs at play in cliffs defy gravity. They are spunky, agile imps that sail fearlessly in long jumps through the steepest of cliffs.

their mothers. Beginning in March, the dams pay less and less attention to the yearlings. The yearlings join one another and even follow rams once in a while, but they gather with increasing frequency about the old, barren females. These ewes shed their normal indifference toward other sheep and begin to "look after" the yearlings. They watch their little followers attentively; they may bleat after a departing youngster as if enticing it to return. They may—rarely—groom the head of a yearling, but most often they simply play with the yearlings, bouncing and frolicking through the cliffs in a manner belying the age of these old ladies.

 o o o

In the meantime, the gravid females disperse one by one, secluding themselves in the cliffs and ridges to give birth to their lambs. When the lamb-leading females come down and join others, the yearlings ignore the old ewes and begin following lamb-leading ewes.

Among bighorn sheep, however, matters are not always so neat. In bighorn societies the yearlings, the barren females of all ages, and a few young males may move off to the summer range while the lamb-leading ewes form distinct bands. The lamb-leading ewes stay for about a month in their own company before joining the rest of their clan on the summer range, where the lambs grow from babies into highly functional little sheep.

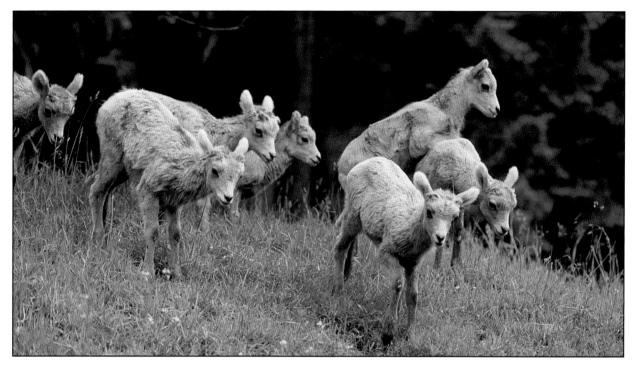

Sheep are proverbially social creatures, and lambs join others in forming gangs within five to ten days after birth. At that age their social skills are modest, but they already know how to butt and to mount. The gang members stick together and choose which adult they will follow—or whether to follow at all. The lambs may choose, for instance, to stay behind on a mountain while their mothers go off to a mineral lick.

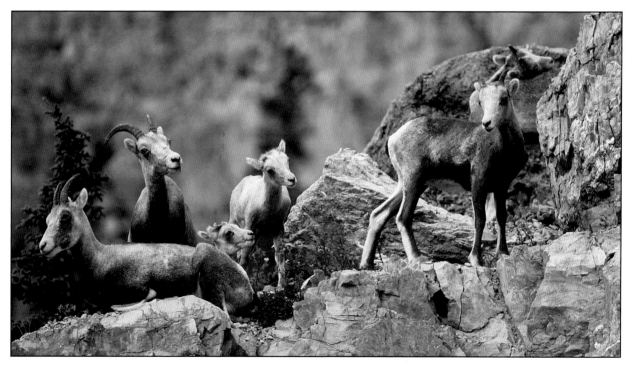

A nursery group of Stone's sheep in late summer. At this time, even the lamb-leading ewes have shed the old winter coat and sport a dark, short-haired summer dress.

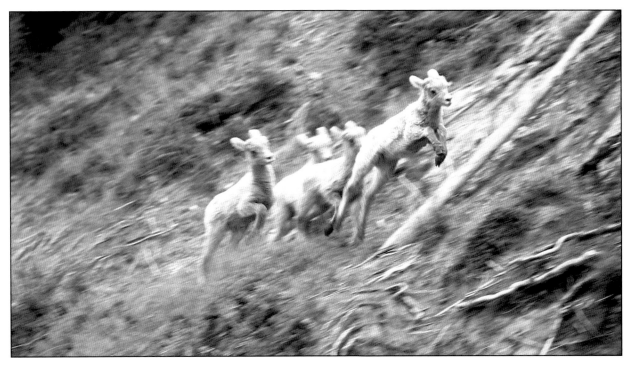

Lambs are born mountaineers. They have generous footwear—namely large, rubbery hooves that provide excellent traction in rocks. They have big joints to absorb the energy of long jumps and steep drops. And they have sturdy, well-powered legs for high, rapid bounds.

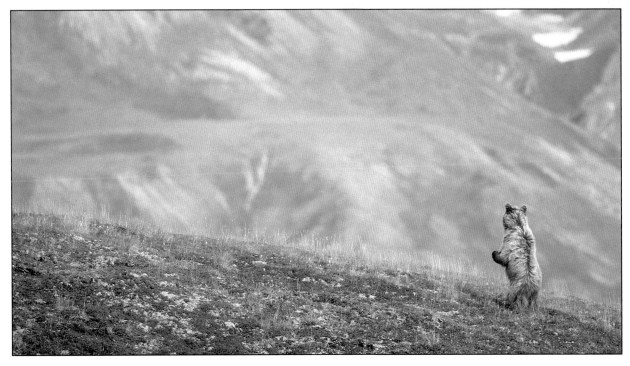

A grizzly overlooks sheep habitat in anticipation of finding and catching tasty lambs.

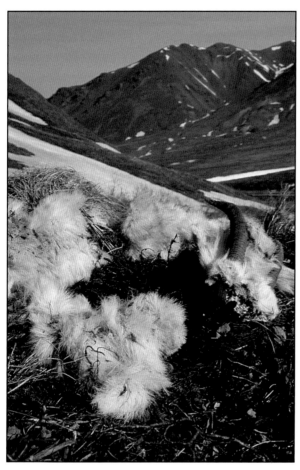

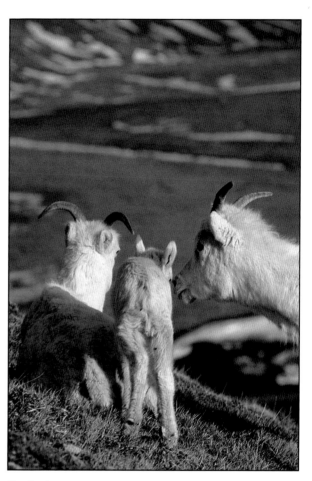

A Dall's sheep ewe, killed and fed upon by a grizzly. Grizzly bears rarely catch adult sheep, but are fairly successful at tracking down and catching small lambs. The fragile nose and face of a sheep is quickly eaten by bears and wolves, and is thus missing, as seen in this photo.

The first-born is the center of attention, particularly by yearlings and again by old, barren females. They all try to sniff and follow the new member of the nursery group.

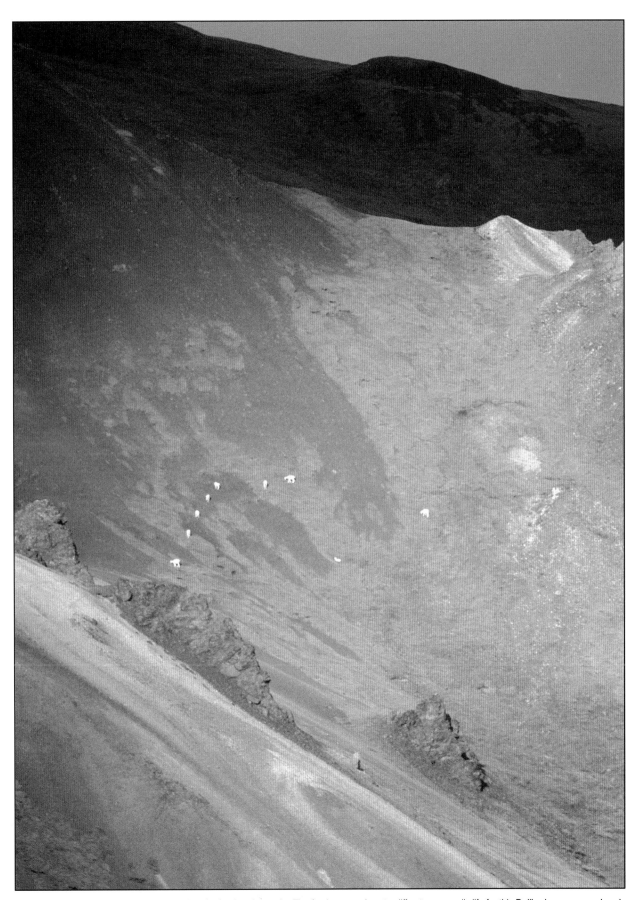

Female sheep know how to pick the best sites for feed and security. The fresh green close to cliff outcrops spells life for this Dall's sheep nursery band.

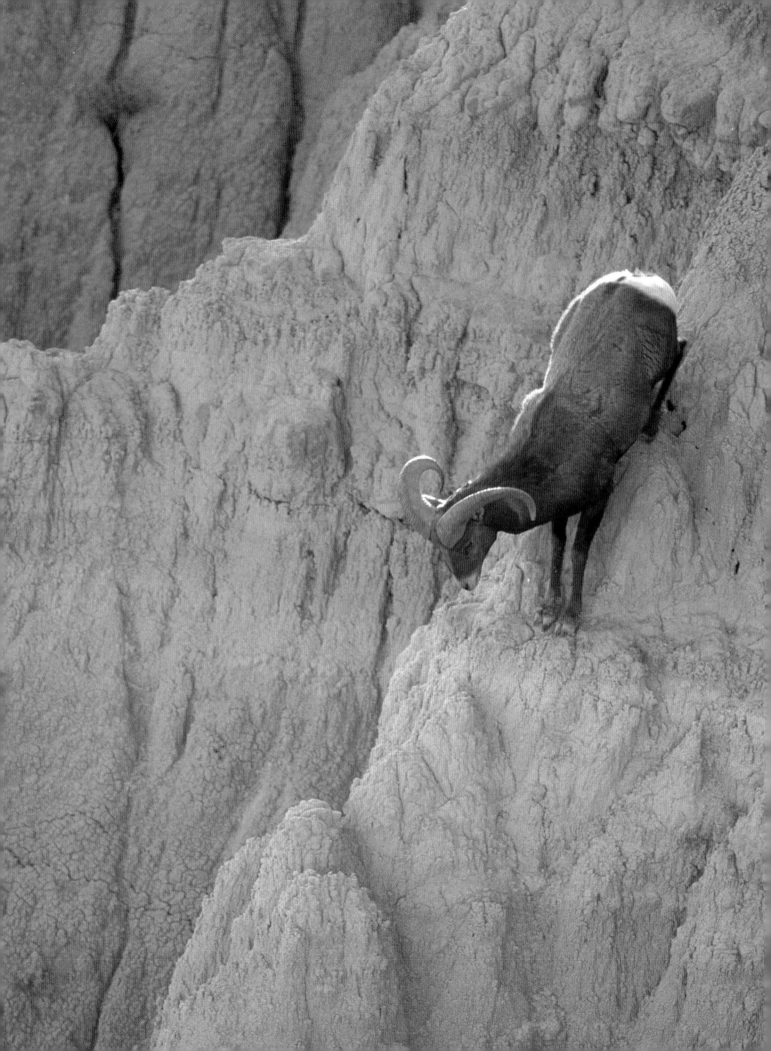

MOUNTAIN SHEEP

M ountain sheep have long been recognized as different from other sheep and are even placed into a separate subgenus, *Pachyceros*. There are three species of mountain sheep.

Ovis (Pachyceros) nivicola, the snow sheep, is found sparsely over a vast range in the cold, barren mountains of northeastern Siberia. Its Siberian range is as large as that of the two North American species combined, and that range is almost entirely subarctic and arctic in climate—the exception being low-latitude areas in Kamchatka, particularly coastal cliffs.

Snow sheep are rather poorly understood. They tend to be small—about the size of Dall's sheep—and in winter, they are conspicuously long-haired. Seen from the front and side in their short, brown summer fur, or even in fall, snow sheep may look remarkably like small bighorns.

Mountain sheep are cliff jumpers that seek security from predation in cliffs. The cliffs may be of rock, or they may be badlands formations such as the formation this reintroduced bighorn ram is descending in Badlands National Park. The sheep that was once native to the badlands was the Audubon bighorn. The last member of this race, an old ram, was killed at Magpie Creek, North Dakota, in 1905.

However, they differ regionally in color and in the shape of their rump-patch.

Ecologically, snow sheep differ from others in that they feed heavily on ground lichen in winter, much like reindeer. Dall's and Stone's sheep eat some lichen, but not in the amounts reported for snow sheep. Like Dall's sheep in Alaska, the Yukon, and North West Territories, snow sheep in Yakutia and the Chukota are found north of the Arctic Circle. They are, therefore, able to survive in the dark polar winter along with reindeer and musk oxen.

On the opposite side of the Bering Straight, in Alaska and northwestern Canada, one finds the thinhorn sheep, *O. (P.) dalli*. There are two subspecies, the white Dall's sheep *O. dalli dalli* and, more to the south, the dark, often black Stone's sheep *O. d. stoni*.

Still farther south, beginning in central British Columbia and extending into northern Mexico, one finds the large bighorn sheep, *O. (P.) canadensis*. Its southern races, which extend into Mexico, are collectively called desert sheep.

o o o

Whatever their species, however, mountain sheep are closely related and can be easily identified at a glance, even though they may vary in coat

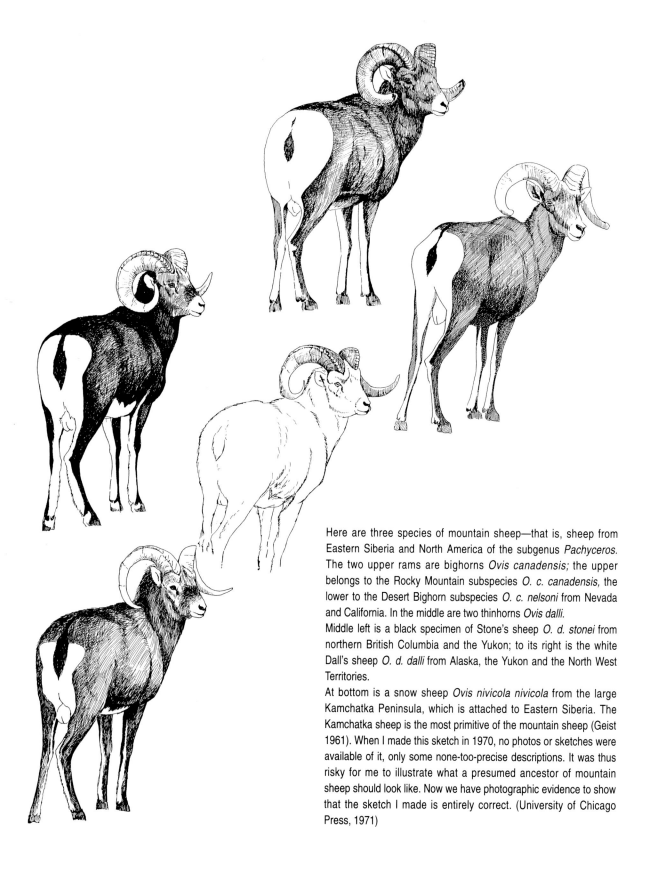

Here are three species of mountain sheep—that is, sheep from Eastern Siberia and North America of the subgenus *Pachyceros*. The two upper rams are bighorns *Ovis canadensis;* the upper belongs to the Rocky Mountain subspecies *O. c. canadensis,* the lower to the Desert Bighorn subspecies *O. c. nelsoni* from Nevada and California. In the middle are two thinhorns *Ovis dalli*.

Middle left is a black specimen of Stone's sheep *O. d. stonei* from northern British Columbia and the Yukon; to its right is the white Dall's sheep *O. d. dalli* from Alaska, the Yukon and the North West Territories.

At bottom is a snow sheep *Ovis nivicola nivicola* from the large Kamchatka Peninsula, which is attached to Eastern Siberia. The Kamchatka sheep is the most primitive of the mountain sheep (Geist 1961). When I made this sketch in 1970, no photos or sketches were available of it, only some none-too-precise descriptions. It was thus risky for me to illustrate what a presumed ancestor of mountain sheep should look like. Now we have photographic evidence to show that the sketch I made is entirely correct. (University of Chicago Press, 1971)

I like argalis! Rams of three subspecies are looking at you. Argalis are much more diverse and colorful than mountain sheep. Though larger, they live shorter lives than our bighorns but compensate with a higher reproductive output. They may twin under good conditions. They escape predators through swift, enduring flight and rely less on cliffs than our mountain sheep.

At top is the famous Marco Polo sheep *(O. a. polii)* from the Pamir Mountains, "The Roof of the World," where the great Italian world traveler saw it in the 13th century. The record horn length in this sub-species reaches 75 inches!

At middle is the larger Altai argali. Its horns and skull may reach 60 pounds in weight, or about twice the mass of comparable horns from Marco Polo sheep. This was the first of the argalis to be described by science, and its Latin name *Ovis ammon* describes it, essentially, as "The Sheep of God."

At bottom is the primitive white-ruffed Tibetan argali, which in some populations is not much smaller than the Alta argali.

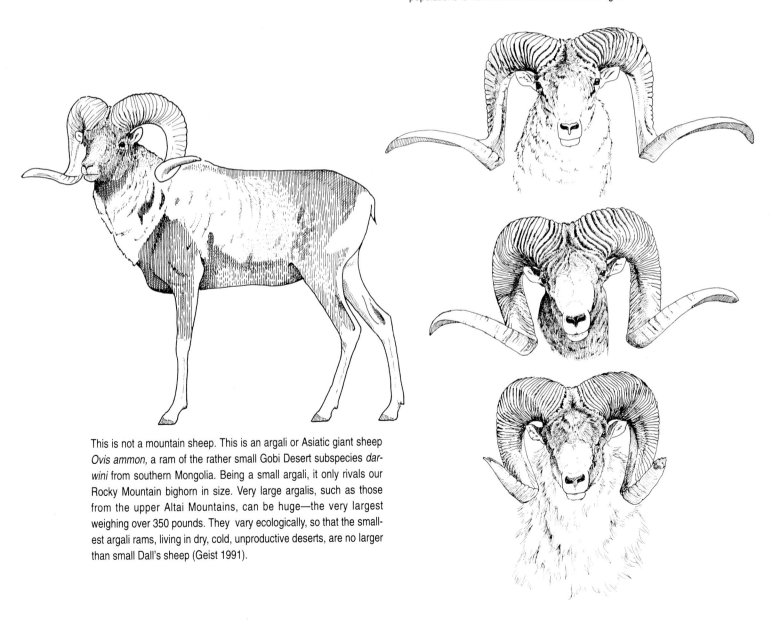

This is not a mountain sheep. This is an argali or Asiatic giant sheep *Ovis ammon,* a ram of the rather small Gobi Desert subspecies *darwini* from southern Mongolia. Being a small argali, it only rivals our Rocky Mountain bighorn in size. Very large argalis, such as those from the upper Altai Mountains, can be huge—the very largest weighing over 350 pounds. They vary ecologically, so that the smallest argali rams, living in dry, cold, unproductive deserts, are no larger than small Dall's sheep (Geist 1991).

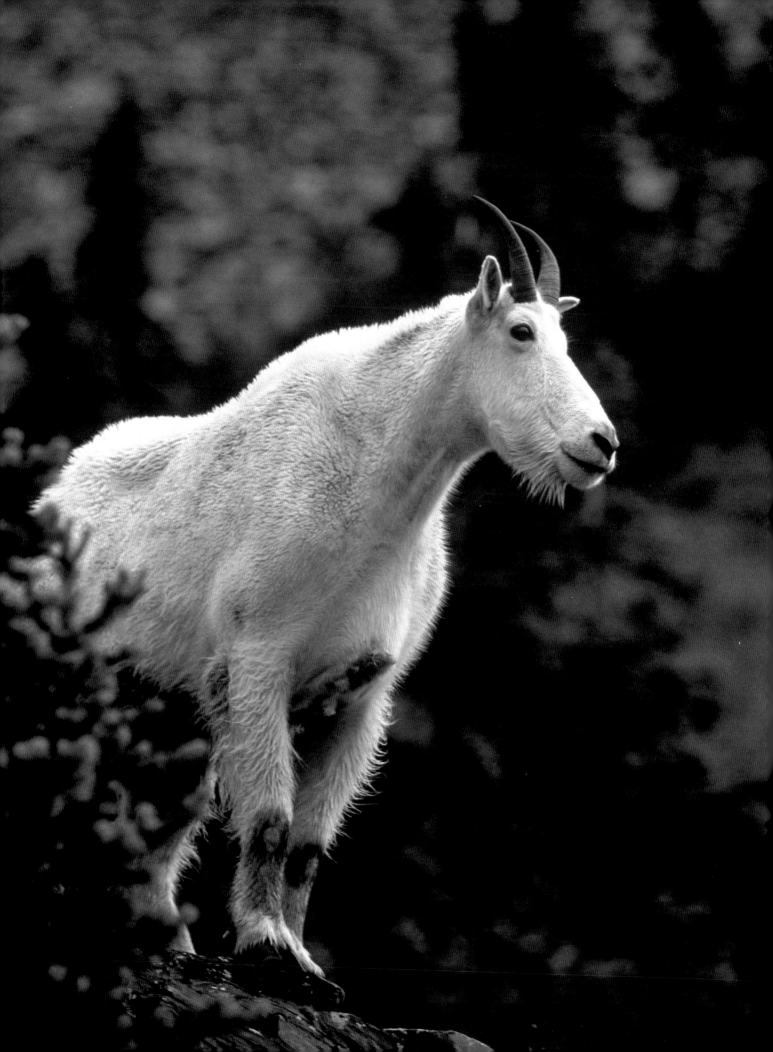

This is what today's most primitive relative of the mountain sheep looks like. It's a mainland serow *Capricornis sumatrensis* from tropical Southeast Asia, a secretive, territorial beast about the size of our mountain goat. It vigorously excludes others of its kind from food resources it lays proprietary claim to. Moreover, it is perfectly ready and able to back up this claim by using its sharp horns in bloody attacks. It may also confront predators, and it has been known to kill bears. Serow usually live alone in steep, densely vegetated slopes and cliffs, and were once widely distributed in 11 subspecies from Sumatra and Malaya to northern India and central China. A smaller species is found in Japan and Taiwan.

Though superficially resembling bighorns, argalis (top) depart sharply in a number of features. Here is a subspecies from the greater Tibetan Plateau *(O. a. hodgsoni),* which features a neck ruff of long, white or grayish hair. In its summer coat (below) it has neither ruff nor a rump patch or a facial mask, and thus looks almost unrecognizable (Geist 1991).

Mountain goats like the one at left share many localities with mountain sheep. The two species differ greatly in external appearance and social behavior, but overlap somewhat in habitat requirements. Mountain goats are long-haired and white; they have short, sharp horns and live in a society in which females often dominate males.

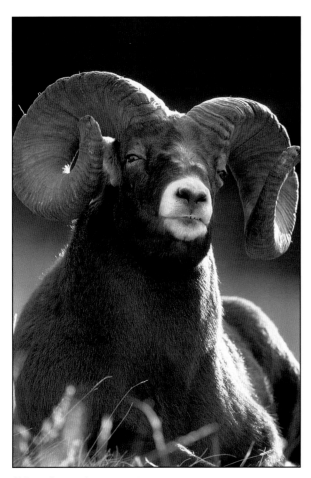

Old age is not often reached by sheep, the average age at death being nine years. The oldest-known ram lived to 21, the oldest ewe on record to 25 years of age. This is a very old ram that probably exceeds 15 years of age.

color from white to black.

Mountain sheep are distinct from the classical Old World sheep of central and southeast Eurasia—the urials, mouflons, and argalis. Mountain sheep differ by having an ibex-like body build, by habitat preference, and by security behavior. They are, therefore, stocky, short-legged cliff jumpers that escape predation primarily by bounding into steep cliffs where predators are on bad footing.

Unlike Old World sheep, too, mountain sheep never share their range with true goats. Old World sheep such as urials and mouflon are invariably accompanied by wild goats, while giant sheep share their range with Siberian ibex or with bharal. The latter are also known as "blue sheep," though sheep they are not, just very different goats. While the true goats inhabit the cliffs, the Old World sheep populate the rolling terrain nearby, escaping predators by sprinting across the open terrain. To this end, the Old World sheep have evolved into elegant, long-legged runners, or cursors. They have light-boned bodies, big lungs and hearts, and long, thin legs. Like all long-legged cursors, such as our pronghorn buck, they run with their heads held up, as if watching for obstacles and irregularities in the terrain.

Thus Old World sheep and goats have divided the mountain ecologically by using different anti-predator strategies, just as our white-tailed deer and mule deer have divided the landscape. The goats get the cliffs and the sheep get the rolling, open terrain.

However, in the absence of true goats as competitors, mountain sheep have adopted the anti-predator strategy of the goats. Consequently, they have an ibex-like body build and share the goat's escape behavior. Even where mountain sheep in North America overlap with mountain goats (a goat-antelope, not a true goat), they retain their strategy of fleeing into the cliffs.

Mountain sheep, though, are distinctly less bound to the cliffs than mountain goats, whose habits are those of slow, methodical, muscular climbers—a necessary tactic on steep cliffs that may be covered with deep snow for most of the year. American mountain goats do not act at all like true goats, but have, besides a unique social system, unique anti-predator and foraging strategies based on slow, methodical progression within the steepest of cliffs.

All mountain sheep species differ in reproductive strategy from the Old World sheep by bearing just

one young of modest size, by having a gestation period about 25 days longer, and by living, on average, longer than Old World sheep. Old World sheep have a higher reproduction rate, producing twins and even triplets, but they have a shorter life expectancy. While Old World sheep rarely exceed 12 years of age, mountain sheep are reported in excess of 16 or even 20 years of age. The oldest bighorn female I was aware of in Banff National Park reached 25 years of age; the oldest ram reached 21 years.

<center>∘ ∘ ∘</center>

The thinhorn sheep of northern North America—the two subspecies of Dall's sheep—are cold-adapted, much like snow sheep. The Dall's sheep are usually smaller than other mountain sheep, but this varies regionally. Some Dall's rams, taken in the St. Elias Range of the western Yukon, weighed up to 250 pounds whole weight, which is close to the average weight of mature bighorn rams from southern Alberta, where the largest bighorns reside. Small Dall's sheep are found in the extreme north, in the Brooks Range of Alaska and the Yukon. However, in the Mackenzie Mountains at similar latitudes, one finds some remarkably large-bodied Dall's sheep.

The dark-colored sheep, including the gray-saddled "fannin" sheep of northwest British Columbia and the southern Yukon, are classified as Stone's sheep. They are named after the explorer Andrew J. Stone, just as Dall's sheep are named after the Professor W.H. Dall, who explored in Alaska. Light, silver-gray individuals with slightly darker flank stripes or saddles are also found as isolated cases in southern populations of dark Stone's sheep, while in light-colored populations of the southern Yukon, one may occasionally find a dark individual. In general, the color of Stone's sheep becomes lighter from south to north. Thus Stone's sheep and Dall's sheep have a large zone of integration—particularly in the Yukon, where one

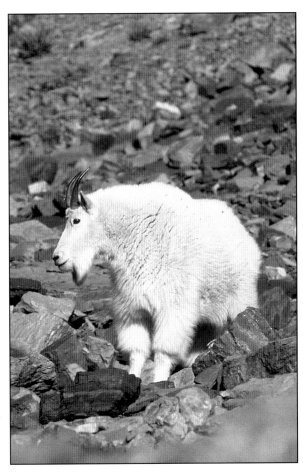

Mountain goats share many localities with mountain sheep. The two species differ greatly in external appearance and social behavior, but overlap somewhat in habitat requirements. Mountain goats are long-haired and white; they have short, sharp horns and live in a society in which females often dominate males.

Overleaf: These large Dall's rams have begun to shed the old winter coat and grow a new coat of hair. The horns have also begun to grow. Dall's sheep range north from about the 60th parallel in Canada to beyond the Arctic Circle in Alaska. They therefore live part of the year in darkness.

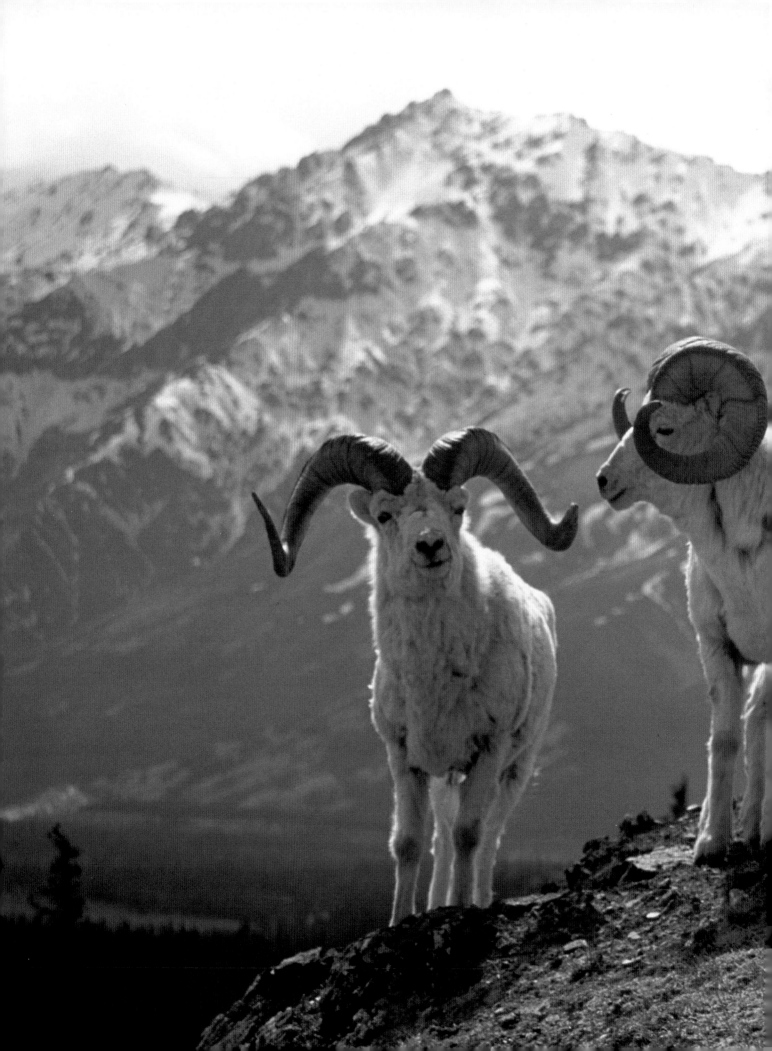

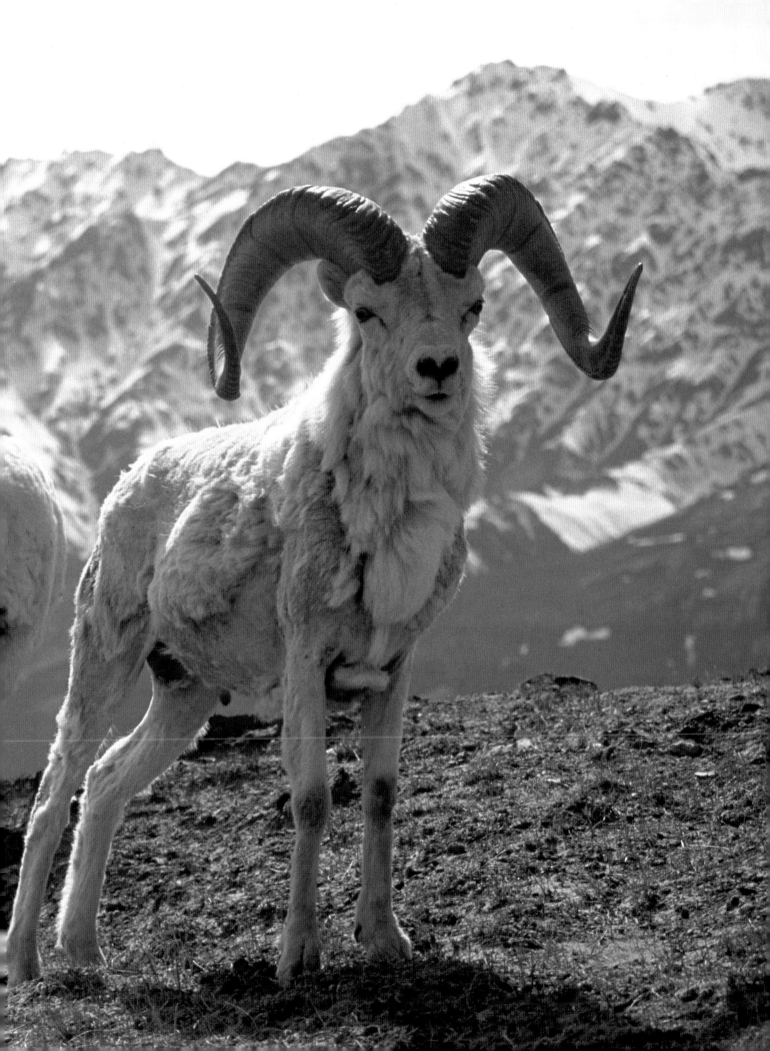

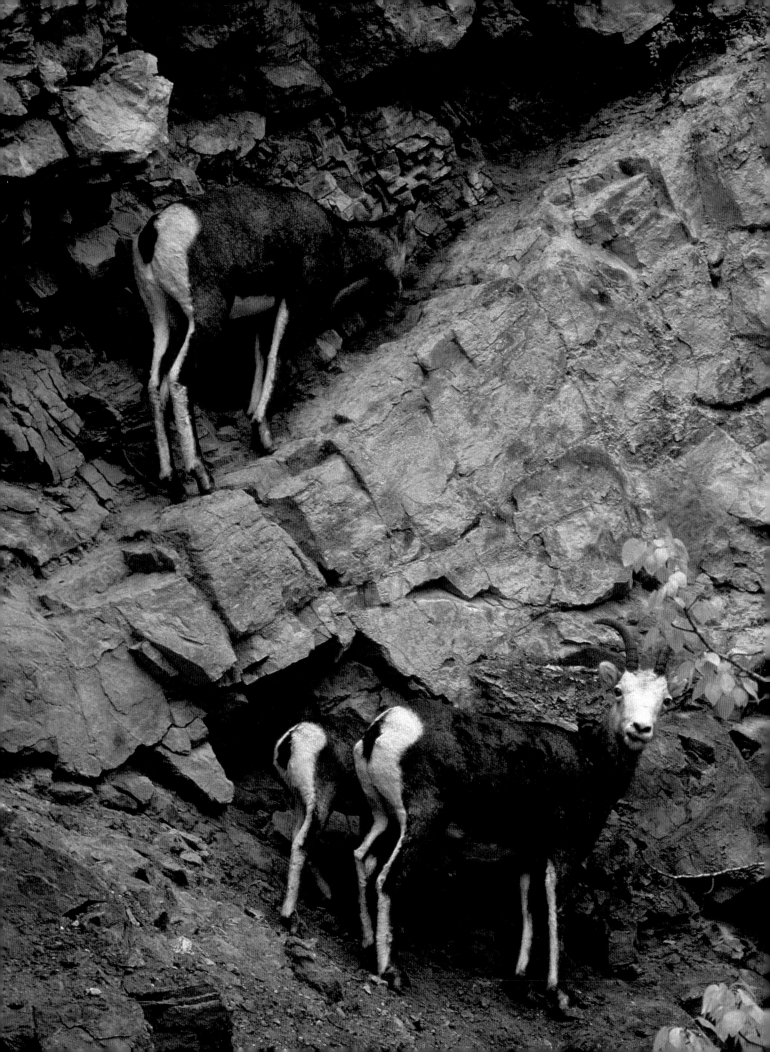

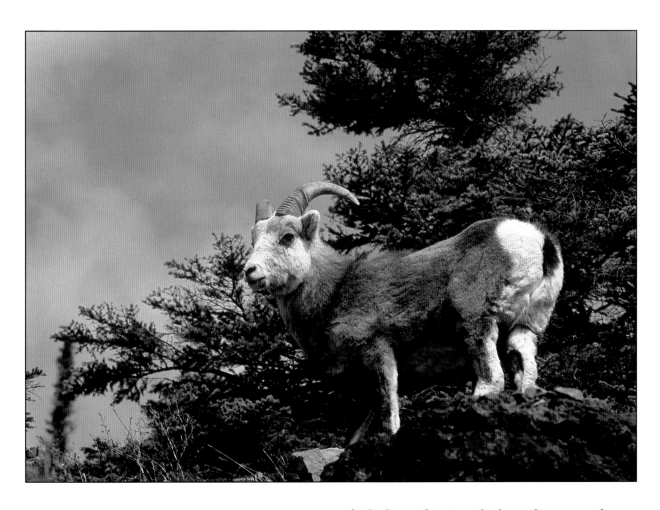

This slate-gray Stone's ram is 2 1/2-years-old. He is lighter in color than many Stone's sheep. One may find in the same band black, brown, and also light, silver-gray individuals. Where Dall's and Stone's sheep meet, one finds the light-gray "fannin sheep."

These Stone's sheep have grown a new winter coat in early September. This race of thinhorned sheep is indigenous to Canada, found in northern British Columbia and the southern Yukon, where they integrate with Dall's sheep.

finds sheep of various shades and patterns of gray.

Stone's sheep are quite diverse in color and in patterns of pigmentation, and can easily be identified individually because of this. However, the classical Stone's ram looks like a Dall's ram in evening dress. It is a striking animal with amber horns, a silver-gray head, black body, white rump patch, and trim on the front and hind legs. Stone's sheep tend to be somewhat larger than Dall's sheep, particularly the gray-necked Stone's sheep along the Rocky Mountain Trench in north-central British Columbia. Dall's sheep with black tails are even found deep into Alaska.

 ◦ ◦ ◦

The ranges of the Stone's sheep and bighorn sheep approach one another in British Columbia at the Peace River, but do not meet. The bighorns

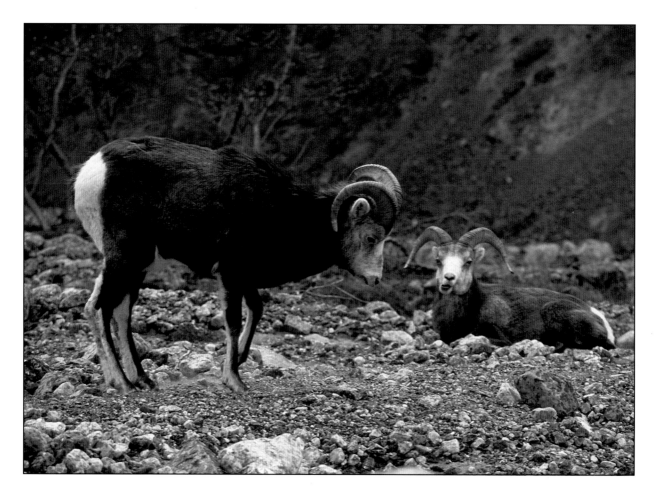

A Stone's ram is like a Dall's ram in evening dress. These sheep show such individual variation in marking that one can soon learn to identify individuals. Sheep may act at ease at low elevation as long as steep walls are nearby for escape. Note these two rams bedded or about to bed in a dry creek bed, where a steep wall is within easy reach.

form a number of races. The Rocky Mountain bighorns, as their name would suggest, are essentially cold-adapted. The California bighorns are a lineage of small bighorns found west of the Cascades in isolated populations that reach southern British Columbia. The large bighorns that once inhabited the Missouri Breaks and the Badlands of South Dakota are now extinct. They are recognized as a separate subspecies, the Audubon bighorn, but the distinction is dubious.

In the deserts of the southern United States and Mexico, one finds widely scattered bighorns that are somewhat smaller than the Rocky Mountain bighorns and show some adaptations to dry, hot terrain. However, populations of desert sheep that happen to live at high elevation in ranges with cool climate and adequate moisture look remarkably similar to Rocky Mountain bighorns.

Nevertheless, desert bighorns have distinctive features, including shorter-haired coats, larger ears, somewhat smaller rump patches, longer tooth rows, and rapid growth in lambs compared to Rocky Mountain bighorns. Desert bighorn females have remarkably large, thick horns, and while each ewe gives birth to only one lamb, as is normal for all mountain sheep, the lambs may be born in an extended birth season, or even year-round.

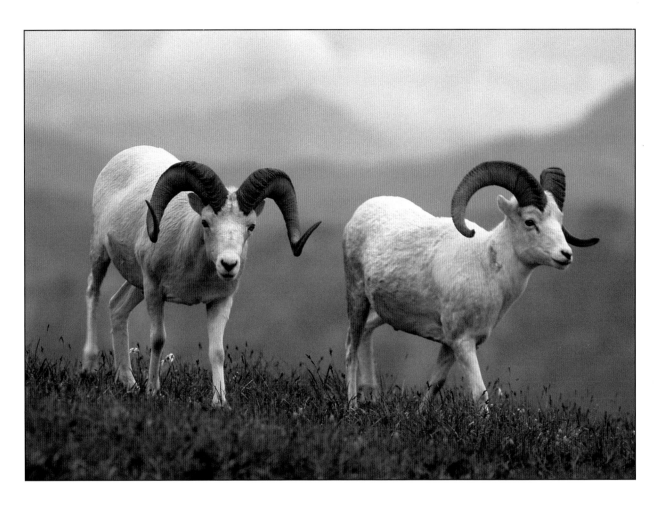

The biology of desert bighorns, generally similar to that of other mountain sheep, is noticeably different in particulars. This can be related to the hot, dry climate that desert sheep inhabit. For instance: Water is a scarce, usually seasonal resource in deserts. It is often available in small, temporary puddles and seeps. To get at these, the sheep must be large, aggressive, and able to withstand physical abuse from other sheep. This selects for rapid growth of the young, as small-bodied lambs are easily displaced or injured by others pushing and butting to get at the water. Such competition also selects for sturdy horns, as butting contests are likely to erupt among sheep competing for a spatially confined resource. This also selects against sheep congregating in large bands, because large groups would be inefficient in

Two middle-aged Dall's rams on the summer range. How different they look from the black Stone's rams, their closest relatives.

Overleaf: Under serious scrutiny: A young Stone's ram cautiously observes the human intruder. These are large-brained sheep that shape much of their behavior by learning, and grow readily tame where humans are no threat to them. Hunted mountain sheep, however, soon become almost impossible to find, as they become extremely cautious.

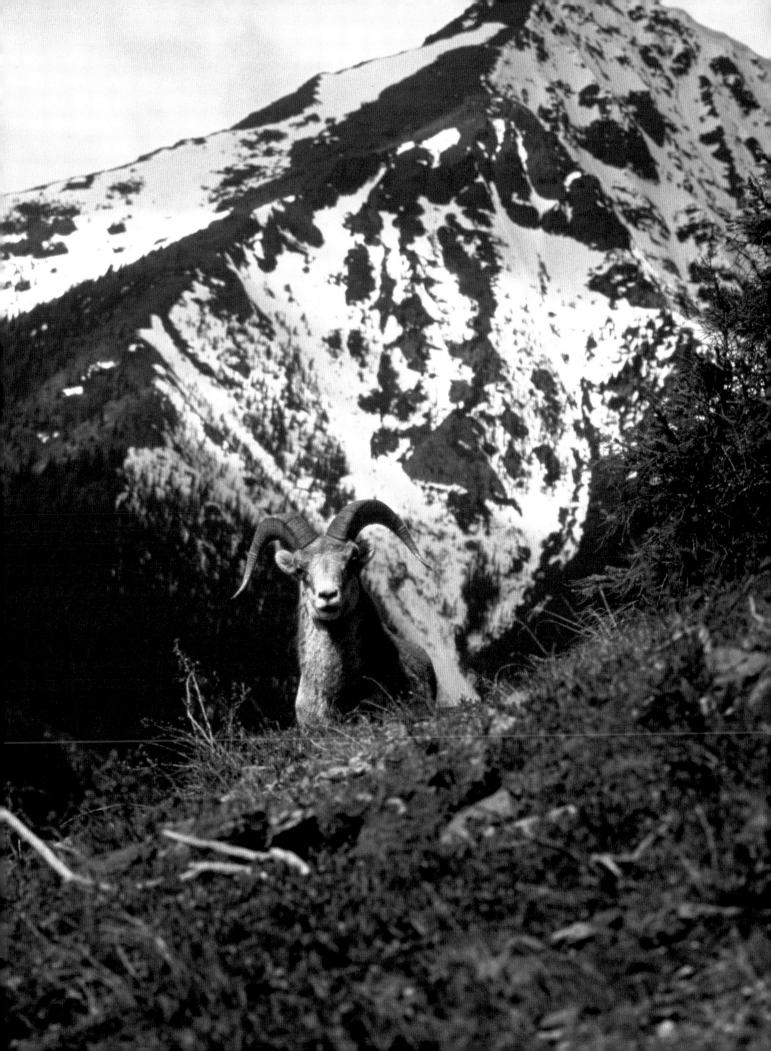

exploiting small, dispersed sources of water. We therefore expect desert bighorns to form relatively small bands at the same population densities as cold-adapted bighorns.

In deserts with unpredictable rainfalls and relatively high daytime temperatures year-round, there is no season of the year particularly superior to another for raising lambs. Under such circumstances, births should be spaced year-round. The most advanced adaptation in this regard is achieved by the North African "Barbary sheep" from the mountains of the Sahara Desert. Females of this species, which are distantly related to true sheep, give birth to small twins throughout the year. They are fertilized shortly after giving birth, so they lactate and suckle lambs even while pregnant. Barbary sheep thus have "rapid-fire

Desert bighorns are the mountain sheep's answer to marginal habitat. However, desert bighorns are relatively new to the desert and are noticeably less well-adapted to hot, dry conditions than are some Old World relatives such as the Barbary sheep.

A group of Badlands bighorns. Today, bighorns are again thriving in the Badlands, an area that was once home to the extinct Audubon bighorn. Despite the land's barren appearance, this is good bighorn habitat, and the sheep respond by growing large and fertile.

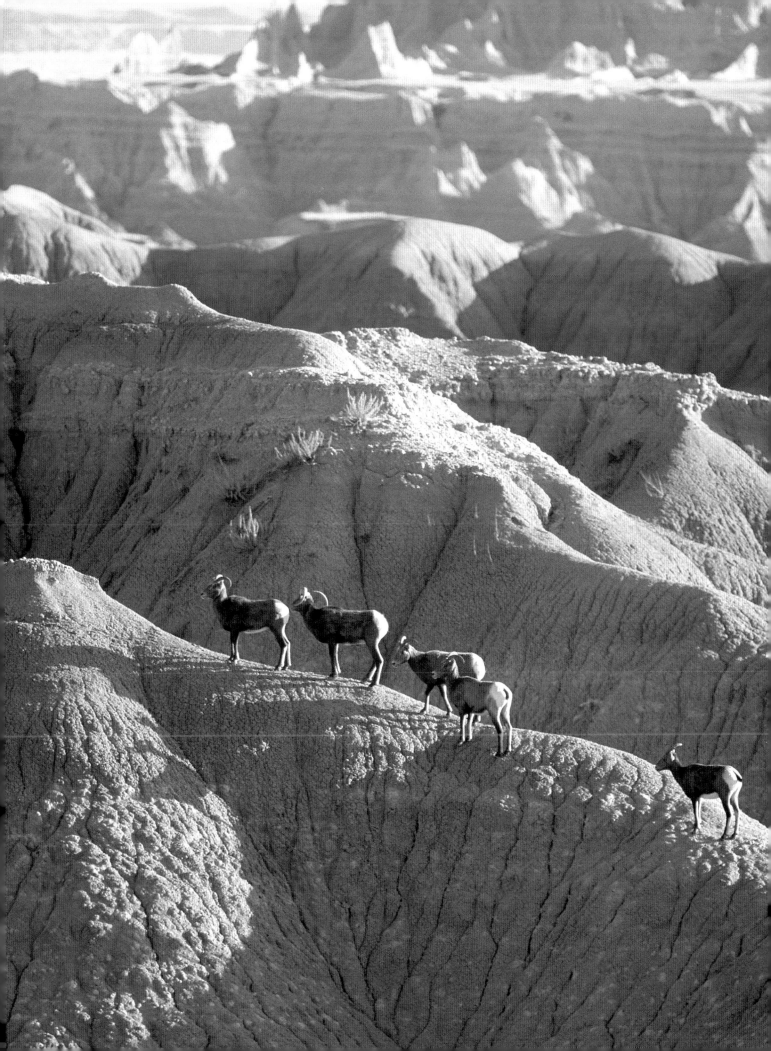

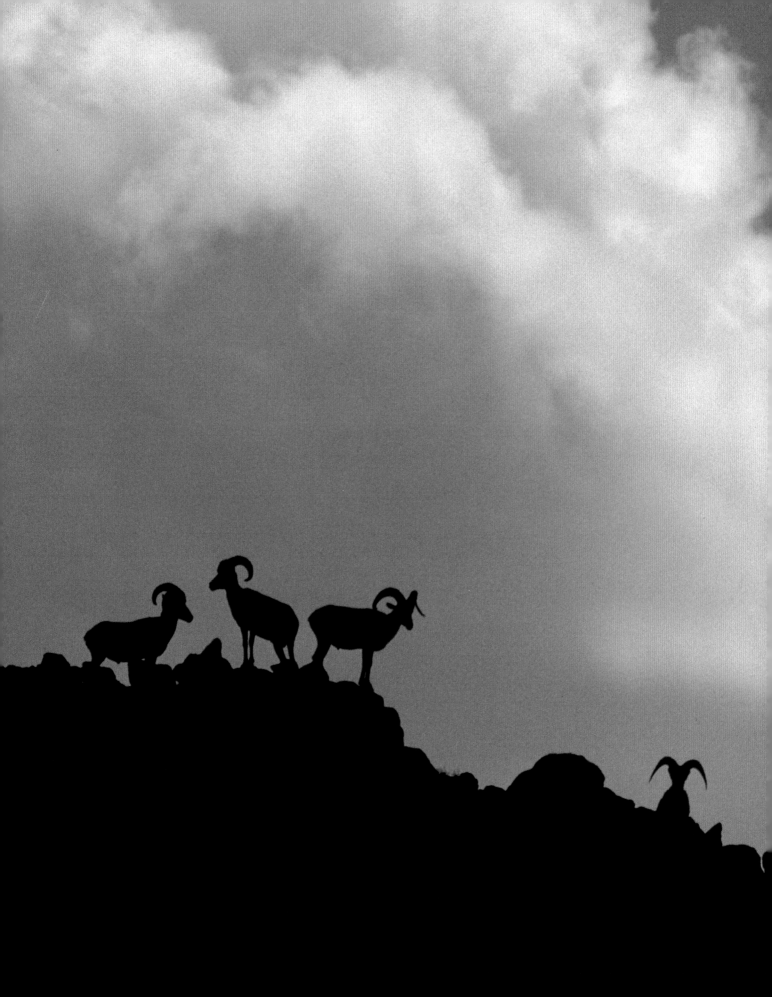

reproduction" in a land with unpredictable rainfalls. If a pair of twins is born shortly after a rainfall that makes the desert burst forth with annuals and grasses, the female has food enough to produce milk, and the lucky twins live. If there is no rain and the female fails to lactate adequately, the twins die, but the female is ready to bear the next pair in 160 days.

Barbary sheep females grow rapidly, mature early, and bear multiple young in as rapid a succession as the gestation period permits. They practice, essentially, a gambler's strategy, betting that some births will occur shortly after rainfalls. Barbary sheep, which have probably fought over water seeps and dwindling puddles for hundreds of thousands of years, not only grow rapidly, but the females also have very large horns that come close in size to those of males.

This species, with its long history in hot deserts, illustrates the adaptations that desert bighorns are heading toward but have only partially realized. While desert bighorns—ancient, cold-adapted Siberians by origin—struggle with desert environments and live a precarious existence, the Barbary sheep introduced to American deserts are thriving, multiplying, and expanding their range. In fact, they represent a distinct threat to the existence of our native desert bighorns.

Desert bighorns illustrate a feature common to today's North American fauna of large mammals. With few exceptions, it is a fauna quite imperfectly adapted to the environments of this continent. The Barbary sheep is a "real desert sheep," but the desert bighorn is still in the process of evolving into one, a process far from completed. Bighorn sheep in North America are evolving away from

Desert bighorns, short on water, may bash the thorns off barrel cacti in order to reach the moist, succulent flesh. Storms bring a temporary respite from heat and thirst.

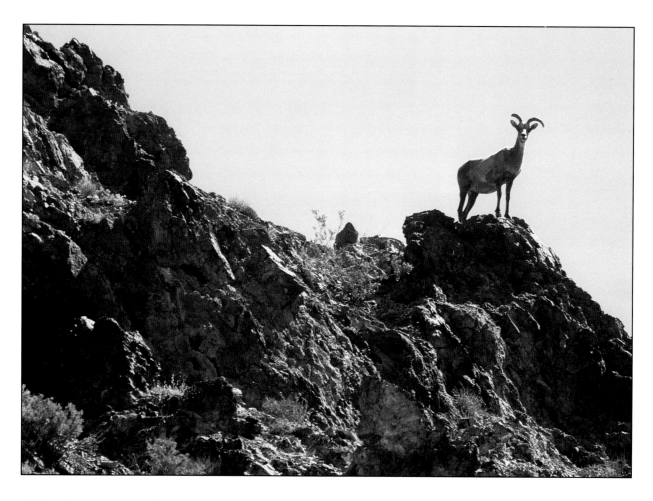

their adaptations to Siberia's icy winters and the relatively limited threat there from parasites and pathogens. So are the other Siberian immigrants, be they fairly old immigrants such as the bighorn sheep or rather recent immigrants like the elk and the moose, which colonized North America after the last glacial retreat. Northern North America has been to some extent an eastern extension of Siberia, and the thrust of Siberian animals into North America after the great extinctions of large mammals at the end of the last Ice Age made it more so.

As we shall see later, the fact that our mountain sheep originate from cold-adapted Siberian ancestors is a vitally important point to consider in their conservation. Because of it, our mountain sheep are very sensitive to the diseases of southern

The horns of female desert sheep are much longer and stouter on average than those of the Rocky Mountain race. They have to withstand much more stress, due to the fact that desert females fight over access to small springs or puddles.

relatives such as Old World sheep and goats, Barbary sheep, and domestic sheep. In a similar vein, native people here were extremely sensitive to the diseases of Eurasian and African people, and died in epidemic numbers after making contact with European explorers. We need to internalize this concept thoroughly, because it is applicable— in fact, central—to the conservation of all large mammals in North America.

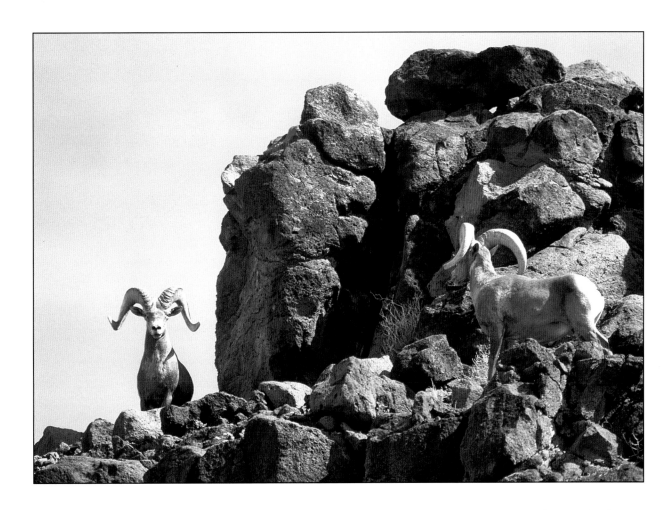

Desert bighorns may have flared horns quite similar to those of northern thinhorns. In hot sunlight, desert sheep squeeze into every bit of available shade.

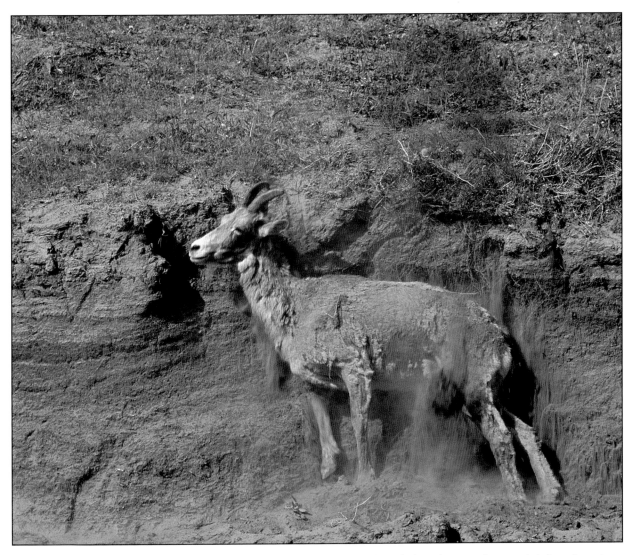

Mountain sheep rub off their winter coat in late spring. They use various objects, but in particular rock outcroppings or cuts in the soil, as shown by this ewe.

The tragedy of American mountain sheep is their low tolerance for diseases carried by domestic stock. This ram, however, lived to a ripe old age and probably died of exhaustion after the stressful rut, as do most old rams.

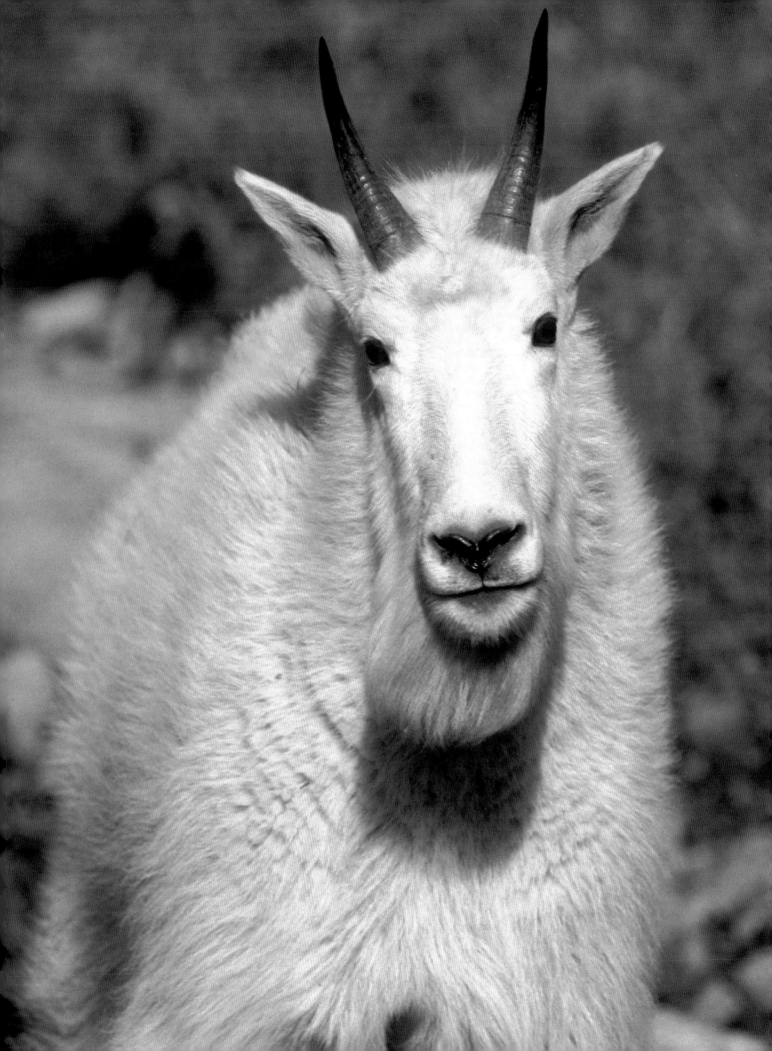

GOATS AND SHEEP

Big horns are as central to the biology of bighorn sheep as small horns are to the biology of mountain goats. Of course, the horns in these species are used in an entirely different manner. Understanding how the horns are employed helps one understand how creatures as different as mountain goats and mountain sheep can live on the same mountain.

If you were to stand in a deep valley in the Cassiar Mountains of northwestern British Columbia, you might see male mountain sheep and mountain goats graze almost side by side. The contrast could hardly be greater, even though the males would be of comparable body weight. The Stone's rams would be black and relatively short-haired, the mountain goat billies white with long, flowing hair. The rams would sport huge, yellowish horns, curling 40 inches and beyond, with basal circumferences of 13 to 15 inches and weights of 18 to 25 pounds. The billies' black, shiny horns would rarely exceed nine inches in length and six

The horns of mountain goats are sophisticated daggers—sharp and smooth, but above all short and curved. This allows the aggressor to quickly withdraw its horns from an opponent's body without risking getting stuck and breaking its horns, skull, or neck.

in circumference. The rams would be protected against horn blows by a thick skin on the face; the billies would be protected on the butt-end. The skulls of the rams are large, massive, and tough, while those of the billies are small, light, and fragile.

The rams are at all times dominant over females, while the billies are subordinate to females much of the time. The rams are sprinters and jumpers *par excellence*; the billies are slow, powerful, methodical climbers. When mountain sheep slip in the cliffs, they propel themselves downward onto a safe ledge by little bounds, hitting the steep rock with all four hooves and moderating their descent. Not so mountain goats. They spread their legs apart, flatten themselves against the rock face, and claw with their hooves for a hold, much as you and I would do in a similar situation.

They are very different, mountain sheep and mountain goats, though they happen to be (and this is another marvel) not that distantly related. They belong to the same basic group, though we split them into different tribes.

° ° °

The mountain goat is the quickest to explain, and serves as a useful introduction to how different features are closely interrelated, and how puzzling

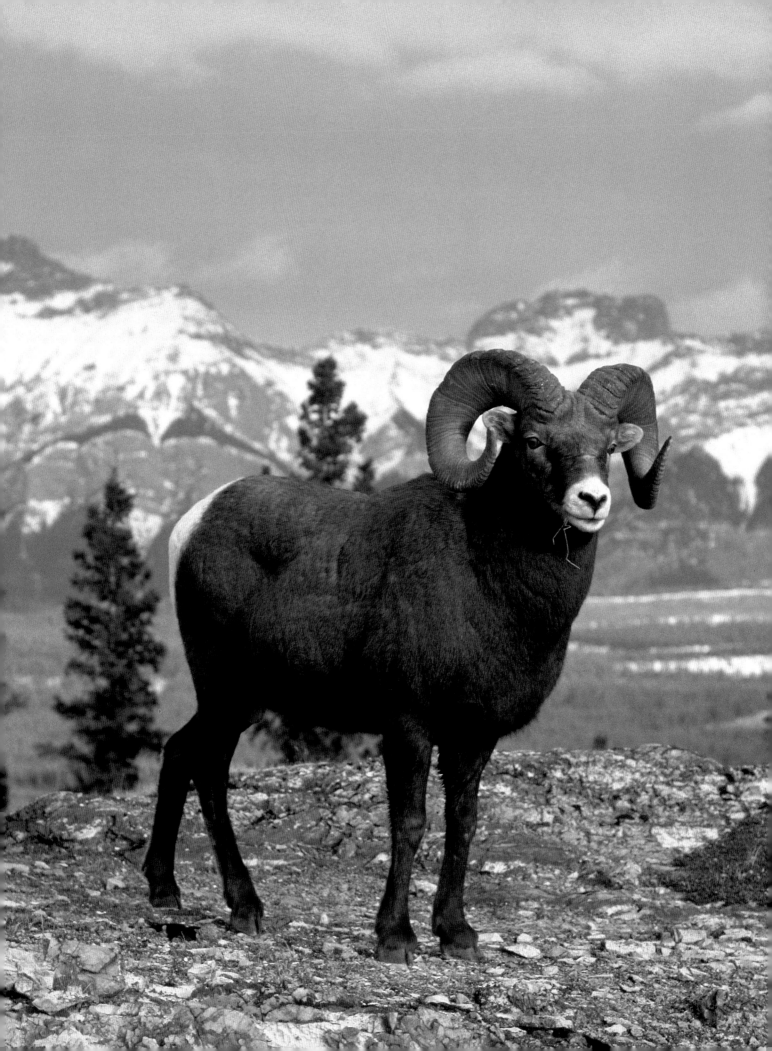

differences can unite into logical entities. The tiny, smooth, very sharp, and slightly curved horns of the mountain goat tell us that the goat is, at least seasonally, a defender of material resources. That is, the goats sometimes defend territories to exclude other goats from precious, scarce forage that is absolutely essential for reproduction.

The goats' horns are daggers, designed by nature to inflict painful, festering wounds, but even more so to slip out quickly from the opponent's body. After penetrating another goat's body with its horns, the attacking goat must get the horns out or the violent struggle of the opponent to free itself will snap the aggressor's fragile neck, skull, or horn bases. Consequently, the horns of goats must never be long or rough on the outside.

In fact, goat horns are cleverly constructed to slip out of another goat's body. They are curved, and the curvature ensures that the horns point in the direction in which the opponent will escape. When they engage in a really serious fight, mountain goats strike at the body, not at the head. Simultaneously, each is trying to avoid the other. Physically, that can only be achieved if they are positioned anti-parallel—side by side, but facing in opposite directions. Because each is trying to strike while avoiding the strikes of the other, they whirl around one another. Because most strikes land on the rear, billies in the rut carry skin shields or dermal shields up to an inch thick on their rumps. They are armored where it really counts.

However, if a goat digs its horns into the opponent's rear while facing in an opposite direction, then the curvature of the horns allows the other goat to slip off. Large horns would be— to a mountain goat—a deadly handicap.

To succeed in life, a ram must grow the largest possible body and horns. Its status and breeding success depend on this growth.

Female goats with young are the ones that become territorial in hard winters. Living on selected steep cliffs that shed snow readily and thus expose much-needed food, the female ruthlessly attacks all other goats, except her young, and chases them off. When female goats become territorial, it means high mortality for other goats. These other goats, deprived of the good places to make a living in winter, wander off in a desperate search for adequate food and shelter. Many—and sometimes most—do not make it.

Holding out and resisting the challenges of other mountain goats in desperate need of a place to live, the kid-leading females must be very competent fighters and defenders of their precious pieces of ground. Nature, over eons, equipped them to succeed with weapons: sharp horns, a body almost as large as that of most male goats, and a nasty, courageous disposition. In mountain goat society, no love is lost on one another, and threats and jabs are exchanged even in apparently peaceful groups during the summer.

Billies, of course, are larger than nannies. How, then, can these big, tough, very dangerous fighters be displaced from territories by females?

The billies are in a catch-22 situation. The big males have virtually exhausted themselves by fasting and fighting one another, and by courting and breeding the very females that now confront them. If, after all that sacrifice to reproduce, they displace the very females they have bred, they also destroy their own offspring, now gestating within the females. The genes of a billy would go to extinction if he evicted the females he bred from their space. Such a male would suffer severe loss in reproduction compared to billies that find an alternative way to make a living in a bad winter.

Therefore, the large, robust male gives way to the pregnant females and moves off to the periphery of the range occupied by females. Being somewhat larger than females, dominant males can make a

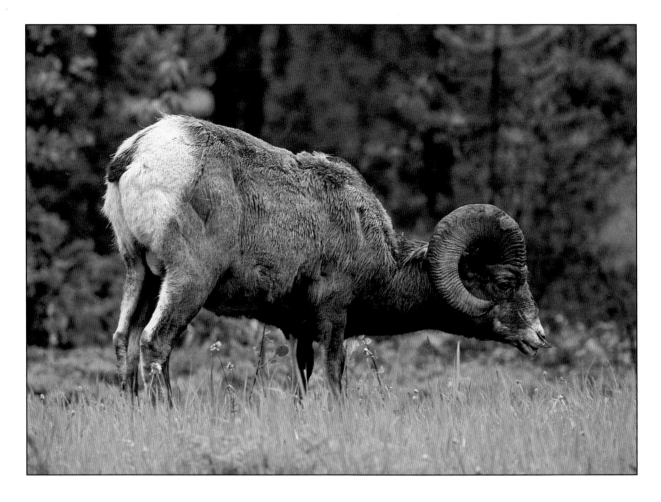

tolerable living exploiting monotonous, less nutritious browse resources, such as alpine firs in deep snow areas close to or on the cliffs. They also wander more than females once solid crusts form on the snow in mid-winter. They disperse widely over ridges blown free of snow, where there is a meager supply of food. However, in deferring to females once, the big males defer to females at most other times as well, acting thereby as if they were subordinate to females. As far as we know, that is a unique practice among ungulates.

What about young billies that have not bred any females?

They have, ostensibly, nothing to lose reproductively by displacing a pregnant, kid-leading female. If they are physically large enough to challenge a female, however, they are large enough to

Rams take chances with predators and choose to feed in rich rather than secure pastures during the crucial summer months. They restore the body after the winter's stresses, replenish their fat stores, grow horn, and prepare themselves for the rigors of the distant rut.

become dominant, breeding males within a year or two. It does not pay to exterminate the essential source of one's future biological success—namely the females. Moreover, the females are just as large and well-armed as the males, and they are very vicious to boot. I once autopsied a young billy that had been worked over by a nanny. He had 32 horn punctures in his body, and had punctured lungs, liver, and heart. He was, of course, dead.

It's interesting to note that the female mountain goat is close to the same size and appearance

There are other repercussions of territorial adaptations. For instance, little kids must not play with yearling billies. One hard strike from the young billies' horns and a kid is perforated. (A colleague of mine studying mountain goats did find kids dead from horn punctures, and I have seen kids with bloody wounds on their little white bodies.)

Consequently, to safeguard her reproduction, a mother mountain goat must watch her kid closely and chase off any yearling that plays aggressively with it. Conversely, a kid in distress over a yearling's bullying should be able to call for maternal help when needed. Little goats do call for help with a piercing scream. The call is quite effective. All mother goats within hearing, including the affected female, rush in terribly excited, looking for the child in distress. When they do, the offending yearling scampers to safety.

At two years of age, young males are big in body, but thoroughly immature socially. They now are such punks that even large males give way to them, and the normally aggressive, kid-leading females also scamper away. Even in their first rutting season, before the male hormones really take effect and turn the small billies into shrinking cowards, the young males enjoy a brief spell of fool's freedom. Large males display to the aggressive, juvenile-acting males, but then give way to them. For the larger males, fighting with the little males would mean eliminating them and incurring useless wounds. So the large billies act in a remarkably tolerant manner.

Nor do big males necessarily strike back at females that have attacked and even wounded them. Retaliation would be too costly, for in a

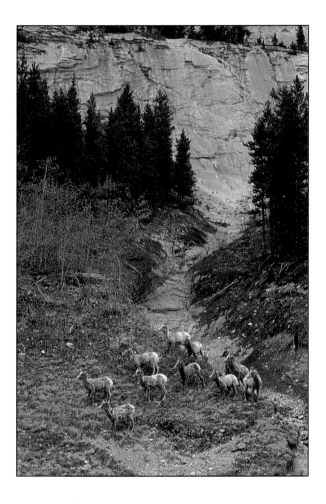

Females and lambs stay closer to cliffs than rams, choosing safety above food. Consequently, the ewes crop the pastures closest to escape terrain, making do with what is available in the security of the nearby cliffs.

as the class of males she is most likely to confront aggressively: the near-socially-mature males. In the female goat's case, the confrontation is most likely over a territory. This principle, whereby females assume the size, shape, and appearance of the males they are most likely to confront, is widely found in ruminants, and it is one we shall encounter again among mountain sheep. It explains, among other things, why female reindeer or caribou grow antlers and look exactly like young males.

Overleaf: These rams are taking a chance by feeding on rich forage far from the nearest escape terrain.

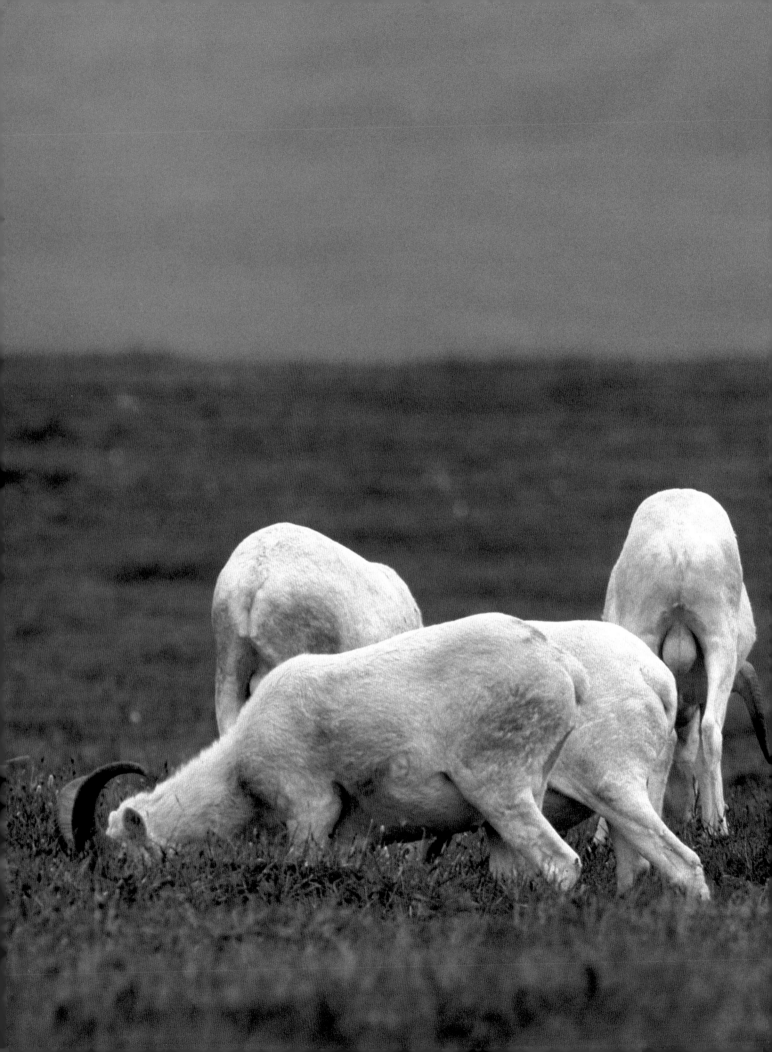

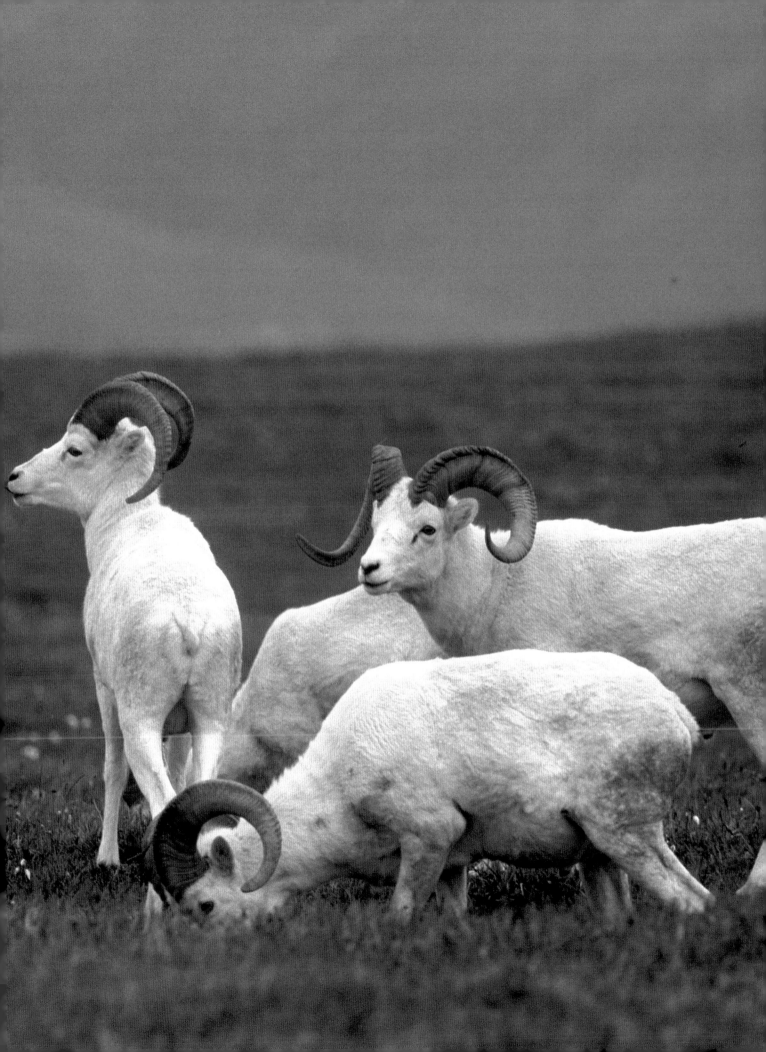

fight, mountain goats sustain horrible wounds. The body musculature in males that have fought may be beaten to blackish-red pulp. Much of the flesh will be yellow-green in color, muscle groups may be mangled by horns, and vital organs may be pierced. In fact, victorious and vanquished males look much alike.

Consequently, victory—if one can call it such—is very costly. It's best to bluff, bluff, and bluff, and to hope that the opponent loses nerve and runs—as most do. To bluff, mountain goats make themselves as big as possible, stand broadside to the opponent, move about in stiff, muscle-bound motion and, on rare occasions when the opponent is persistent and fails to yield, give out a loud, harsh roar. Combat in goats is, understandably, a very rare and terribly costly event.

<p style="text-align:center">○ ○ ○</p>

Mountain sheep are quite different.

Sheep do not defend territories, no matter how severe the winters. The female sheep also dispense with males, but in a very different manner than the mountain goat females. Female sheep do it just as effectively, but without force or the need for sharp horns. They do it via superior competition close to the best escape terrain. The female sheep remove the males via a "scorched-earth policy" under which the females, but not the males, can survive.

Female sheep take advantage of a difference in reproductive strategy that allows them to survive on less food than the males in winter. This is how it works: Male sheep must always maximize body and horn growth; if they fail, they pay with loss of dominance status and reproductive success. Females, however, never need to maximize food intake during pregnancy, because they are not under pressure to produce young of maximum size at birth. In fact, a female maximizing the birth-size of her lamb would court death when giving birth. Large young are likely to get stuck in the birth

canal and die, probably causing the death of the female as well.

Young that are too small, readily spilling from the birth canal, are also disadvantageous. Small young are too poorly developed at birth to survive the cold temperatures in spring, and are too slow and weak to escape predators within hours after birth, as they must. Consequently, a female must optimize birth size. She requires relatively and absolutely less food than a growing male. Given her needs, the female can graze down the forage about cliffs to a level that's intolerable for males, forcing them to be hungry, to leave, and to search for food in less secure but richer places. That's why male sheep leave female ranges in winter.

The females choose security for themselves and their lambs over rich forage, while rams choose rich forage over security. And they should. Compared with lambs, the rams are much more competent at escaping predators. They are quite safe at distances from cliff terrain that would be lethal for lambs if wolves should appear. Rams, compared with ewes, roam farther from cliffs, visit more feeding areas, and roam about over much larger areas, always on the lookout for better feed. The male's life strategies are different from those of females and so, as a result, are their respective ecological niches.

What happens to males that stay with females, refusing to leave the security of the female ranges?

I have not seen such males among North American mountain sheep, but they have been encountered among the giant sheep of distant Tibet, the Tibetan argalis. Ernst Schaefer, the great explorer of eastern Tibet who led the Brook-Dolan expeditions of the Philadelphia Academy of Sciences in the mid-1930s, shot a good number of argalis of both sexes for the Philadelphia Museum of Natural History. Among these were a number of males that lived within female bands on the steep, rocky ridges that these animals inhabited.

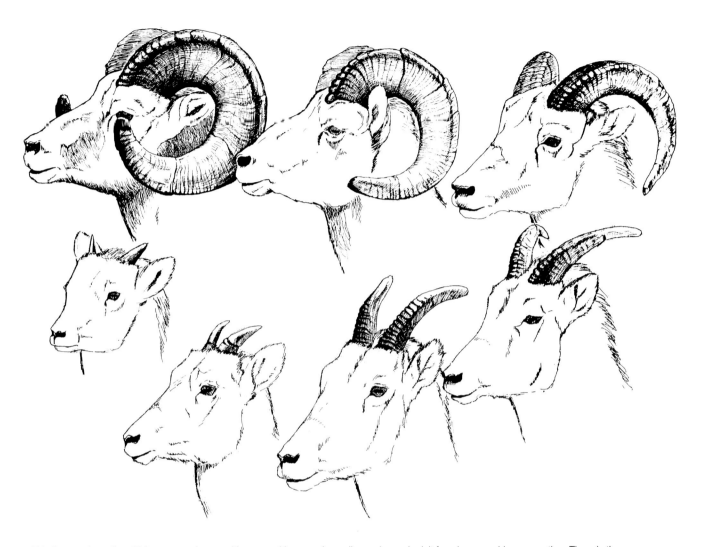

This line-up shows how bighorn rams change with age, and how much yearling males and adult females resemble one another. There is thus no distinct female image, so that big rams address smaller males and females in the same fashion. Only by seven to eight years of age have bighorn males reached their full maturity (Geist 1968. Z.f.Tierpsych. 25:199-215).

These males were old, but very small, with horns that were poorly developed although larger than those of the females. Like the females, they were retarded in shedding, and had light, poorly grown skeletons.

The big males that lived in small bands on the rolling, grassy uplands, away from the rocky ridges, were not only huge in body and horn size, but had nearly shed their winter coats while the underdeveloped males still kept theirs. This suggests that, in this species at least, males may opt for one of two strategies: Get away from the females and live a rich, exciting, but short life; or

stay with the females, starve, be small, suffer the frustrations of inferior status, but live a long time and breed the occasional female when the opportunity beckons. The small but old males would not be able to compete with the large ones during the rut.

Different social strategies generate different weapons, different body shapes, different social behaviors, and differences in the ecology of sexes. Mountain sheep females, which do not need to confront large males over resources, retain small horns, fragile skulls, and small bodies. They do aggressively confront males, but only small males.

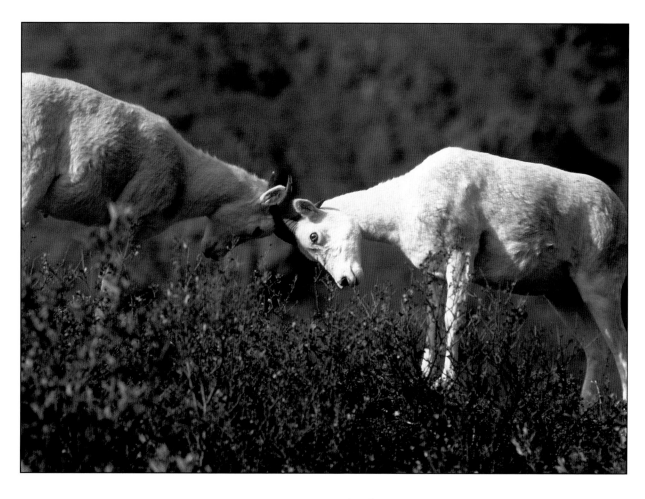

In their second summer, the young rams are of the same size as the ewes, and are deceptively similar in appearance. Now they test each female and may even fight with them until they have gained dominance. No male can breed a female he does not dominate. The yearling male is on the left.

This happens in the second summer of the life of growing males, when they are still within the maternal band.

At the end of their second summer, the males are barely as large as females, and they begin dominating. First they choose the two-year-old and small three-year-old females. When the precocious rams have thoroughly dominated these females, they turn to the larger, older females and start courting them. The females turn on the cheeky young "friars" and attack them, but ultimately to little avail. By early fall the "long yearling males" are able to court females without being attacked.

By two years of àge, or in their third summer, young males drift away from the maternal bands, explore the country, and join older rams. Consequently, the males that adult females

regularly face in aggressive contests are the long yearlings still within the maternal band. Taking a close look at a yearling male and an adult female, one will notice how similar they are in body and horn size and external appearance. While it is difficult among mountain goats to distinguish adult males from females because the sexes look so much alike, among mountain sheep it is the yearling rams that can be confused with females. Only a knowledgeable observer can segregate them consistently among Rocky Mountain bighorns and Dall's sheep. Among desert bighorns, with their accelerated juvenile growth, the sexes diverge quickly, and the yearling males have relatively and absolutely much larger horns than their cold-adapted cousins. Female desert sheep, however, also have larger horns and sturdier skulls.

In their third summer, young rams drift away from the nursery bands, roam the country, and begin attaching themselves temporarily to different ram bands. They may appear in places otherwise not visited by sheep. This fellow is shedding winter fur.

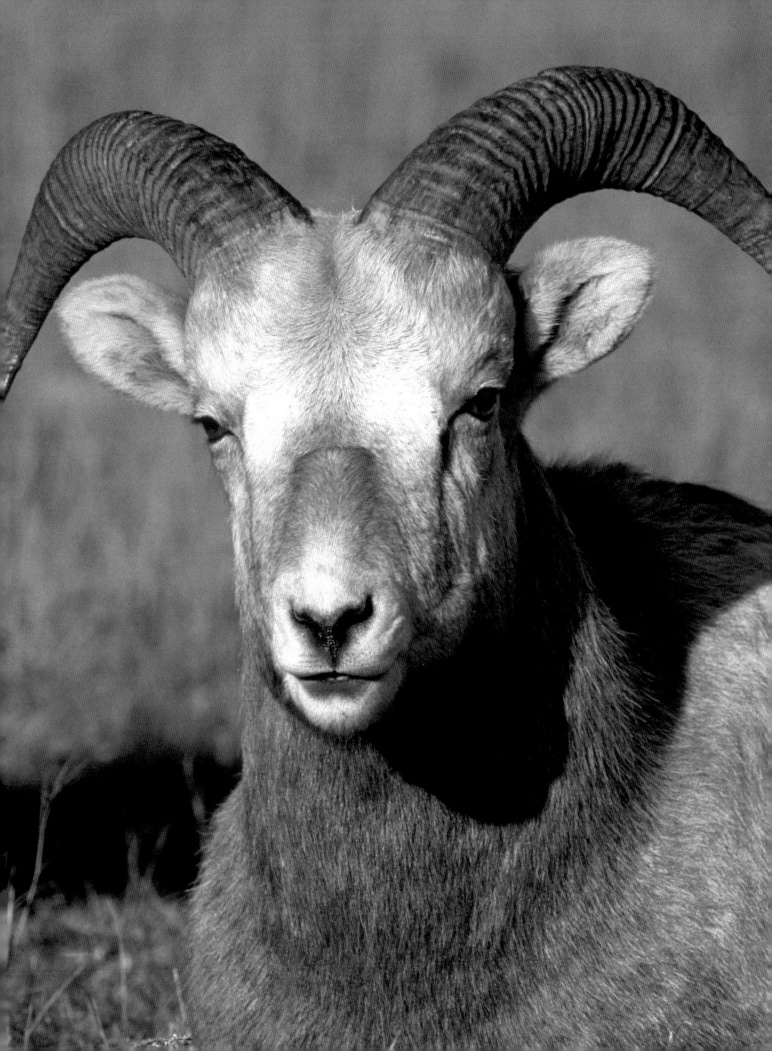

HORNS

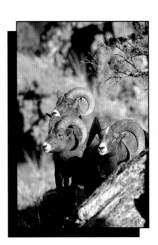

The heavy, curling horns of mountain sheep retain a mystique. Not only hunters but scientists, too, become fascinated, just as I am. I remember vividly one brilliant, cold, late-November day in the Ashnola Mountains of southern British Columbia. A group of graduate students, hunters all, had decided to go and visit a sheep range inhabited by California bighorns. We took our rifles, with the aim of shooting a mule deer buck to augment our meager incomes in a substantial way.

We climbed up to the sheep, but we did not hunt, even though we saw several large mule deer bucks. Instead, we found ourselves fascinated by the rutting activities of the sheep, by the many big rams that went after the ewes and each other with a peculiar, extended body posture.

What did this signal mean, if a signal it was?

I was puzzled, and the puzzle remained with me well into the study of Stone's sheep that I began a couple of years later, when I saw the posture again and again, performed by rams of all sizes.

A three-year-old bighorn at the beginning of his fourth summer, barely beginning the growth of new horns. This is a "quarter-curl" ram.

I named it the "low-stretch." The ram would extend his head parallel to the ground and approach a female or another ram. He would also twist his head, sometimes flickering his tongue and grunting. I named that motion the "twist." Sometimes, at the end of a low-stretch, the ram would sharply raise one front leg as if kicking. I labeled that the "front-kick."

But what did it all mean?

One day I was busily studying two three-quarter-curl Stone's rams on a ledge. For convenience, students of sheep label rams according to the development of their horn curls. A half-curl is a basically a male only four to six years old; three-quarter curls range from five to eight years in age, depending on development; full-curls are the old, socially mature, dominant, and usually breeding rams rarely seven and more likely eight years of age or older.

Returning to the two three-quarter curls, one was resting as the other approached. The approaching ram low-stretched to the prostrate companion. The prostrate ram, in turn, tilted his head upward as if showing its horn. That's when I realized for the first time that the rams, one in the low-stretch and the other in the "present" position, another horn-display posture, were showing

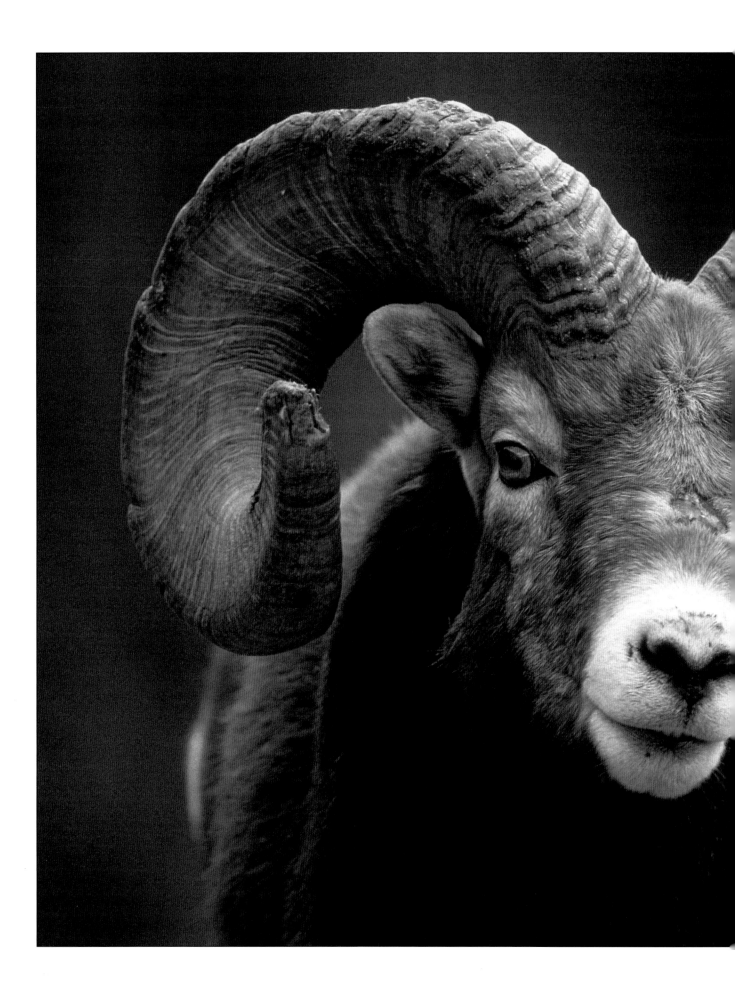

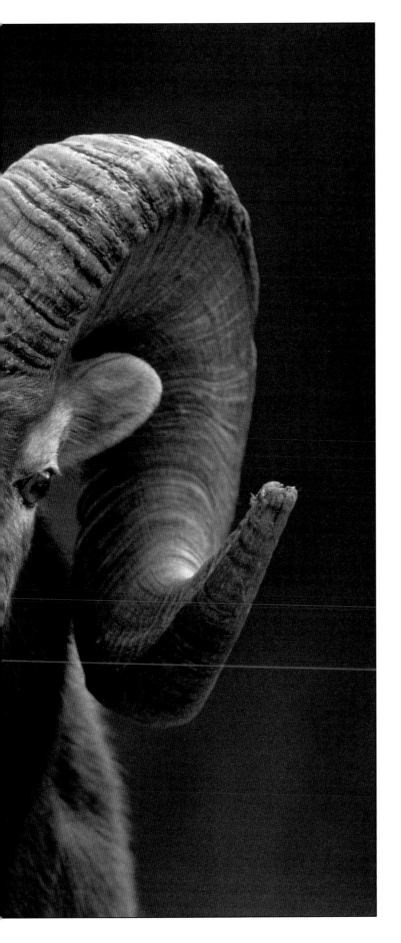

off to one another with their horns. That was the crucial flash of insight. The rest came easily.

Why should rams show off to one another with their horns?

It is a complex story.

First, we must understand how rams use their horns in fighting. We have all admired in movies the clashes of rams, how they run on their hind legs at one another, and how they collide with their massive horns. What a sight in slow motion! What a big bang it produces! However, let's study these clashes more closely.

One ram, invariably the smaller of the two fighters, starts the attack. If at all possible, the attack comes from uphill, as if the ram uses gravity to increase the speed of its descent and the force of its attack. The larger ram quickly rises to the occasion and, balancing on two legs, catches the aggressor's horn blow between its own horns.

Prior to and during combat, the attacking ram never takes its eyes off the opponent, and neither does the defending ram. As the attacker gets close, it sharply pulls its head and neck down and tilts its head sideways. This means the ram strikes the opponent with the edge of one horn. The outside edge of each horn is the combat edge. That's what all rams use to hit their opponent. They swing their massive 20- to 30-pound horns in a motion resembling a karate chop. The horns are like sledgehammers in terms of weight, but they are used deftly like a karate chop to have an impact on the opponent. From the mass, the sharpness of the horns, and the speed of the attack comes the velocity and, consequently, the force of the attack. In total, it's a terrible blow indeed.

What does the defending ram do?

It balances itself and catches—skillfully—the

The horns of a large, old "full curl" ram may exceed 13 percent of its body mass.

horns of the opponent between its two horns. However, that does not stop the attack, as the attacker's body sails forward. To neutralize this impact, the defending ram lifts its hind legs off the ground and allows the force of the attack to carry it backward a few steps. The defending ram now lands elegantly, and both the attacker and the defender raise their heads sharply upon landing, showing off their horns to one another. The defending ram can judge quickly the force it experienced with the size of horns responsible for it, and the attacker can instantly assess the size of the horns it could not budge. To this end, for a minute or more, the two fighting rams stand and show off horns to one another.

Occasionally, if an observer happens to be very close to the fighting rams and knows how to read sheep behavior, he or she will notice how the ram losing the contest begins to close one eye—the one on the side nearest the winning rival. The

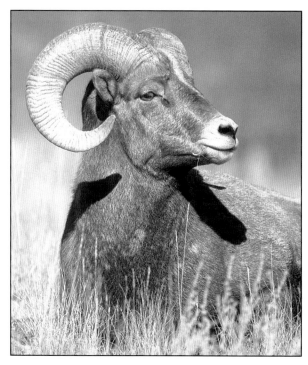

This "three-quarter-curl" bighorn ram is approaching the prime of life and breeding status.

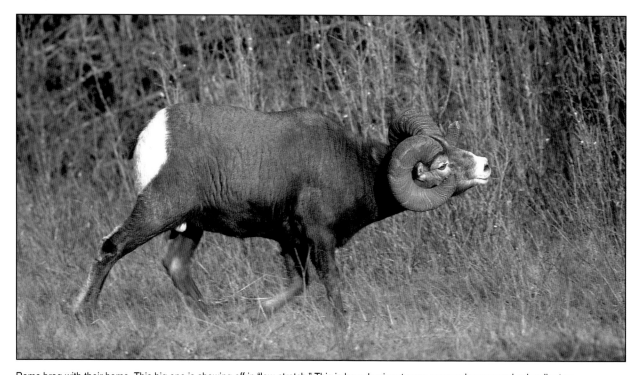

Rams brag with their horns. This big one is showing off in "low-stretch." This is how dominant rams approach ewes and subordinates.

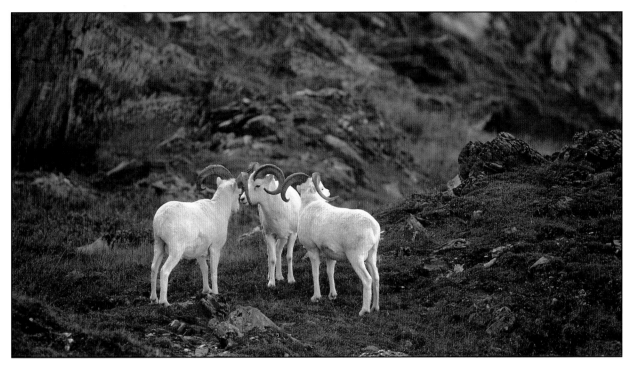

Rams in groups also show off horns by using an elevated head, a display known as the "present." This gives youngsters an opportunity to sidle up and rub their head and horns on those of the big ones.

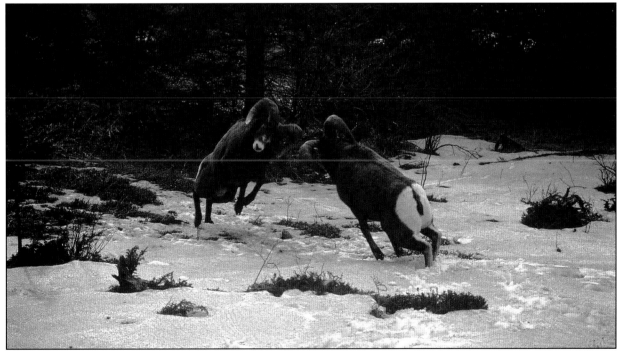

To maximize force, rams race at one another on their hind legs and jump into the clash. The attack is usually initiated by the smaller of the two rams; the bigger one calmly catches and neutralizes the blows with his horns.

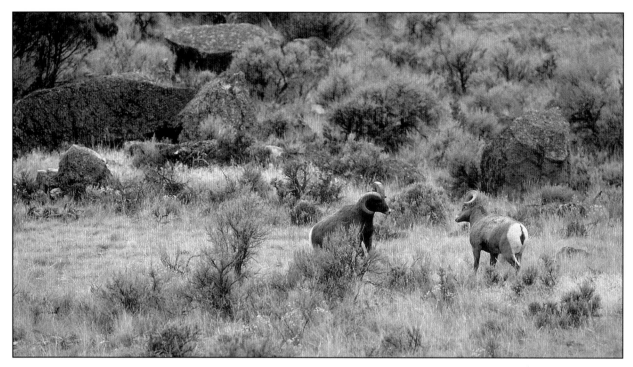

A fight sequence. Most serious fights erupt among the "three-quarter-curl" rams. The opponents here are about to clash.

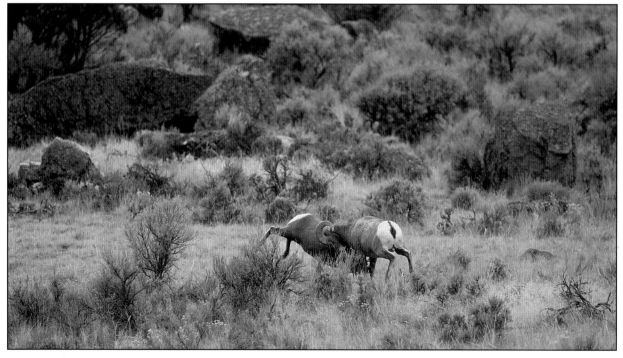

The rams slipped in this clash. The defending ram did not catch the attack perfectly, and the attacking ram dived horn-first into the ground. Many clashes take place, and fights have been timed to last over 25 hours.

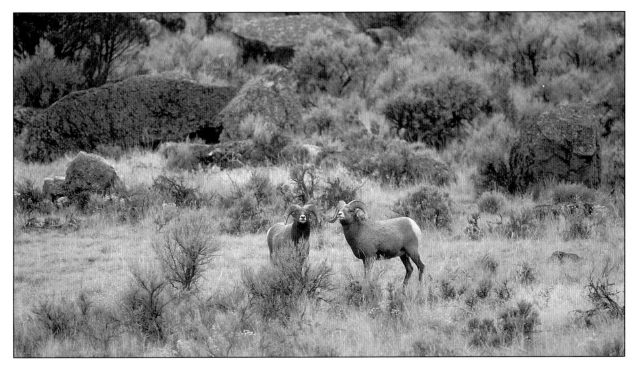

Right after the clash, both rams "present" horns to one another. Thus, each can compare the force of the blow with the size of the horns that caused the pain. A ram may now "blink," that is, close its eyes and not look at the opponent's horns, a sure sign that he is about to lose the fight.

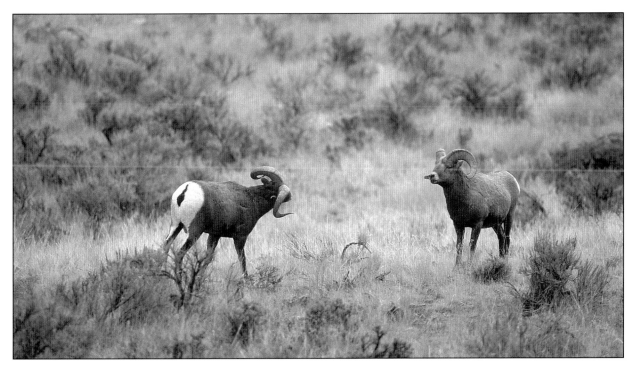

After many clashes, the winning ram insults the loser with the bloody nose by approaching in "low stretch." The winner courts the loser as if it were a female.

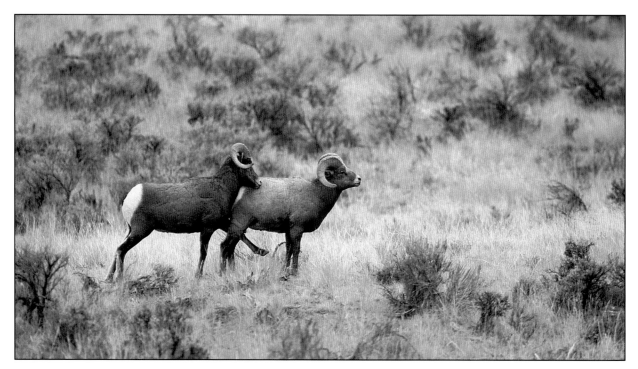

The winner "kicks" the loser, a sign that the winner is dominant. The "kick" with the front leg is a frequently seen courtship behavior of rams about to breed estrus ewes. A "kick" does not hurt physically, but is an insult to the subordinate ram.

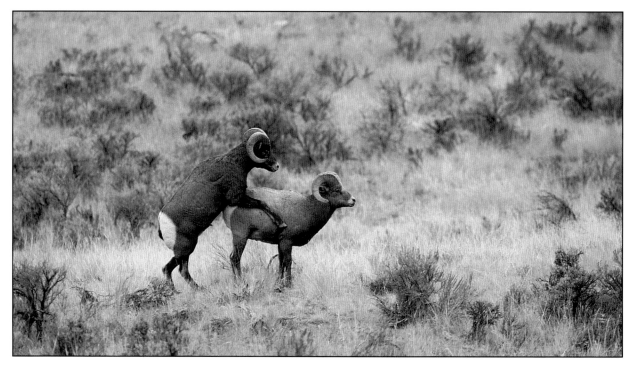

To add more insult to injury, the winning ram mounts the subordinate. The defeated ram accepts being treated like a female and thereby remains a member of the band. It is not forced to leave the home range, the rutting grounds, or its companions.

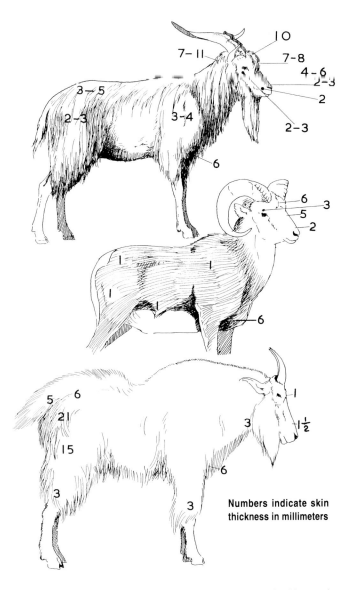

Numbers indicate skin thickness in millimeters

True sheep and goats use their horns to catch the blows of opponents and thereby protect themselves against damage. Consequently, they have a rather thin body skin except on their faces, where blows are likely to land. The mountain goat, by contrast, does not catch blows with its small horns and fragile skull. Rather, it tries to evade blows. Failing that, its thick skin catches the attacks. Note the skin thickness in a domestic billy goat, a Stone's ram, and a mountain goat billy in rut. The skin in the mountain goat is especially thick on the haunches. The measurements are in millimeters (Geist 1971).

losing ram may also begin to squint.

Understanding the above requires some clarification of the anatomy of rams, the horns included. The horns act as weapons, but they act also as shields to catch the opponent's attack and absorb at least part of the blow. In addition, they act as display organs allowing opponents to gauge horn size against force. Thereafter, rams use horns as visual rank-symbols, to judge other males' dominance status without the need to re-experience, through fighting, the ranks of larger- and smaller-horned rams.

The skin on a ram's nose and face, measuring up to 1/4 inch in thickness, is then logical: It is part of the animal's protection against being hit in the face by a horn. The ram's massive skull, grown out of very hard, dense bone, is also logical: It is structured to withstand heavy blows. The large hinge mechanism at the back of the skull, anchoring the head and spinal chord, is equally logical: It is sturdy in view of the massive force it must absorb. There is apparently even an absorptive mechanism beyond these, in the form of a thick, tough tendon that attaches to the spinal process and the back of the neck, which may provide further cushion. When short-haired desert rams fight, this nucheal tendon, as it is called, visibly swells in size. How and why this happens, we do not know—there is still plenty to explore about mountain sheep and their anatomy.

If horn size is a rank-symbol, strangers meeting for the first time ought to at once establish a rank based on horn size. Strangers with badly broken horns should be regarded by much younger rams as inferiors, until they learn otherwise. If horn size matters, then horn size ought to reflect dominance rank and breeding success within any one year. Observations suggest that this is so. Rams spend much time in their social contacts displaying horns to one another.

It is nevertheless true that very old rams with

Note the old ram grazing. Its horns are badly "broomed," that is, the ram has broken off much horn in past battles. Since rams judge the status of others by horn size, old rams with "shrunken" horns may be challenged by younger males, such as in this photo. Some old boys, however, remain dominant, dishing out telling blows even with broken horns.

massive horns but aged bodies are defeated by younger, smaller-horned rams. So we occasionally see a large-horned ram playing second fiddle to a smaller-horned one. But for the most part, among rams of comparable body size and age, large horns win out in fighting and contests.

If we return to the structure of fights between rams, we note that the smaller ram usually attacks, using a downhill run to gain momentum and force in clashing. After the clash, the rams stand like statues, displaying horns. Now the smaller ram lowers its head into a low-stretch, walks up to the defending ram, twists its head, and growls and kicks with its front leg repeatedly at the belly of the bigger ram.

The larger ram then marches off uphill in low-stretch. The smaller ram faces the larger, and acts as if it is getting ready to rise on its hind legs. He better be prepared! For the larger ram suddenly whirls, rises on its hind legs, and runs at the smaller ram, which now plays the role of the defender and smashes into its opponent. The smaller ram also catches the clash between its horns, but it is thrown much farther backward. The larger ram has retaliated.

The smaller one, however, does not give up. It counter-displays and again kicks at the larger male, causing the larger ram to repeat its attack. If one of the rams is caught so as to stumble, let alone fall, then the fight is over. Eventually, though, if neither ram stumbles or falls, the smaller male gives up by turning and grazing. Now the larger male pesters the smaller for a good long while with low-stretches, twists, front-kicks, and more. It repeatedly mounts the smaller ram, which grazes and does not run away.

What happens is that the larger ram behaves towards the smaller as if it were a female. The same behavior by the smaller towards the larger ram triggered severe retaliation. The aim of combat is thus not to chase away a defeated subordinate, but merely to establish dominance and "insult" the subordinate with courtship behavior. The subordinate may eventually turn, gently horn the chest and shoulder of the dominant male, and then begin to rub its face and horns on the face of the dominant ram. On a ram's face, just below the eye, is the preorbital gland. On that gland the defeated ram rubs his horns and face, impregnating them with the preorbital scent of the dominant.

All rams communicating in this fashion thus acquire a dominant ram's scent, and signal thereby

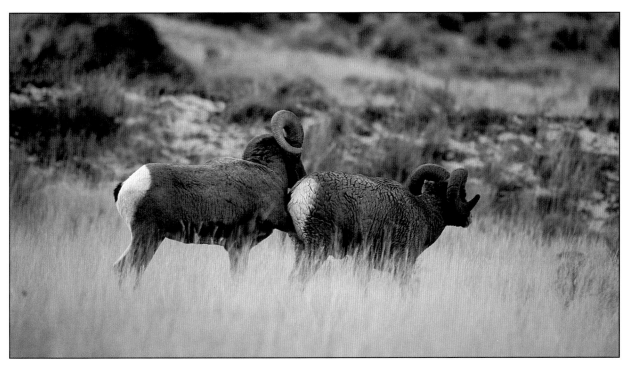

When rams know one another well and the tension of the rut is distant, younger males may take liberties with bigger "friends," as this three-quarter-curl is doing by kicking its buddy. In large populations where acquaintance is fleeting, the rams are more "correct" with one another.

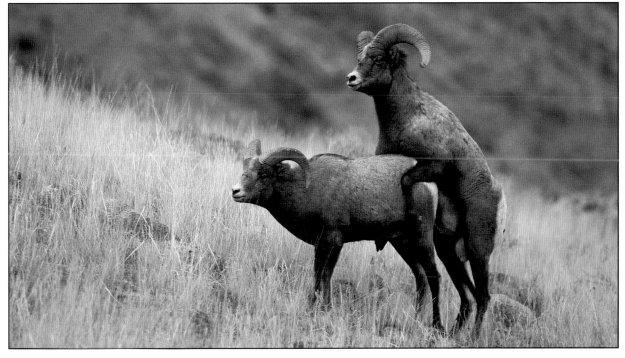

Dominant mounts subordinate.

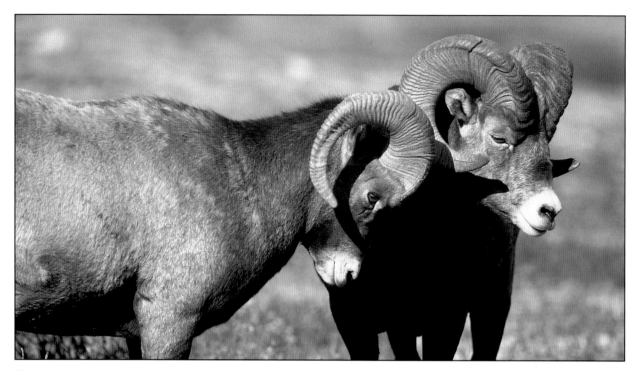

The younger male on the left is "horning" the head of the full-curl ram. While horning, the subordinate is gently rubbing the face, horns, neck, and chest of the dominant. It is the most common behavior addressed by the smaller to the larger, and it serves as a means of bonding between members of a ram band.

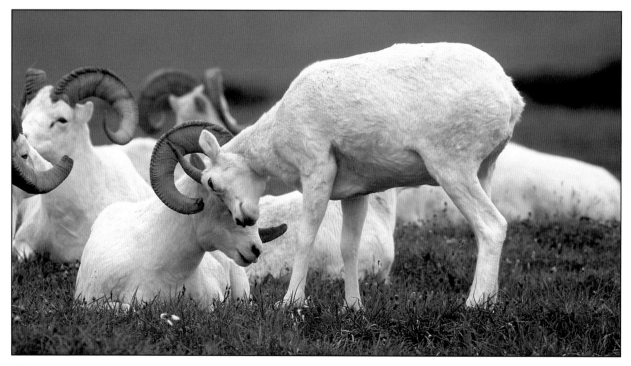

This is not common. A ewe has approached a resting full-curl and is "horning." In front of the eye, a ram has a protruding gland, the preorbital gland. It is on this gland that subordinate sheep of both sexes rub their heads, impregnating themselves with the scent of the dominant male. In white Dall's sheep, dominant rams may consequently have a "dirty" face during fall, due to all the homage they have received.

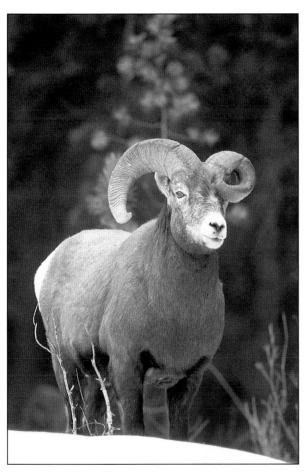

A bighorn with an "in-grown" horn. Here the defective horn obscures the ram's vision. It could be worse. Occasionally horns grow into the head or neck. Such defects may shorten life expectancy.

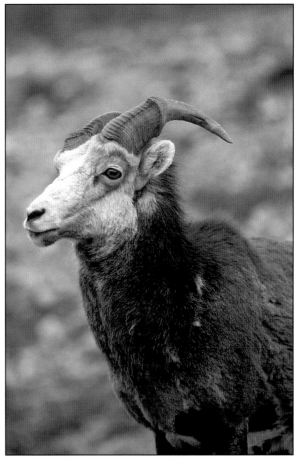

A four to five-year-old Stone's ram with an unusual horn breakage. This ram probably sickened and grew structurally defective horn during its illness. The horn broke cleanly along the weak line and the sheath, composed of horn grown in the preceding two to four years, pulled off the normal, strong horn below, resulting in this peculiar shape. Now the horn continues to grow normally.

day and night their subordinate status. In white-haired Dall's sheep, full-curled rams, the dominant class of rams, carry dark patches and streaks on their faces just below and ahead of the eyes, surrounding the preorbital glands. These spots are where the smaller-horned subordinates rubbed their dirty horns.

The advantage to the subordinate of this scent-marking probably lies in being recognized by the dominant ram during the long, dark nights of the rut, especially in the far north beyond the Arctic Circle. In the far north the rut takes place virtually entirely in darkness or during moonlight. Sheep have, however, large eyes and bright tapetum lucida, the eye tissue that shines brightly when artificial lights are turned on them at night. In the reflection of perpetual snow, sheep must be able to deal with contingencies, even in darkness and during starlight. Clearly, they manage.

° ° °

There is more to sheep horns. Much more.

For instance, the horn size of rams varies with

the quantity of high-quality forage they are able to ingest: The better the forage regime, the larger the horns. Thus horn-mass is an indicator of a ram's success at finding and assimilating forage. Horn size is, of course, also a function of age, as with each year the ram adds a new horn segment to the existing ones. Consequently, horn size is also a symbol of a ram's success in escaping predators and accumulating years of life. As we shall see later, young rams take advantage of these messages. As also expected, rams with rapid horn growth will gain dominance and enter the rut earlier than rams with small horns.

For a number of years the theory behind ram behavior as it relates to horn size stood essentially as told, but there were additional points to ponder. Why, for instance, did sheep have heavier horns than goats of comparable size? And if large horns were so useful, why had few other species opted for the same horn size?

Among sheep, it is true that at least two lineages evolved large horns and behaviors surprisingly similar to mountain sheep. The giant sheep of Asia, the fabled argalis, evolved enormous horns and social behaviors that are strikingly similar to those of bighorns, even though they are more closely associated with the urials and mouflons. Actually, the giant sheep appear to outdo mountain sheep, if not in relative mass, then in the size of their horns.

In a similar vein, why were there large-antlered and small-antlered deer of the same body size? Why were there cattle with tiny horns and others, like water buffalo or African buffalo, with very large horns?

Answers to the above questions were discovered, significantly extending our understanding of horn-like organs. However, the answers did not come from the study of mountain sheep, but rather through studying a creature very spectacular and very dead: the extinct Irish elk. This elk's huge, showy, somewhat puffy antlers have been a wonder for a very long time. The clue to their enormous size lay in the body proportions of this magnificent, huge deer. It had a distinctive body shape—the build of a cursor, or an animal adapted to speedy, sustained running.

What is the relationship between running and large horns?

Briefly, animals that escape predators in open spaces by running require large, highly developed babies at birth that can grow rapidly to a large, survivable size and achieve speedy, endurance running. That's important whether the animals have horns or not. Horses and camels, denizens of the open plains renowned for their speedy departure and enduring gaits, have no horns, but they have huge young at birth.

Horns enter the equation only if the species is non-territorial in its mating strategy. Species in which males court females on small territories have modest horns that function strictly as organs of attack and defense.

The logic is as follows: The female, in order to grow large, well-developed young and in order to produce the amount of milk needed to sustain rapid growth following birth, requires a relatively large amount of nutrients. The female must generate these nutrients and energy at the expense of her own body growth, and by running a very efficient maintenance regime. To have a daughter that is as good as or better than herself, the female must look for a mate that is equally good at sparing resources from growth and maintenance.

The male cannot put these into milk or young. He may, however, stick excess nutrients and

While ewes allow all males to court them, copulation is normally reserved for the largest-horned ram. Large horns signal success in finding food, living in security, and being able to spare protein and energy for purposes other than mere maintenance and growth. Horns are thus "luxury" organs bragging of a ram's success in life.

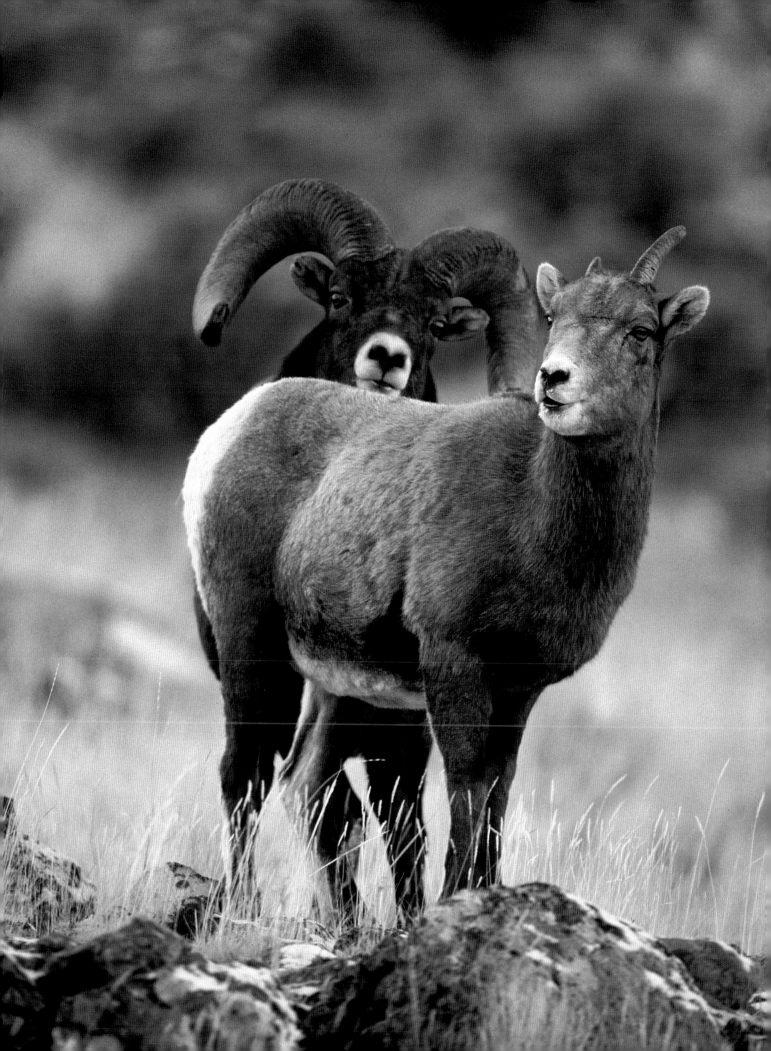

energy into growing luxury organs. Horns and antlers can function as such luxury organs in species where the size of these "adornments" is susceptible to, or determined by, the nutritional regime experienced by the male. Consequently, to find the male best able to spare resources from growth and maintenance, the female must look for a male with the largest antlers or horns. Such a male also signals that it is a superior forager, and since foraging is associated with risk-taking, it means the male is also adept at escaping predators. Not a bad choice for a mate.

Under this condition, when the female's choice of mate becomes a significant factor in reproductive behavior, the males ought to advertise their worth to females by elaborate courtship that focuses on antlers. That is, horn-displays by males should become very conspicuous signals in courtship. Species with larger horns should exhibit more conspicuous courtship displays that center on horns; also, horn size should correlate with the relative size of the species' young at birth, and if the amount of milk solids in the female's milk is a sign of how good the females are at sparing nutrients from growth and maintenance, then milk solids and horn size should correlate as well. It turns out that these predictions all fit.

How, then, does one explain the fact that North American bison, which are cursorial plains dwellers, are not territorial in the rut, and bear a large, well-developed calf, have horns of such modest size? In bison, as it turns out, it is not the horn size that varies and is flouted at mating time but the length of hair and the development of the bull's hair coat. That is, the hair coat of the bison bull functions analogously to antlers in deer, which also fluctuate annually in size and development,

Mountain sheep normally rely on sprinting into steep terrain for security. Their muscular haunches and backs foster quick acceleration, essential to reaching the cliffs ahead of predators.

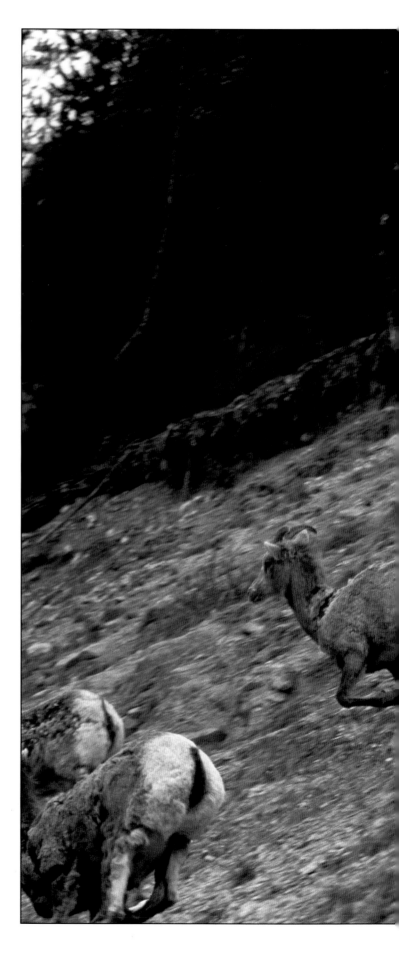

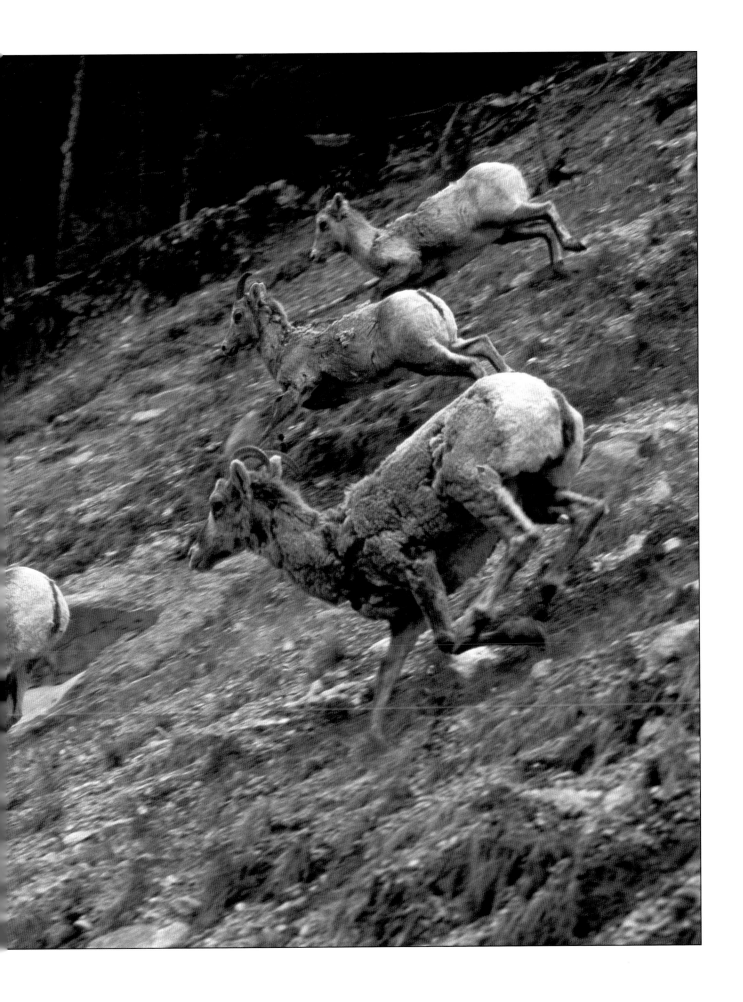

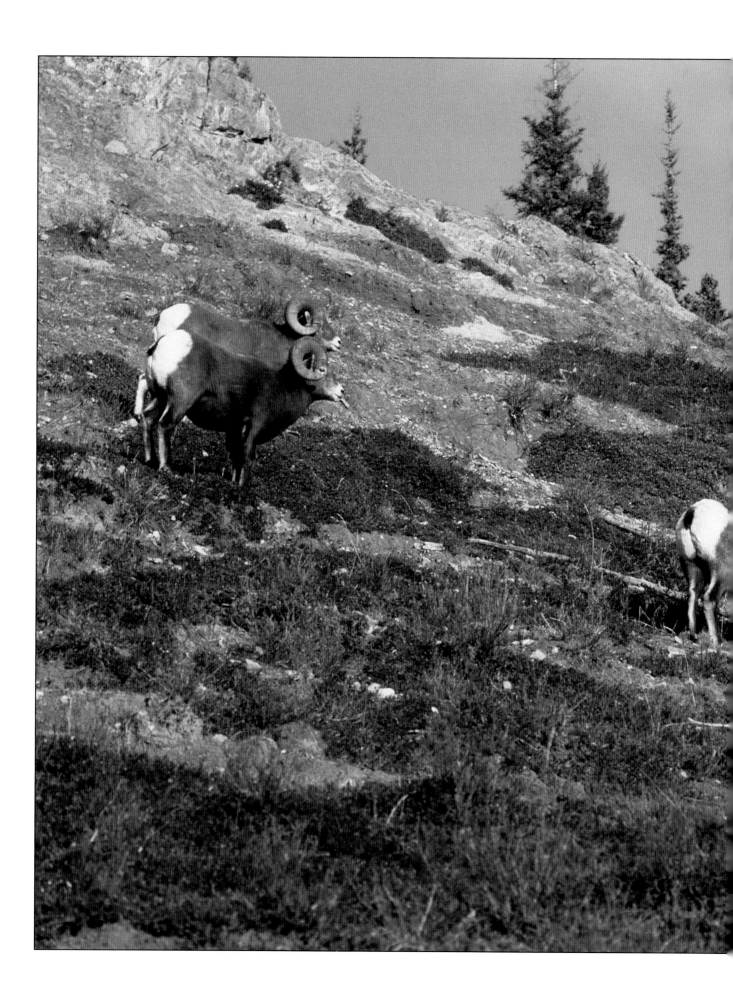

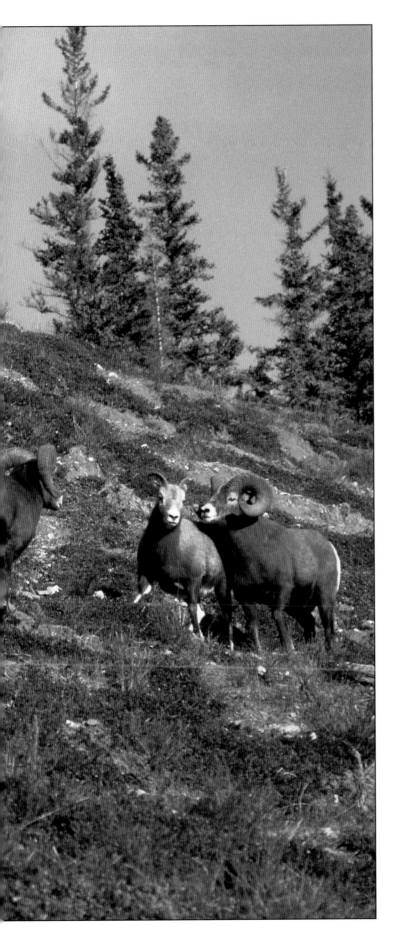

depending on the food supply.

Sheep, compared to true goats, are capable runners In the Old World, and even in the New World and Siberia the mountain sheep still rely on sprinting and jumping to conquer rock faces. In other words, mountain sheep retain running and adaptations of running as part of their behavior. And a comparison of sheep and goat milk shows the expected difference between cursorial and non-cursorial ungulates: The sheep's milk is higher in milk solids than is the goat's milk. Consequently, along with the very frequent displays of horns by rams during courtship, we also expect in mountain sheep a significant amount of female-choice in mating. That is the case, but it is subtle.

While many rams compete for the female in heat, it is invariably the largest-horned that breeds the female, even though the others may mount as well. However, the female is capable of being selective as to which ram breeds, for she is able to frustrate the mounting of lesser rams. Large horns appear to be thus adaptive in the sense that females choose males with superior foraging strategy, maintenance physiology, and anti-predator strategy for mating—a mating strategy that greatly facilitates bearing daughters with the same qualities.

Surrounded by hopeful suitors, a female in heat is guarded by the largest-horned, most dominant ram. The lesser rams will disrupt the couple and try to rape the female, successfully on some occasions.

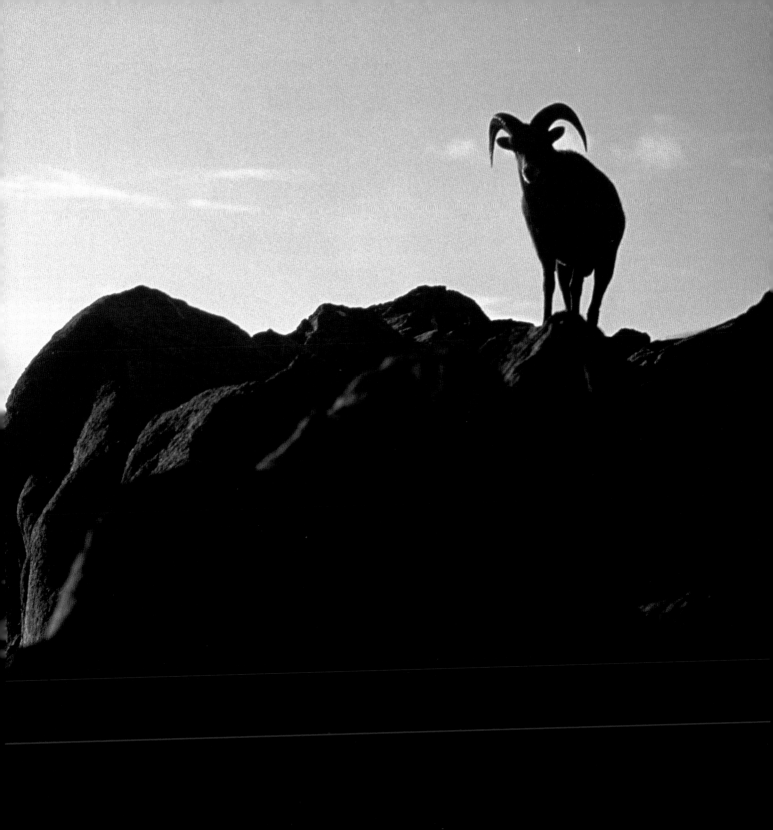

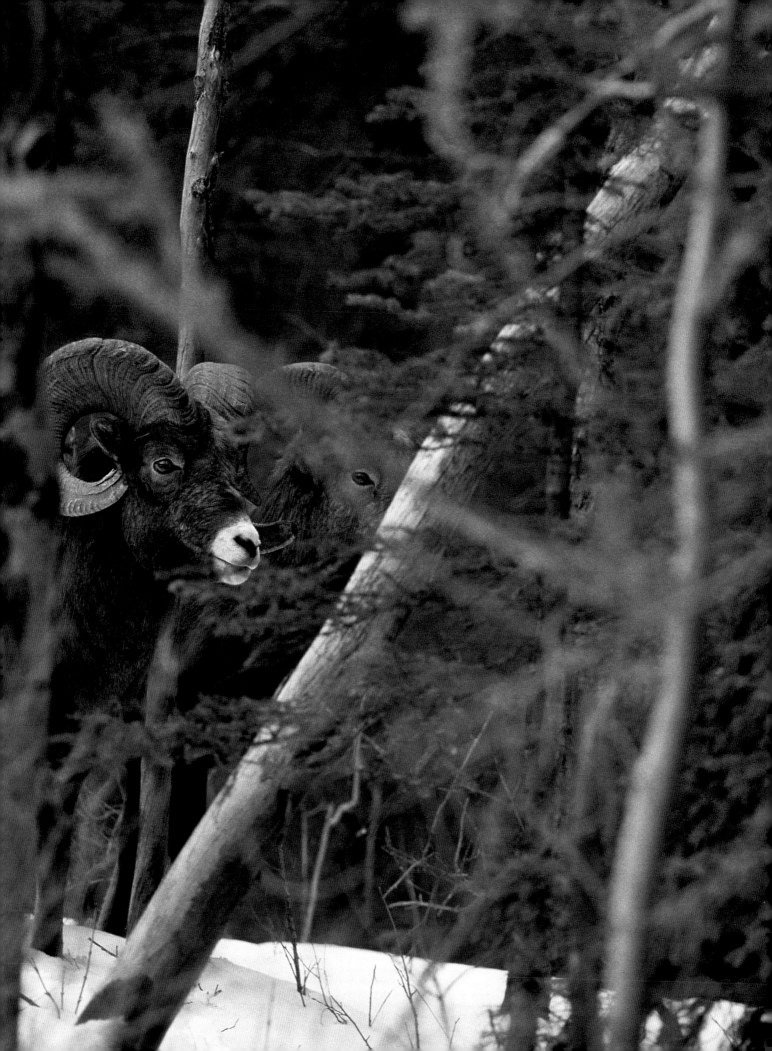

FOLLOW, FOLLOW LITTLE SHEEP

Once they have been alienated from a part of their range, mountain sheep rarely if ever return. Large areas that once held thriving populations of mountain sheep today lie barren. Why are the sheep not returning? Bighorns introduced into former habitat—and each new recolonization is hailed by biologists concerned with sheep conservation—rarely disperse beyond that habitat's old boundaries. Clearly, mountain sheep act differently than other species such as deer or moose, which readily disperse and colonize vacant patches of habitat. And yet mountain sheep act very logically and sensibly—but understanding the logic requires some explanation.

Let me briefly depart at this point to discuss certain populations of feral goats—domestic goats that have reverted to living in the wild state—on the picturesque Gulf Islands off the south coast of British Columbia. These small goat populations are narrowly confined to a few areas where they

have overgrazed as only domestic goats can overgraze. An abundance of potential sites is available for them to live on, but they are restricted to just a few areas. They simply stay there and go nowhere else.

Ecologically, the geographic distribution of these goats makes no sense at all. They should be found on the many suitable mountain sites with steep cliffs on these heavily forested islands. They are not. The distribution of the goat population cannot be explained at all with reference to preferred goat habitat. In fact, some populations occupy very poor goat habitat while good habitat nearby remains uninhabited. Only history explains the distribution of these goats: They are found where their former owners abandoned them. Decades later, the goats are still there and nowhere else, and they show today no more willingness to disperse and colonize than they did formerly.

Mountain sheep behave just like these goats. Not ecology but history explains their distribution. And this is not only true for sheep in North America. The eminent explorer-scientist Ernst Schaefer, in his expeditions through the wild, thinly populated highlands of eastern Tibet, puzzled over the ecologically illogical distribution of the giant sheep, the Tibetan argalis. Then he realized that

Mountain sheep disturbed or harassed by people or predators may opt to hide in dense timber. This happens despite the fact that sheep "dislike" heavy timber and may enter such terrain with elevated heartbeats, as we discovered through radio telemetry.

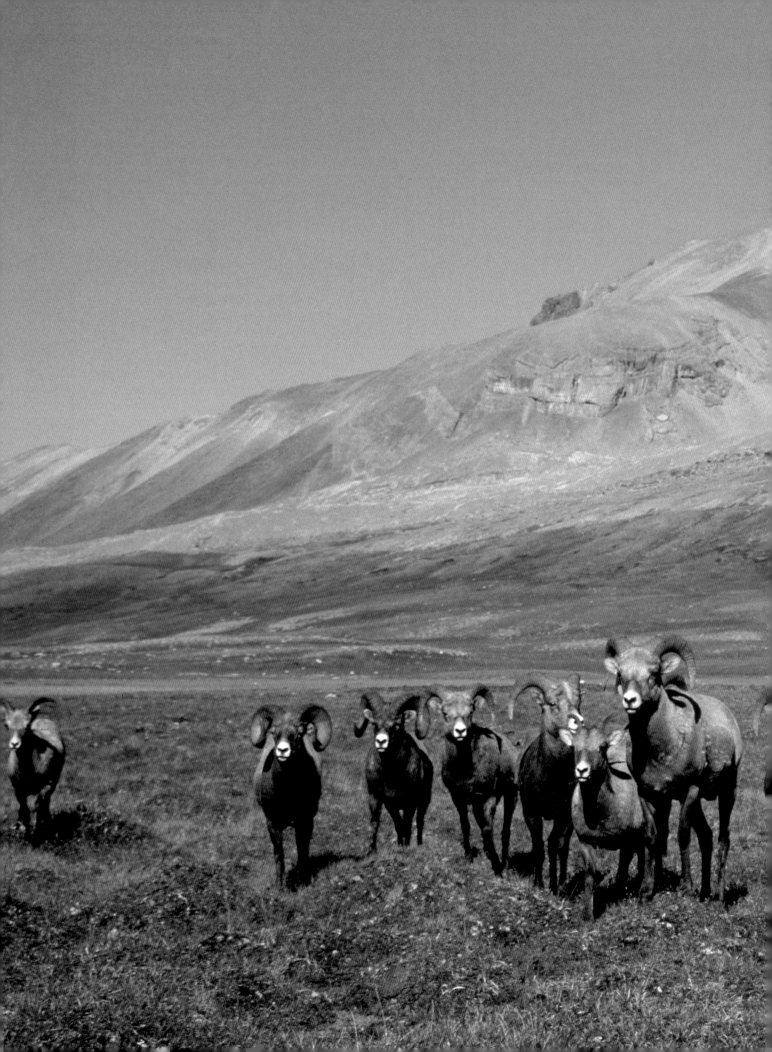

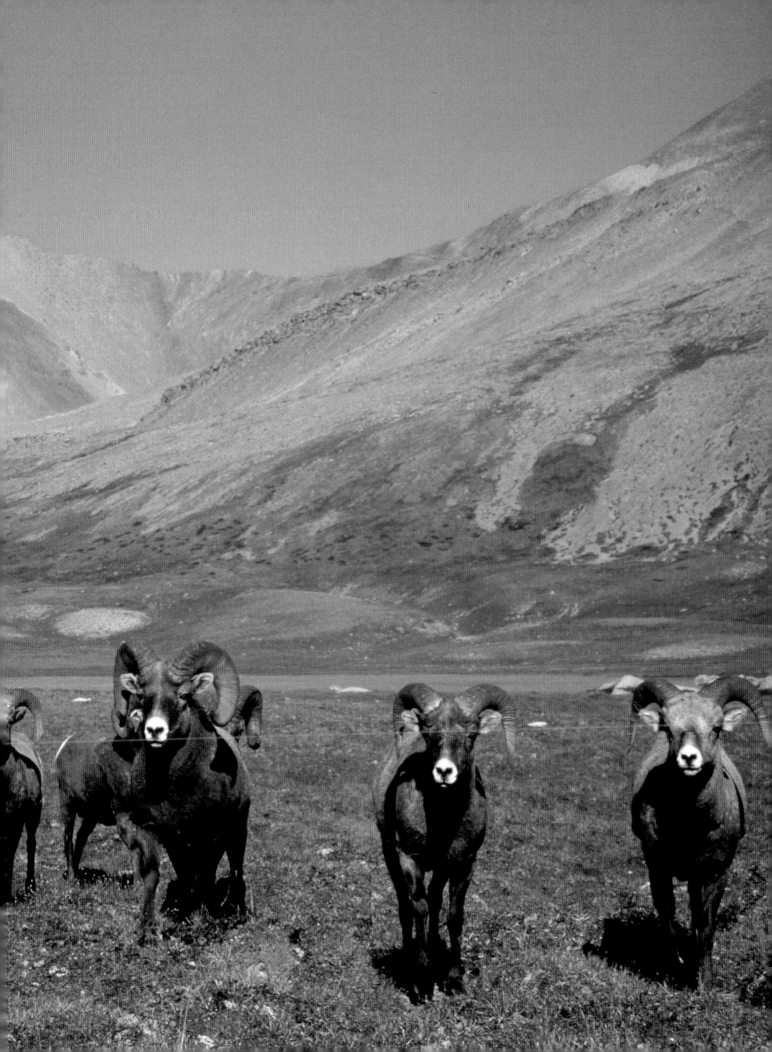

the distribution of these beautiful animals coincided in good part with protection granted to them by the monasteries. In short, a human historic factor was central to explaining where these sheep could and could not thrive. Just as Schaefer puzzled about suitable but abandoned argalis habitat, I've wondered what prevented mountain sheep from colonizing available habitat. The answer lies also in history, but in the glacial history of the northern mountains.

During the current interglacial period, the ecology of northern mountains poses a particular problem for mountain sheep. Whereas forests after a fire revert very slowly back to their original condition—and then only through a succession of ecologically differing plant communities—the mountain grasslands or prairies along the badlands return at once to grassland or prairie after a fire. This means that the areas mountain sheep inhabit are essentially stable and fixed in space. Fires in forests adjacent to sheep ranges may briefly generate conditions not disliked by sheep, and sheep may exploit such burns with their many stumps and windfalls, but sheep primarily choose climax grassland communities or the next best thing—provided there is undisturbed vision in all directions. Even though mountain sheep will accept the cover of timber for security under some conditions, and even though hunted bighorn rams become particularly good at imitating white-tailed bucks when hard-pressed, mountain sheep prefer the wide-open spaces and the security of climbing on steep cliffs and attaining dizzying heights.

Thus mountain sheep inhabit patches of stable climax plant communities. Even today, where

Overleaf: Sheep much prefer the wide open spaces, such as alpine slopes and alpine valleys in the Rockies. They rely on their keen vision to spot moving predators like the coyote that has attracted the attention of these bighorns.

Sheep love heights. Disturbed rams clump in a cliff, a typical response to predators by mountain sheep that live in reasonably undisturbed landscapes. Harassment drives them into timber.

reasonably undisturbed by human interference, they migrate with great precision over long distances to these seasonal habitat patches. That is, through their migratory habits, mountain sheep often stitch tiny patches of habitat together into large home ranges.

The migrations of individuals can be very precise and predictable. My individually recognizable Stone's sheep reappeared on their respective seasonal ranges within three days of the same calendar date. I even constructed a small mathematical equation that predicted the appearance of bighorn rams in my Banff National Park study area from year to year. It predicted well.

It takes little genius to deduce that, for a young mountain sheep, the very best strategy for ensuring a future place to live is to simply follow a successful adult on its annual migrations. By doing so, the young sheep becomes acquainted with foraging and escape terrain of proven worth in the safest way possible. After all, by its very existence the older sheep has shown its competence at living safely and feeding well. Given a choice, if there is a choice, the young male sheep ought to follow the most successful adult of its sex. Little males ought to pick the largest-horned ram to follow—and they do. Females, conversely, ought to follow the most watchful females that are leading lambs, and they do.

Clearly, it is not in the largest-horned ram's interest to have every little ram running after it. Its good feeding grounds would soon be overrun by other rams and lose quality through sheer overgrazing. Thus young males intent on following a large male ought, ideally, to "bond" with it in some fashion.

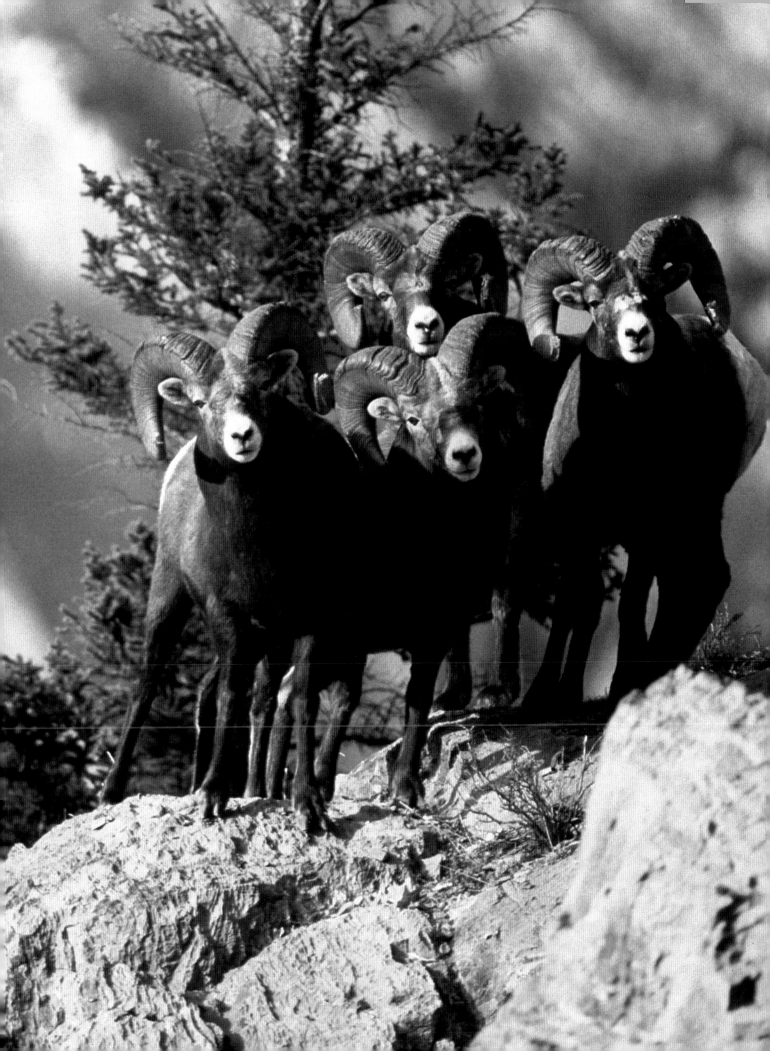

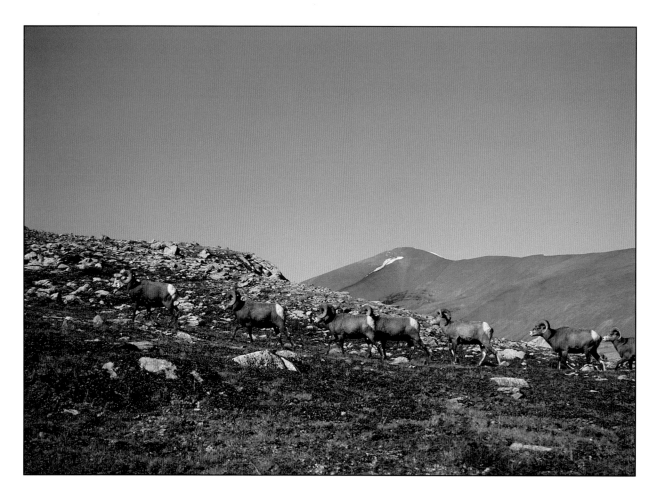

The young rams do indeed behave toward large-horned rams in exactly the way that females in heat behave toward a dominant breeding ram. The similarity is both qualitative, in the type of social signal used by the small rams, and quantitative, in that the proportions of various signals used by small males and estrous females toward large rams are similar.

Here, apparently, lies the root to one of the peculiarities of mountain sheep: The larger males behave toward small males as if they were females and, conversely, small males behave like females toward large males. Thus males appear to treat other sheep distinctly not on the basis of sex, but on the basis of size. Relatively small sheep are treated like females; relatively large sheep are treated as if they were breeding males. This

Rams with large horns attract followers. Large horns speak of success at finding food and security. This is what young rams must look for to be successful. Consequently, large-horned rams become involuntary "leaders."

peculiar behavior appears to be linked to small males choosing large males to follow, thus discovering the best places to feed and escape predators.

Because of the need to link distant patches of habitat into functioning home ranges, mountain sheep cannot normally afford the luxury of having juveniles disperse to find acceptable living space. Under normal conditions, all good living space is occupied by sheep anyway, and a young sheep striking out to find a place to live will find only occupied habitat. This is not the case for some young moose. In this species, dispersing yearlings

may chance upon a large burn in the boreal forest and thus find superior habitat for growth and reproduction.

For young sheep, dispersal is very risky. The patches of sheep habitat are small and difficult to find through random searching. During a long search through forests and swamps, there might be little opportunity to feed properly or to detect predators in time. Juvenile dispersal simply has no payoff, but plenty of needless exposure to hardship and danger; for young sheep, the payoff lies entirely in following.

Sheep society acts as if it knows this. Lambs disassociate very gradually from their dams, over a period of months rather than days as is the case with moose. When female sheep go off to bear the new generation of young, the yearlings are retained by old, barren females in "yearling packs" that are led by the old ladies until the females with their new young arrive again on the accustomed ranges. Roaming by lone individuals is most uncommon, although rams in their third summer have a noticeable "roaming peak."

Nor are there surplus young produced by sheep as there are by the white-tailed deer, a disperser *par excellence*. Rather, adult mortality and yearling recruitment appear to balance closely in sheep. Dispersal is not in the cards for mountain sheep, at least under normal circumstances, and this has unhappy repercussions for today's sheep conservation efforts.

Mountain sheep, just like the feral goats living on the Gulf Islands of British Columbia, are usually incapable of extending their range back to areas that they once inhabited. This is true with a few notable exceptions. Mountain sheep recolonize, without difficulty, barren, open landscapes—land where they can see a long way without interference from a wall of trees. Mountain sheep virtually "hate" crossing forested tracts of land, as we discovered through radio-telemetry studies in

which we wired sheep to detect their heart rates and listened to their thumping hearts as they moved about. A sheep moving toward a forest tract experiences an elevated heart rate. The heart rate stays elevated as long as the sheep is in the timber, but returns to normal once it stands again on open grassland.

Mountain sheep may follow locally idiosyncratic distribution patterns that make sense only in the light of fairly recent history. In the Yukon Territory of Canada, the "gold rush days" of a century ago affect the distribution of Dall's sheep to this day. In the Ogilvie Mountains of the Yukon, sheep are widely distributed, but they are not in the Selwyn Mountains. It appears that, after the hunting that prevailed during the gold rush, sheep populations recovered in the Ogilvies, where the mountain ridges are long and protrude high above a sparse timberline. However, the Selwyn Mountains to the south are choppy, and timberlines are higher. Here, sheep distribution still reflects the pattern of sheep survival after the old market hunting days. Where sheep were exterminated locally, they largely remain absent. Old "fossil sheep trails" tell of former abundance, but the sheep have failed in the Selwyns to recolonize and to restore their former distribution. Yet this failure reflects sheep behavior adaptive to normal conditions in the absence of man—modern man and modern times in particular.

What, then, were these "normal" conditions?

Mountain sheep are essentially glacier followers, doing very well indeed in the vicinity of huge, continental glaciers. They do very well, for instance, at the edge of the 12,000 square miles of ice found in the St. Elias Range in the western Yukon and the adjacent mountains in Alaska. For most of their existence, mountain sheep lived under glacial conditions, periods of about 80,000 years compared to about 20,000 years for interglacial conditions. Moreover, mountain sheep in

This is what ancestors of mountain sheep looked like several tens of millions of years ago. *Phenacodus* from the lower Tertiary was closer to the age of dinosaurs than we are to it today. It had claws and pads, but no hooves. Hooves were destined to evolve. It was, however, a herbivore that probably lived off fruits and shoots and hid in thickets rather than running when spotted by a primitive predator.

North America and Siberia occupy far more land with cold seasonal climates than do bighorn sheep in southern latitudes in North America.

Under cold, dry, windy conditions, the major plant associations are montane herb, grass, and lichen communities with sparsely interspersed woody plants. Most such plants are low bushes, such as dwarf willow and dwarf birch, or even prostrate plants whose woody parts are close to or under the thin soil, such as mountain avens or cinquefoils. There is excellent visibility in the arctic and subarctic areas where these plants are found, and sheep can see predators far off. A trotting wolf is easily detected while it is still a mile away. In such open country there is little to impede the roaming of mountain sheep, and they travel quite freely across the valleys from mountain to mountain.

When timber begins to invade the valleys and lower slopes of mountains, sheep, having crossed through short stretches of sparsely spaced low trees, continue on through wider stretches of closely spaced, tall trees. After all, they have done it year in and year out, and the slow encroachment and spread of the forest does little except make sheep pause and carefully scan the valley before they cross. This is a ritual that sheep perform prior to every crossing, but once committed, they move briskly in single file across the timbered valley.

Eventually, as the interglacial period progresses, the once extensive open range shrinks into small patches of habitat, separated by miles—at times many miles—of timbered lowland. However, sheep continue to move regularly between these patches and through timber because they learned the habit from older sheep. Sheep habitat is thus not a patch of grassland, but an ancient habit passed on from generation to generation of mountain sheep. When a patch of habitat is lost from the population's migratory tradition, it is because the habitat has become unsuitable. There would be little point in finding it again. Consequently, when in modern times mountain sheep are alienated from perfectly good habitat, they treat the loss in a way that was sensible in former and—from the mountain sheep's perspective—better times.

Some colonization can take place nevertheless, but under very specific conditions only. For instance, if sheep are reintroduced to a very productive, reasonably large area free of domestic livestock, then the following may happen: The new population not only grows rapidly in size, but

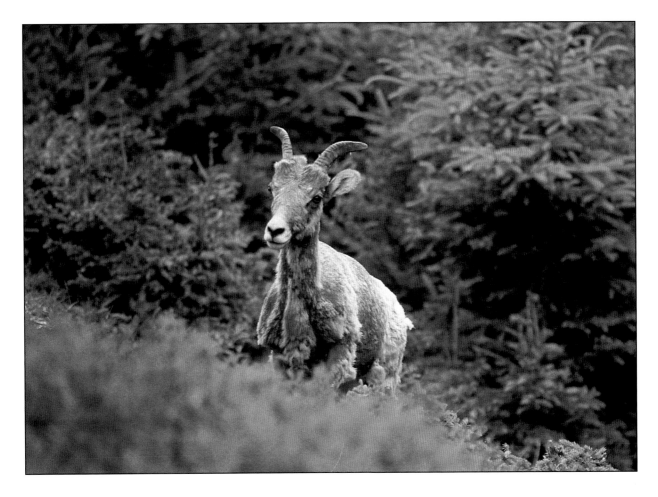

Young rams such as this one follow large-horned elders in order to learn good places to feed and hide. However, they also do some independent exploration. Despite the dangers of lone wandering, the young ram may gain a reproductive advantage in the future by joining rams that normally do not breed with the nursery band containing his mother, aunts, sisters, and cousins.

the individuals also grow to remarkably large size. When this happens the individuals are not only large, but are exceptionally active socially, roaming fearlessly over the landscape. To contrast them with sheep in normal populations under maintenance conditions, we term these sheep "dispersers." Such sheep will indeed recolonize patches of habitat across some timbered valleys. However, disperser-type sheep only arise under truly ideal conditions.

Normal dispersal appears to take place when, for instance, drought conditions have made life difficult. Whole bands may move off and, fortuitously, find some unoccupied good habitat close by. To a sheep, an area is acceptable only if it is experienced in the company of others. Consequently, band dispersal holds real possibility for colonization. Dispersal by individual sheep, however, such as that undertaken by rams in their third summer, cannot lead to genuine dispersal, because the ram is only looking for companions. On suitable but unoccupied habitat patches, such searching rams do not find companions. And suitable land without companions is simply not "habitat" to sheep.

For sheep, thoroughly social beings, the company of others serves not only as protection against predators but also as an essential system for the transfer of ecological knowledge—without which, mountain sheep would soon be extinct. This has been their regrettable fate in the last century. Extinct they would be if not for determined conservation efforts at husbanding these splendid animals, at times through ambitious reintroductions to vacant habitat.

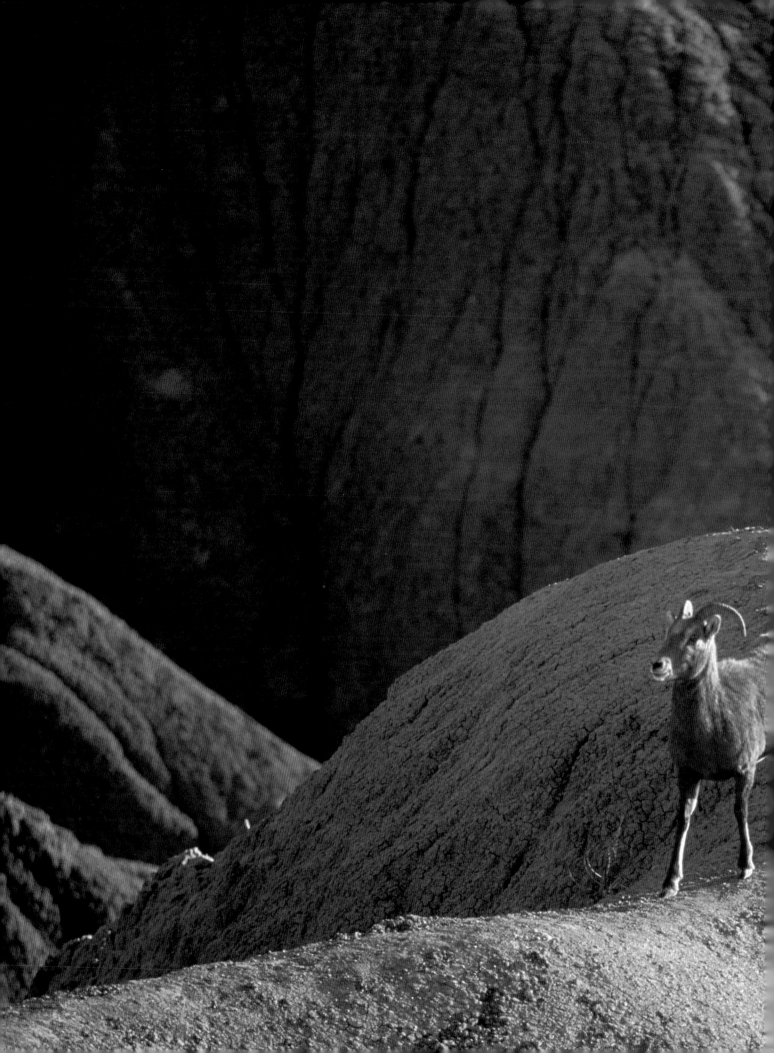

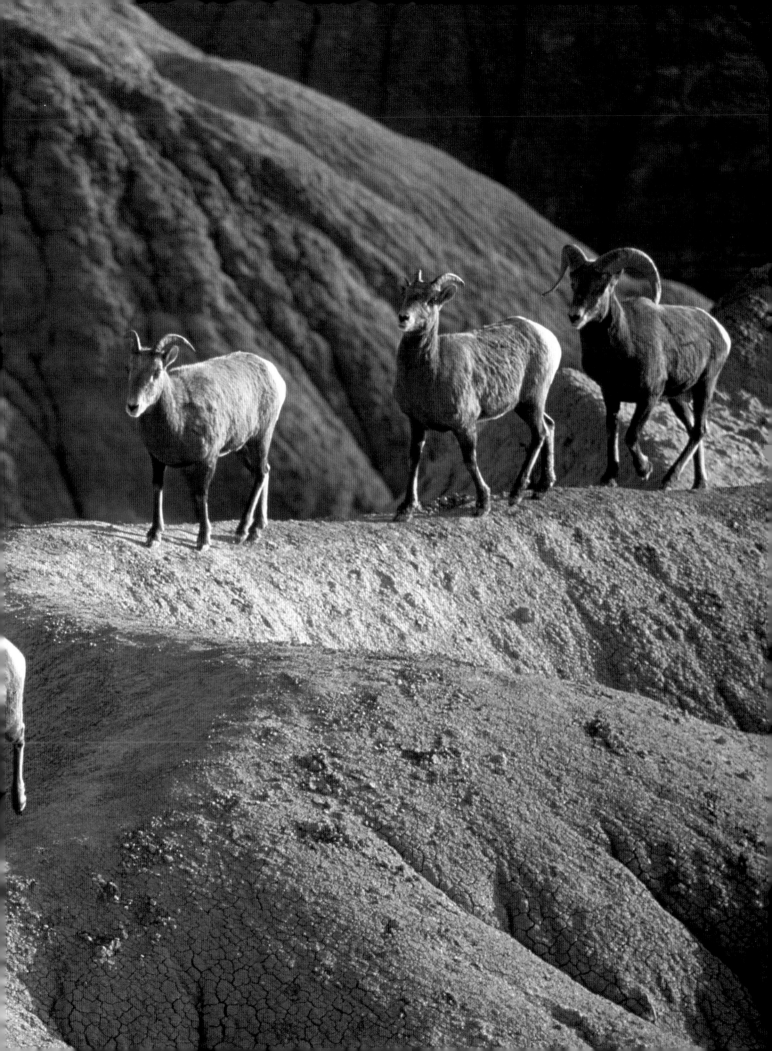

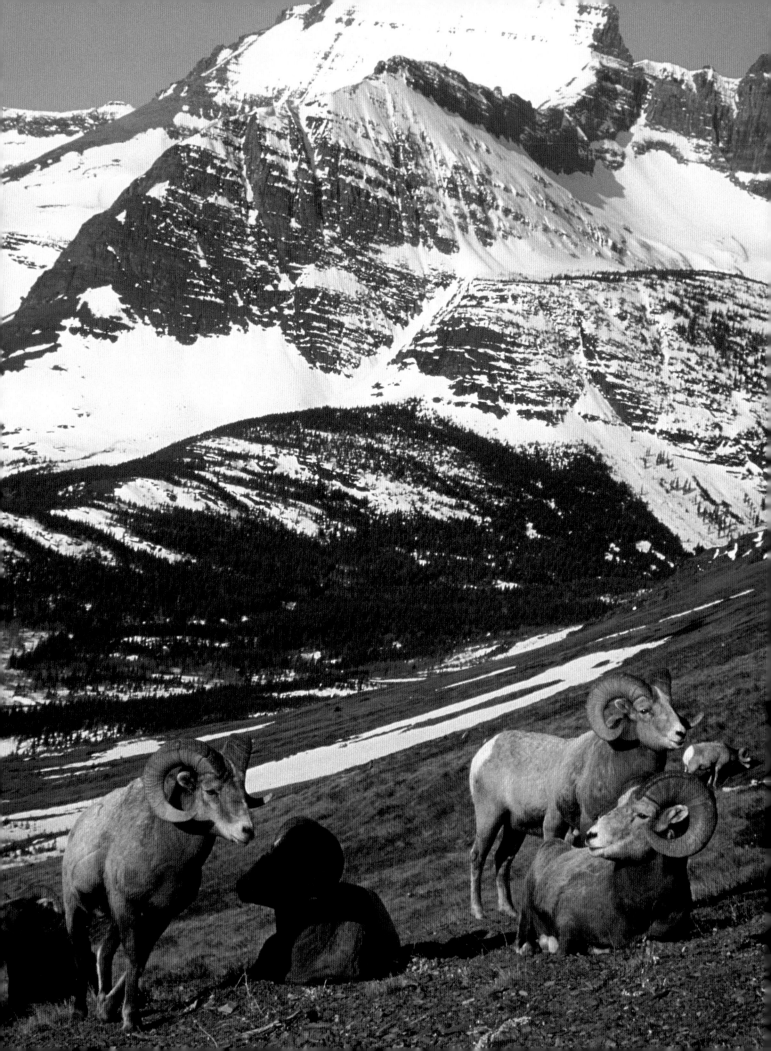

SHEEP TALK

Mountain sheep communicate in a manner of their own. We understand some of this communication, though we cannot know all of it. The part hidden to humans is accessible only by the sense of smell, and what sheep do or do not smell is very difficult to fathom. However, we can deduce a little bit about it.

Before one can follow mountain sheep in their "talk," one must know the common activities that signal no specific social intent. The most common non-communicative behaviors are feeding, resting, standing, and moving about slowly and comfortably. This sort of behavior actually does have meaning—namely that nothing too exciting is happening, and that all is well. Consequently, sheep are relaxed; they feed, rest, or comfortably move about.

However, if one sheep in an otherwise relaxed group exhibits an outburst of activity, the rest of the sheep—which were comfortably feeding or resting only a split second ago—will be up on their legs and off into escape terrain, for a sudden getaway by one means there must be danger for all. It's a signal not to be ignored, even though it specifies nothing except a sheep hightailing it for the cliffs.

To really get the others going, a sheep has only to stott a few times. Stotting involves hopping simultaneously on all four legs in high, stiff bounds that cause a thump on each landing. Stotting is invariably associated with sighting of predators, so it's a gait not often used. And what is uncommon really attracts attention. Sheep pay attention to the unusual, much as we do.

Social signals are always body postures that deviate from the common postures associated with maintenance. In the "low-stretch," the most common social signal used by mountain sheep, the head is held parallel to the ground, nose extended and occasionally tipped upward. It is a distinct deviation from the normal, relaxed stance. Males and females approach one another like this. Rams may run over a hundred yards in this posture toward other sheep. Females, however, use it much less commonly than rams.

Here are relaxed mountain sheep engaged in common daily activities. The normal postures and movements contrast sharply with the "social signals" used to convey specific intentions.

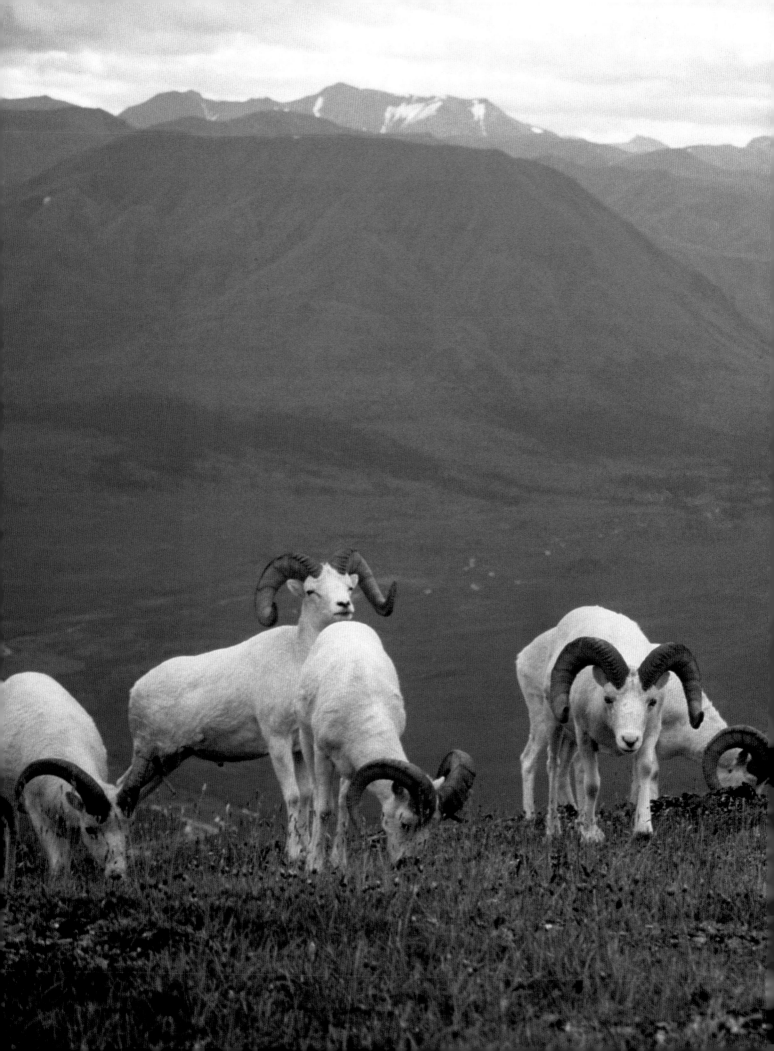

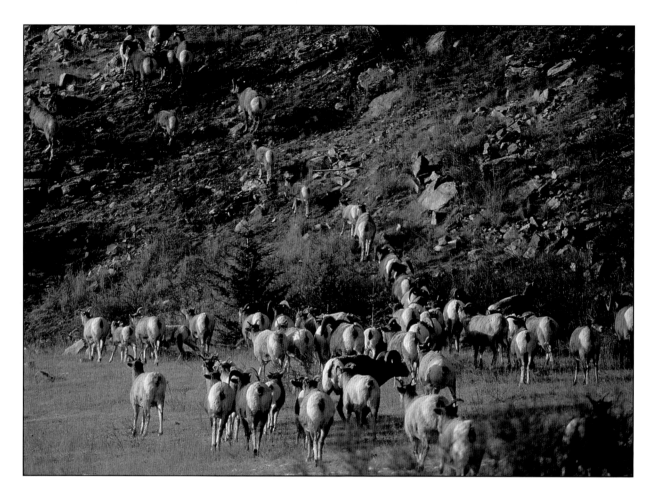

If one sheep suddenly departs from the relaxed normal activities, all sheep are alerted at once. They quickly follow the lead of any one band member that bolts into the cliffs. "Act first, look later" is the norm. Slow sheep are dead sheep.

Its meaning?

The posture is used by rams in courting ewes and in insulting subordinate rams. It is in good part a horn display that shows off horn size. It is a dare, a challenge to other rams. It is a bit like bragging. But invariably it is also directed at another sheep; that is, an individual animal is singled out as the recipient of the low-stretch. Consequently, the behavior tells us to whom the low-stretching sheep is bragging. It is, as expected, a behavior performed mainly by dominants toward subordinates. Young rams may do it to large males, but only when passing uphill and well out of reach of the bigger ram's horns. Occasionally, a small ram miscalculates the distance that the insulted bigger ram can reach, and gets pasted. That, I suppose, teaches it to insult from a safer distance.

The "twist" is used to augment the low-stretch signal. Moreover, the signalling ram may accompany the twist by flicking its tongue in and out and grunting. The signal is performed just in case the addressed party did not quite understand that it was being put down and challenged.

The next escalation is to combine the low-stretch not only with a twist and a growl, but to slam into the opponent with the chest and deliver a series of upper-cuts with the stiffly extended front leg.

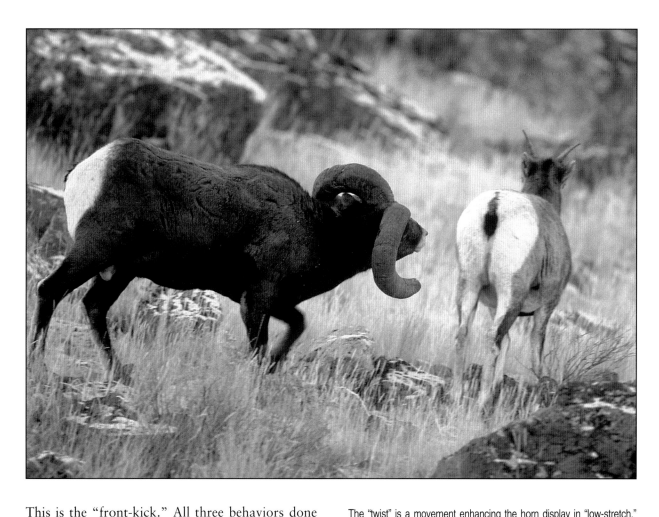

The "twist" is a movement enhancing the horn display in "low-stretch." Here a big ram courts a female, bragging with its horns.

This is the "front-kick." All three behaviors done by one ram to another constitutes a real challenge or provocation. Its meaning is approximately: "Take this, you wimp. I dare you to do something about it." A low-stretch done by a ram to a female, however, would mean something like: "Hello there, beautiful." It's a blatantly sexist approach from a human perspective, but it's just standard behavior in the world of the wild sheep. The added twist and front-kick are an escalation in that general direction, tolerated by none but a ewe in heat.

A low-stretch, twist, and especially front-kicks are done only by rams that are fairly secure in their dominance. If you ever worked with a mountain sheep that you have tamed, then a low-stretch addressed to you would signal a rather serious

matter—one you must not ignore if retaining your health happens to be one of your goals. A ram low-stretching to you, the human herd-follower, is challenging you. If you do nothing, the ram will escalate. Then it will test. The test consists of smashing its horns into you, preferably when you are not looking. That's what's in store for you—if you do nothing. If you run, it might just skip all escalations and go directly to the test. And I will wager you a bet that the ram will be faster than you. So, when a ram low-stretches to you, you are in a pickle. If an elk, moose, buck-deer, or bison

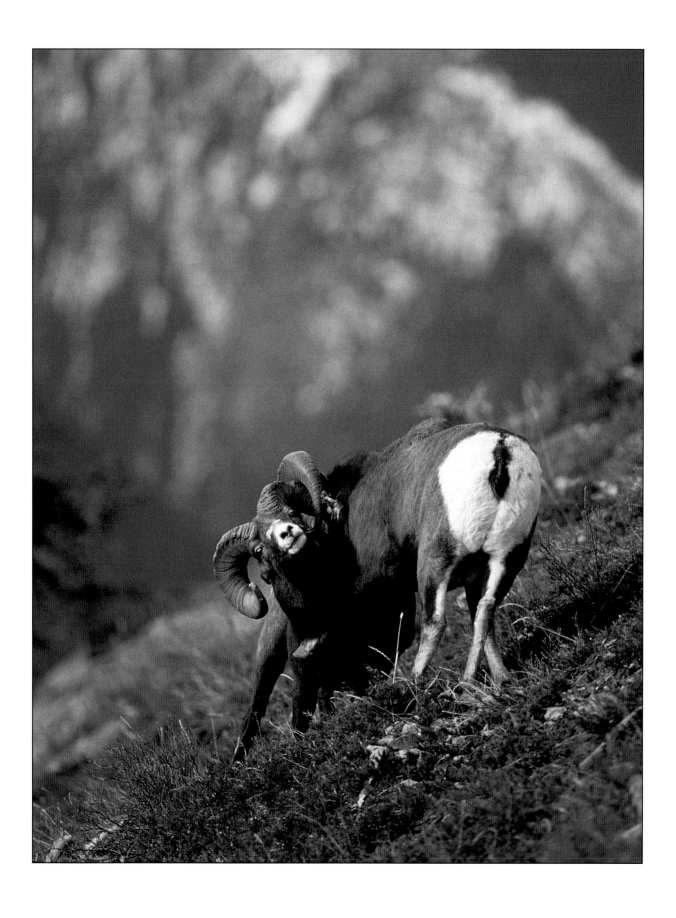

displays to you, then you are in an even bigger mess.

Fortunately, with rams you can do something that stops the developing subjugation cold: Just step up to the displaying ram, shove it downhill, and kick it swiftly in the belly. Kick hard! You cannot hurt that ram. Rams are made from sturdy stuff, and can absorb blows to the body. By shoving and "front-kicking" you tell it that you're a super-ram. In shoving it downhill and delivering a "front-kick," you are hurting nothing but its ego. You are also taking the steam out of the ram. Chances are it will be so petrified of you that it will not want to be friends again for months. That may be bad, but the alternative is worse.

I knew a young biologist working with mountain goats who did not understand the dominance display of the billies. He did nothing when they stalked stiff-legged around him—until he wound up in the hospital with two horn punctures in his legs. He was fortunate. The horn thrusts were meant for his belly.

In zoological gardens, keepers have been wounded or even killed by male ungulates that used dominance displays toward them. So, unless it's an animal you can handle upon first challenge, do not become too closely involved with a wild creature, for it will test you with an attack. My bighorns took three years to get the idea of challenging me, but they got the idea just the same. Wolves, as a biologist discovered when he tried to study the animals by following and taming them, get the idea a lot quicker.

Recognizing challenges is probably the most important lesson one can learn about mixing with mountain sheep—or any other ungulate, for that

The "front kick." A small, "cocky" ram is insulting a larger one that cannot punish the offender with its horns because it is standing downslope. Sheep are socially clever and know how to take advantage of the moment.

matter. It's best not to get close to the animals unless you can defeat their "tests" quickly. If not, stay some distance away, never mix with the herd, and if they get close, move off, though never appear to be running from them. Never, but never, show fear. Never act the part of a predator. Be loud, be showy, and do not look at the animals directly. It's not much fun to deal with an attack, but you may have to, as I did. More about that later, for not too many people will run with herds of mountain sheep day in and day out, as I did for years.

° ° °

There are more than three ways for mountain sheep to communicate their dominance over other sheep. They also brag with their horns in the "present" display. This has the same meaning, roughly, as the twist, but it is delivered with the head held high. The horns are twisted, so as to show the greatest mass. It's a behavior absolutely predictable in a fight, done by both rams right after the clash. It's done occasionally by a ram downhill of another. In any case, it's a challenge and an insult to the other ram. If a ram does it you, you are in trouble.

By far the most common signals issued by big rams are the preceding four: low-stretch, twist, front-kick, and present. These tell us that a big ram's mind is occupied much of the time by power and status. The ram is virtually obsessed with reassuring itself that it is tops, and that it can handle those that still respect its rank. The ram challenges and challenges. As expected, it primarily challenges those closest in rank—in other words, those most likely to turn the tables some day. Occasionally, a ram becomes obsessed with another ram that it can barely dominate. In such a case, the obsessed ram follows the barely-subordinate closely and insults it again and again, usually just before and after a resting period. In addition to the four customary display insults, it may also

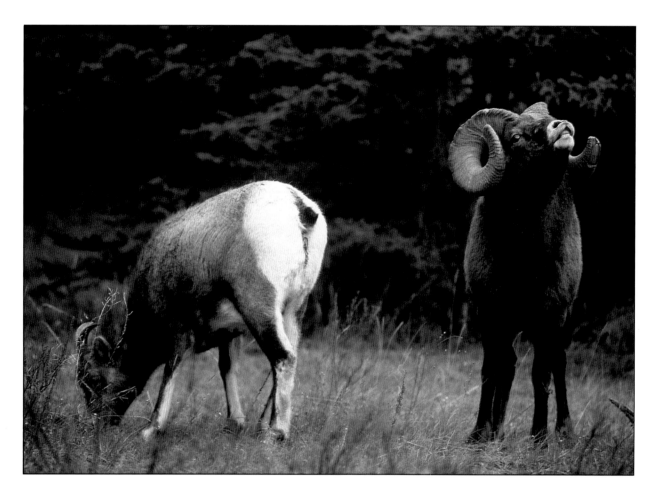

A "lip-curling" ram. He is testing the female's fresh urine for signs of the approaching estrus. Once the signs are detected, the ram stays with the female and chases off all rivals.

mount the subordinate. That's the height of insults, but if it is successful, then the ram clearly remains a feared dominant.

Yet the low-stretch, twist, front-kick, present, and mount are the normal courtship signals of the dominant ram to ewes, be they in heat or not. In that context, the ram's behavior is a sort of bragging, a showing off, a testing of the ewe. She can escape all that attention, though, if she urinates. When she does, the ram will examine her urine with his "Jacobson's organ," a chemical-sensing

unit used to detect estrus in ewes. The organ is located in the front of the midline cleft of the upper palate and contains a specialized ciliated epithelium directly connected by nerves to the brain. A ram finding fresh female urine nuzzles it, then raises its head and curls its upper lip. That action apparently opens the orifice to the Jacobson's organ, where some female urine enters and the test is conducted.

The ram's behavior is known as the "lip-curl," or by the old German hunter's term "flehmen." Other rams seeing a ram in lip-curl hurry over to partake of the expected female urine. There is no jealousy over female urine. All rams are welcome to a test. Only the ewe in heat is defended by the dominant ram. It does not even interfere with the courtship of non-estrous ewes by other rams.

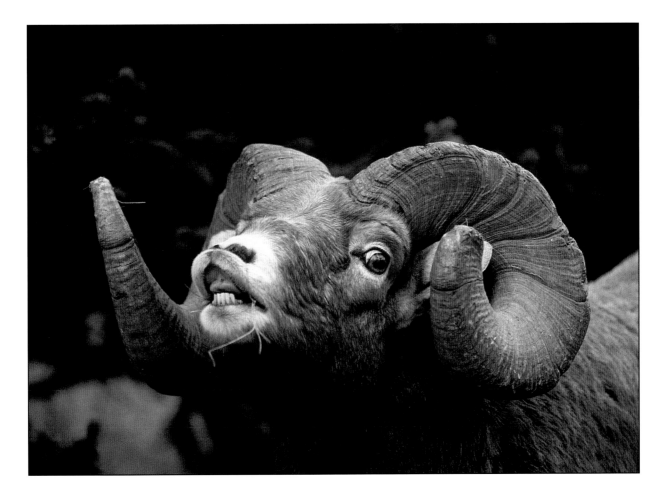

In the "lip-curl," the ram exposes the Jacobson's organ, located in the upper palate, to the female's urine. The retraction of the upper lip opens an orifice to that organ. Ciliated sensory cells then send a message to the brain, indicating whether the female is in heat.

On rare occasions, however, a dominant's position as a breeding ram is challenged by a large subordinate that formerly ran when attacked by the dominant male. The upstart breeder rushes up to the dominant, female-guarding ram, slamming its chest against the defender, then kicking wildly at its belly with a stiff front leg—while the startled dominant is trying to recover from surprise. When it recovers—and this does not take very long—the defender lunges at the upstart, shoving it downhill until the latter turns and runs off. The upstart, in its desperate revolt, used only courtship behavior toward the big ram.

A ram defending an estrous ewe may signal what it is about to do by lowering its horns at an encroaching rival, a signal of the defending ram's intention to rush and butt the usurper. The naked show of weapons ready to use is, of course, a threat, whereas the presentation of horns in dominance displays is merely saber-rattling, or showing off. Threats are not commonly performed by large rams; they are more commonly shown by smaller rams toward larger ones. In that context they mean "Stay away!" It's a good rule of thumb that when an animal threatens with its weapons, it will not attack unless encroached upon. A threat is a warning. Leave slowly and the animal is also likely to leave. That's not the case, however, if the beast

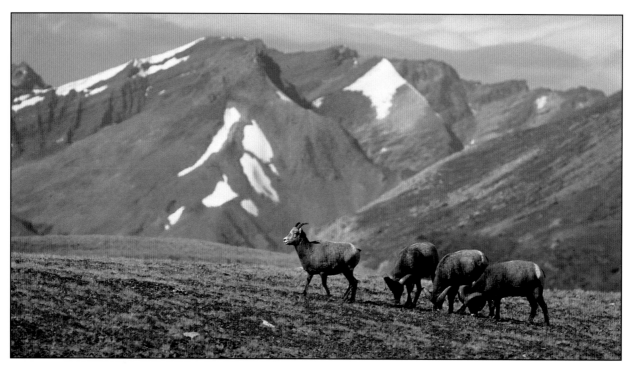

All rams are allowed to test or lip-curl over the urine of females that are not in heat. There is no "jealousy" among rams when it comes to mere testing of urine. Fights erupt, however, over females in heat.

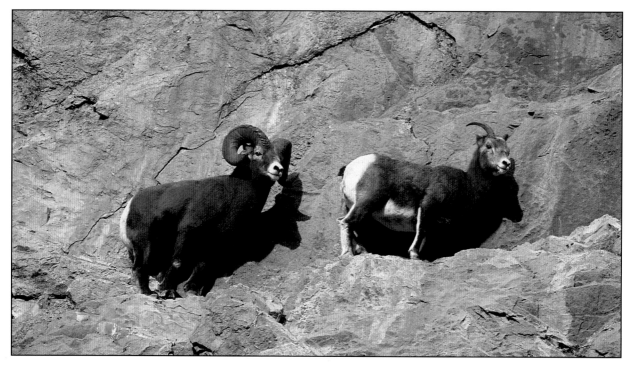

Big rams guard single females in heat. This normally takes place in cliffs where ewes, harassed by courting rams, try to find refuge.

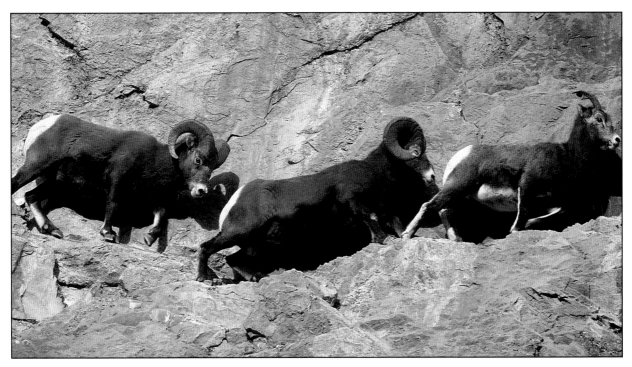

A young ram attempts to disrupt the "tending bond," by trying to barge in between the defending ram and the estrous female. Here he does not succeed.

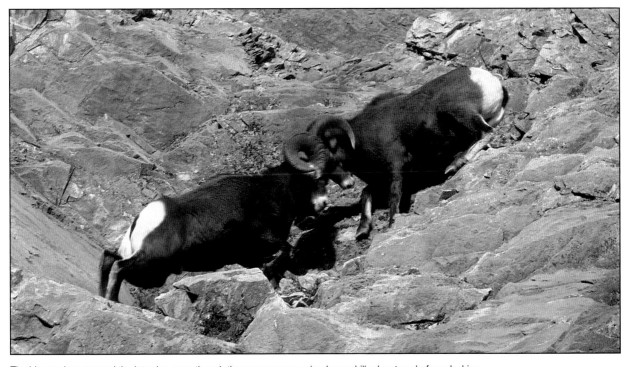

The big ram has stopped the intruder, even though the younger ram gained an uphill advantage before clashing.

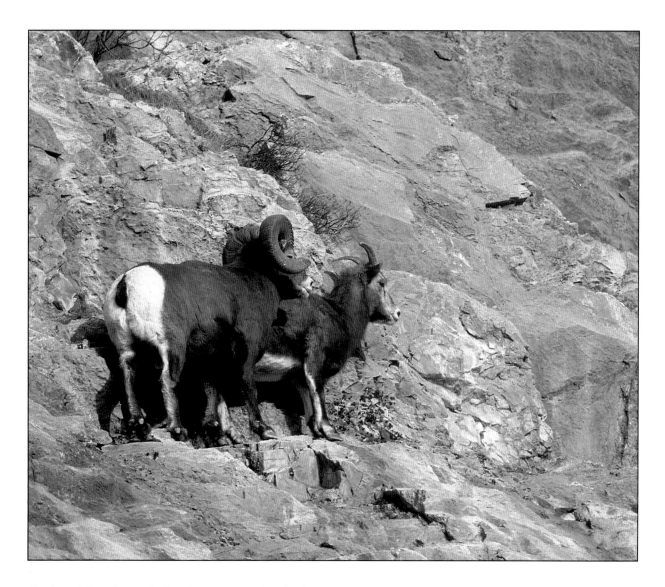

displays. Then he's "feeling his oats" and is fairly-confident about what he's doing.

The young ram has been chased off, and the big male continues to guard the estrous ewe.

 o o o

 Subordinate sheep also have ways of signalling so as to reinforce their status within the group. The subordinate will tilt its horns when slowly approaching the dominant. This indicates the subordinate's intention to horn gently the chest, shoulders, and neck—but above all, the face—of the dominant. As indicated earlier, by doing this, the subordinate impregnates itself with the scent of the dominant's pre-orbital glands. Thereby it becomes "one of the boys"; it assumes the scent of those that run with a group of large rams. Small rams horn and rub their faces on all larger rams, though they prefer the largest-horned fellows in a group. The body contact patterns used by the smaller rams are female mimicry; they are appeasement behavior and submissive behavior at once.

 Most of the signals one is likely to see in a ram band are displays and appeasement. However, the roles occasionally reverse. In the pre-rut and again in springtime, rams quite frequently play as a group. They may bounce and frolic across the slopes and cliffs, though most often one large ram races ahead, then tries to stop the others by blocking their way with its body while doing a very exaggerated present. The rams may then huddle in a tight circle, a bit like football players.

In such a huddle, small rams begin to act the part of larger ones, even to the point of mounting some of the largest rams and getting away with it. Watching huddles in spring, one begins to appreciate how very infatuated small rams are with big ones, and how much they pester the big boys with their attention. One small ram after the other moves in to rub faces with the large ram, to butt it on the head or horn its neck, chest, and shoulders. One also sees, occasionally, a big ram that has plainly had enough, and is trying to escape all the boyish attention. Most pestered rams succeed in their escapes and are later sighted alone. However, roaming gangs of small rams may find one of these detached big rams and take up its company, so it may be in for more attention.

Do sheep ever deceive? Do they signal "falsehoods" deliberately?

During dominance fights, they almost certainly do. These consist of rounds in which the challenger walks away from the defending ram, then, after a pause for feeding, suddenly turns and attacks, jumping into a clash. That, in turn, is followed by mutual presents and quite possibly mutual rounds of pushing with front-kicks. Then one or both rams walk away in low-stretch, only to pause, paw snow away, and feed until one suddenly jumps up and rushes in to clash. And so it goes.

The point of the clash, however, is to make the opponent lose its footing and throw it downhill. If that happens, the fight is over, and the ram that lost its balance concedes by acting like a female and accepting being treated like a female. To make the defending ram lose its balance, the attacking ram ought to catch its opponent off guard, just before it has readied itself to catch and neutralize the clash. Consequently, a surprise attack is most likely to succeed. That can be achieved by deceiving the defending ram about the timing of the attack. One way to do so is to fake normal feeding, then suddenly rise and hurl downhill in an attack. So the attacking ram, after parting in low-stretch, begins to feed, pawing craters in the snow while turning its back on the defending ram. The defending ram, in turn, begins to feed nonchalantly. However, if an observer happens to be close to the fighting rams, it's clear how, despite the apparent lack of interest in one another, the combatants are watching each other closely.

Fake attacks may be started by the attacking ram to test the defending ram's vigilance. In every case that I observed, however, the vigilance of the defending animal was excellent. The defending ram seemed to understand the "game" being played full well, and watched closely no matter how the faker uphill acted.

∘ ∘ ∘

What information sheep get from their sense of smell is not easy to deduce. Animals I studied were able to scent me at about 300 paces. They tracked me when I played hide and seek with them, indicating that tracking was familiar to them. Presumably they can track one another, even though it's not obvious. Smaller rams, as noted, impregnate themselves with the scent from the preorbital gland of larger males; they probably thus take on a group scent and can identify social relationships by scent, and can do so in the darkness of night. Females are able to identify their lambs by the scent of their anal glands. Presumably, the wiggling tail of the lamb when suckling fans this scent out to the female. Lambs may also get the scent of the female's inguinal glands when suckling. But how it is perceived, we do not know.

Overleaf: Rams often "huddle" in order to display to one another, and to exchange "front-kicks" and other minor insults. The rut is still some time away, so the rams are relaxed about being together. The clashes have a playful component, and young rams may even insult old rams without being punished. Being together in fraternal groups appears to be "fun" for bighorn rams.

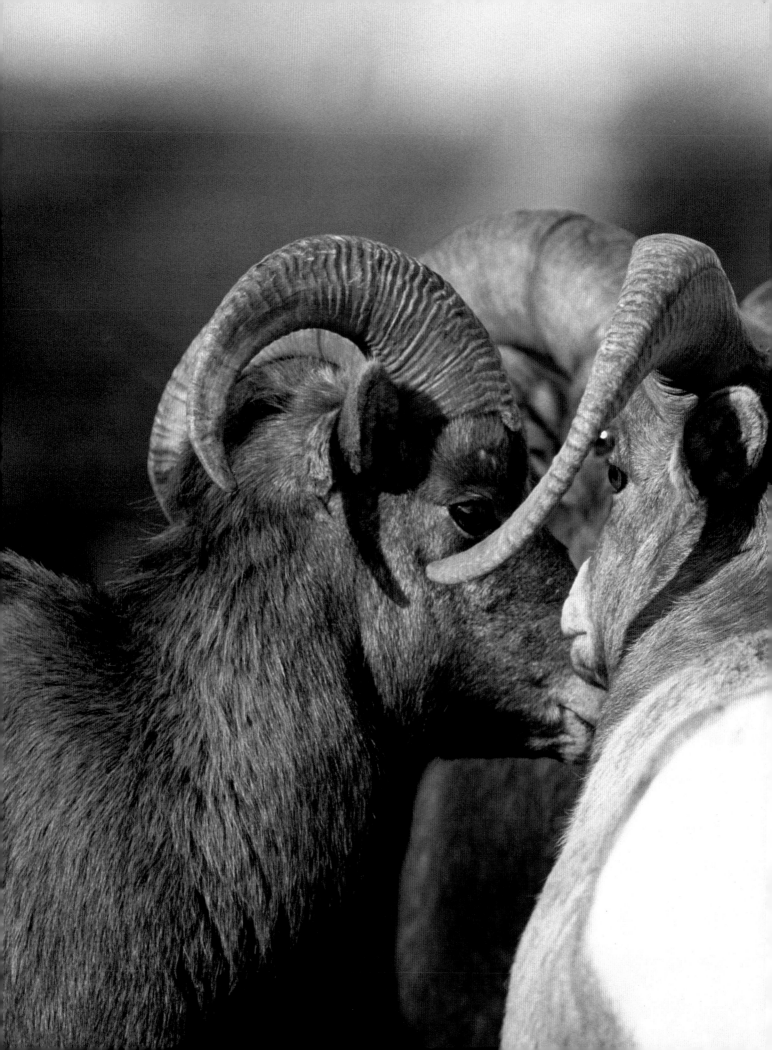

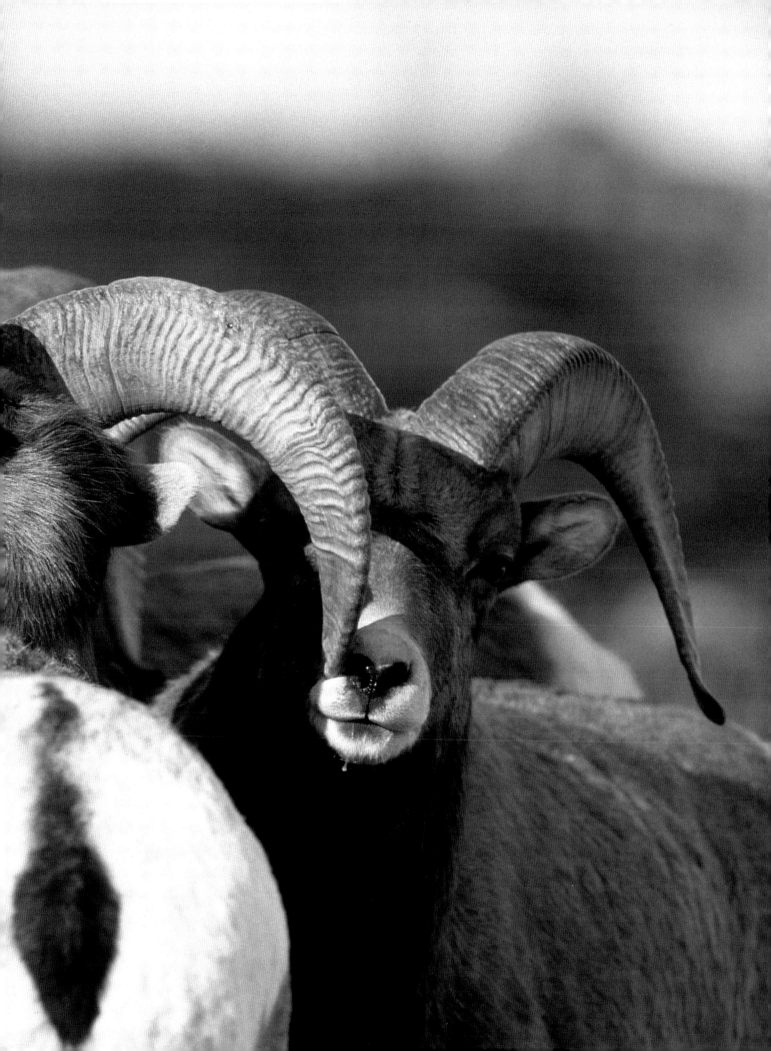

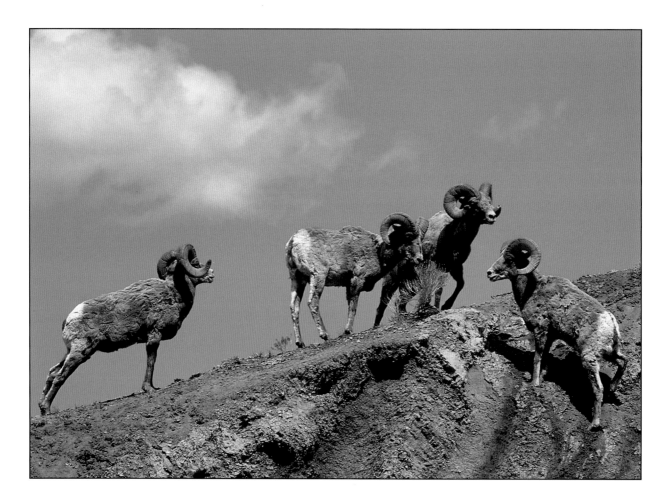

All in all, mountain sheep give the impression of being very visually oriented in their social behavior. Sound plays a rather subordinate role, as the vocal signals are rather simple and few in number. Observing a group of female sheep, one sees little beyond maintenance activities and a rare aggressive interaction. Rams interact to a much greater degree, and are totally involved with status throughout the year. Major dominance fights may, therefore, erupt whenever rams meet after a period of absence from one another or when a strange ram appears in their presence. The longest such fight I witnessed began on March 19 and did not terminate till the next day. That epic battle lasted 25 hours and 20 minutes.

Rams in spring at play. When forage sprouts and the bodies of sheep begin to grow again, play is commonly observed in the morning and evening. It may take many forms, but most commonly it leads to exuberant running games and clashing, in which dominance roles may be temporarily reversed.

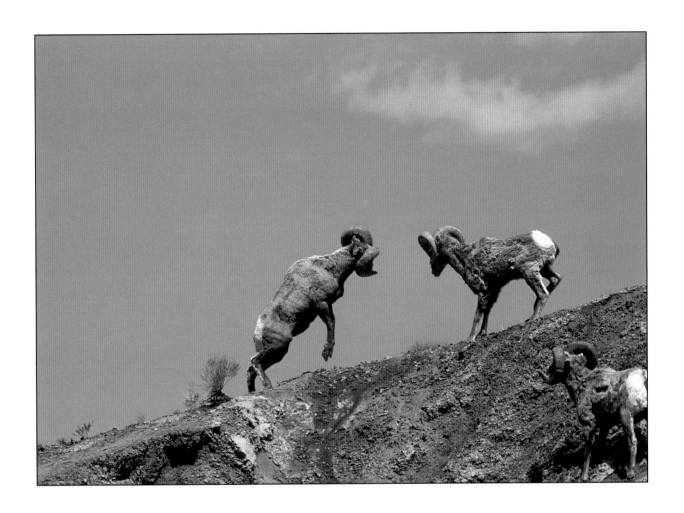

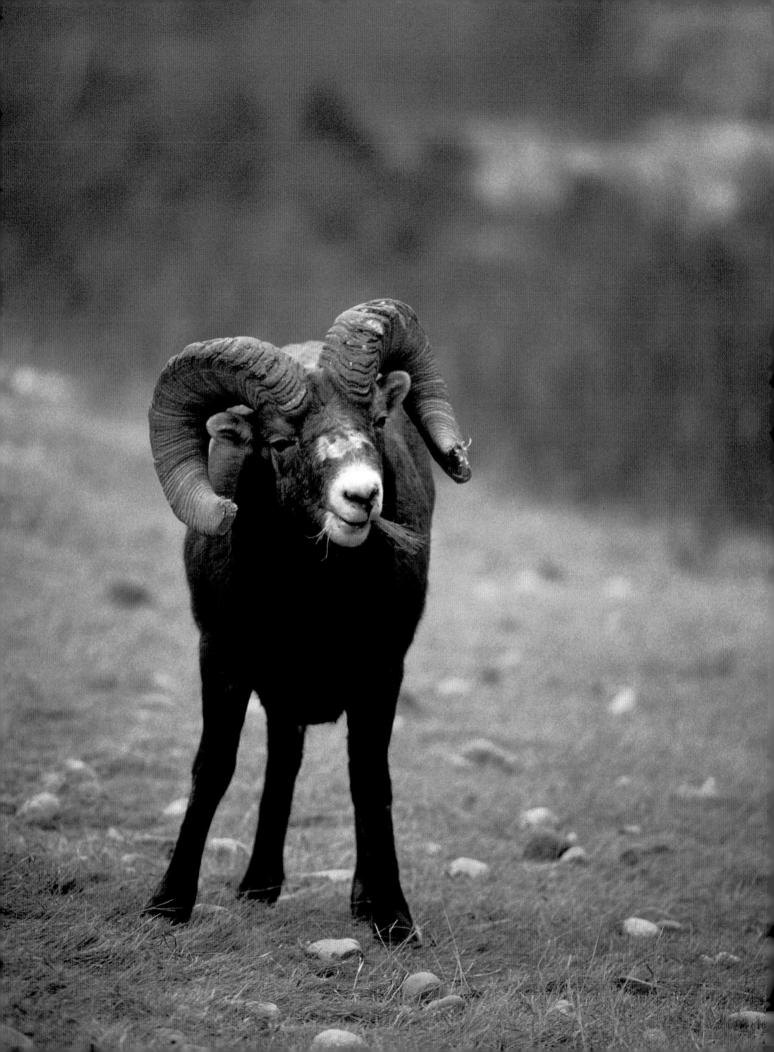

THE RUTTING SEASON

The rutting season is preceded by the gathering of rams in early fall. By then, the rams have grown their new hair coat, filled out their muscles, and refortified their depleted bones. Below their new pelage, their body and innards are covered with layers of fat, and they've added a segment of growth to their horns.

By then, too, the first killing frosts and snowstorms have already swept over the mountains. The rams are now feeding on the rich seed heads of alpine plants and on the dried leaves of willows and fireweeds. They may make long forays into the valleys to visit gravel outwash fans, where lesser creeks join larger creeks. Here they feed on the big umbels of the cow parsnip, a special favorite.

Mountain goats may do the same. For them, however, it's not very safe to do so, and the nervous goats show it. Their nervousness is not without cause, as I saw one morning when one of a group of five rams feeding on cow parsnip was killed by a wolf.

The gathering of the rams sees young and old come together from different summer ranges. For about six weeks they meet as a large congregation, after which they disperse, each moving off to its particular rutting area. The latter is a wintering area of females and young. However, until they disperse in late October, the rams join and engage in many tests of dominance, with little serious fighting. The range they gather on in September and October will be the winter range of a few of them after they return from the rut in late December or early January; there is a good likelihood that the same area will see another gathering of rams in April and May, before the rams disperse to mineral licks and summer ranges beginning in mid-June.

It is difficult to say why the rams go to this fall gathering on a range all their own, just as it is difficult to fathom why rams should congregate again in early spring. Is it for the sheer pleasure of being together, engaging in many huddles, and bashing heads in sporting brawls? Rams love to clash in play, or even to parasitize a serious fight by taking sides. Some can hardly wait to join in,

Some rams are ruffians. Their damaged horns and scarred faces tell the story.

Overleaf: The rutting season is preceded by the gathering of rams in early fall.

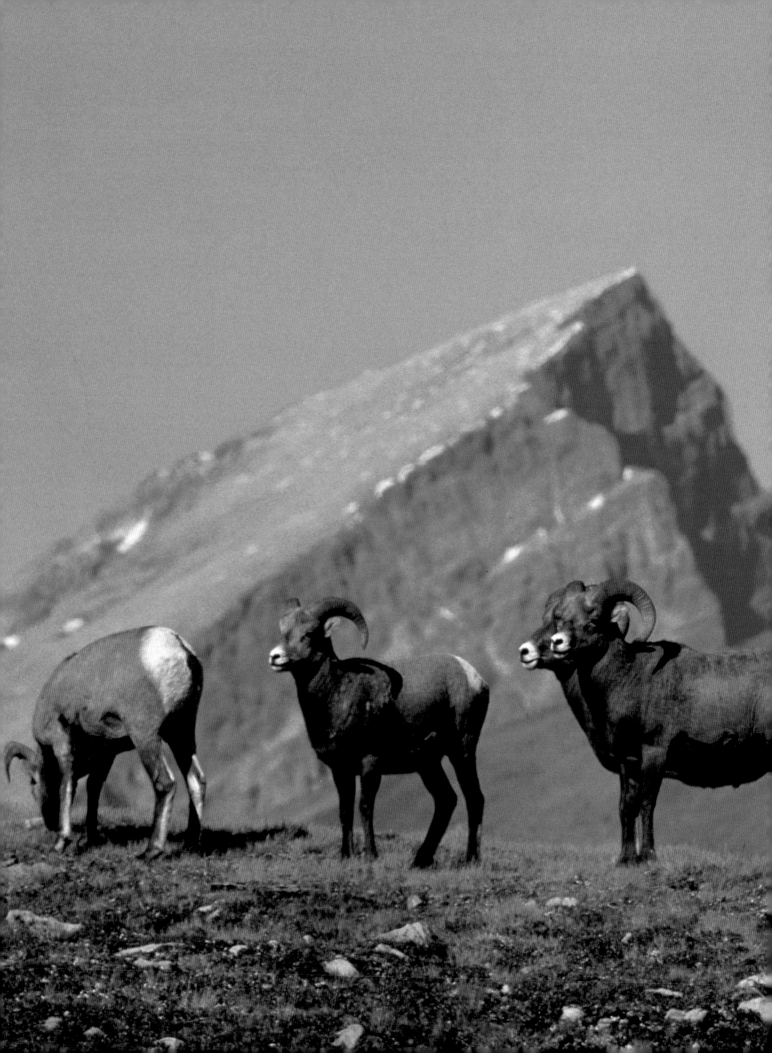

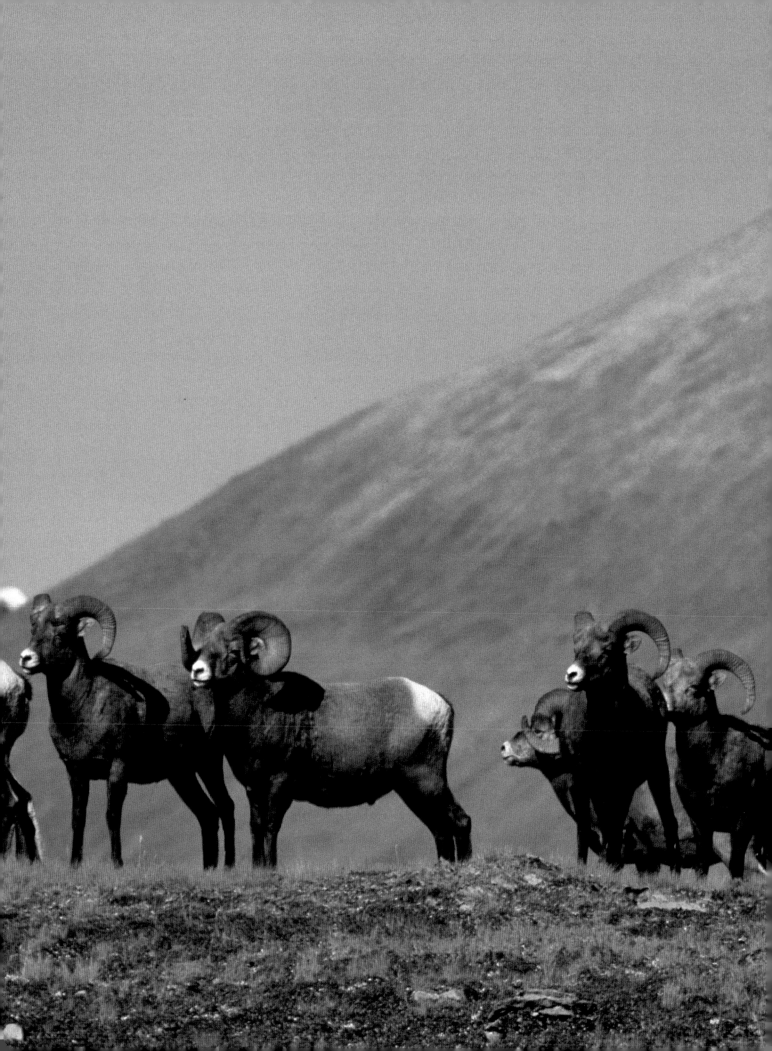

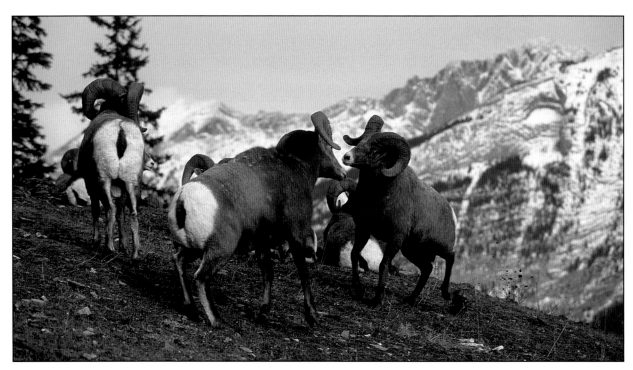

Fighting is great "fun." Rams may race to join a fight. Here the combatants are about to clash, each aiming at the other while their hooves make the soil fly.

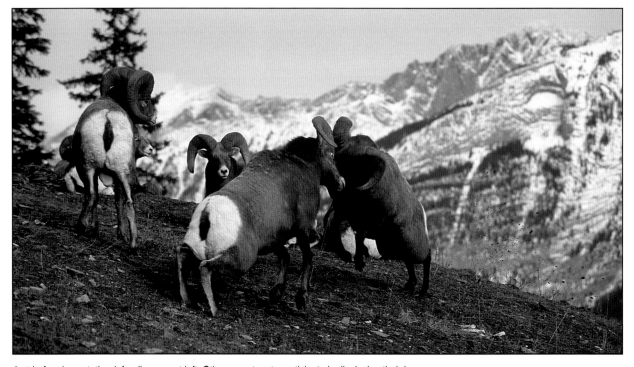

Just before impact, the defending ram at left. Other rams turn to participate in displaying their horns.

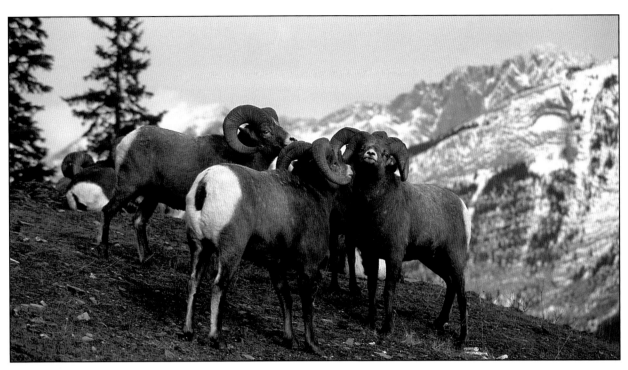

After the clash, the combatants and intruders all stiffly display horns in "present."

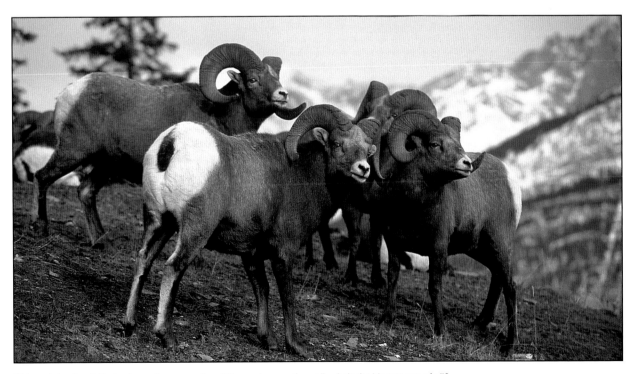

All have joined and display horns to one another. Mirror, mirror on the wall, who's the biggest one of all?

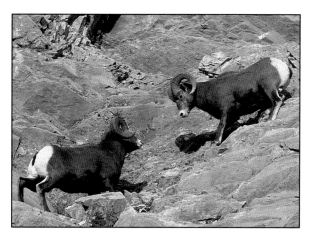

Fighting can lead to tragic accidents. A full-curl and a three-quarter-curl challenger engage on a steep cliff.

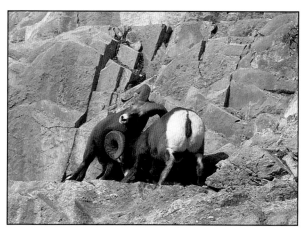

In this clash they slipped, and at once began wrestling. They locked horns accidentally. The larger tried to flip the smaller over its back, but lost its footing. Both (see photo at right) plummeted to their deaths.

running hard when they see two combatants clashing in order to participate in the melee. Big rams appear to have a distinct liking for brawls, for I have counted up to nine extracurricular rams getting in on a dominance fight involving two others. Rams may just be attracted to the "good times" and "sport" in the absence of serious dominance strife. Huddles have, after all, a distinct element of play.

At the same time that rams move from their summer ranges to their pre-rut gatherings, the females are vacating the summer ranges and appearing on the winter ranges. They may appear rather hastily, such as during massive early-fall snowstorms. The range chosen by female sheep and female goats in early fall is, inevitably, also a rutting range come early winter. Then one may see mountain sheep as well as mountain goats travel single file to specific wintering areas. Rarely, one may see a single file including both species moving along in deep snow. Mountain goats may be uneasy about the mixed-species arrangement; compared to mountain sheep, mountain goats are a nervous, insecure species.

In the last days of October, the rams disperse

A small companion looks down at the dead combatants. The small ram later climbed down the cliff to examine them more closely.

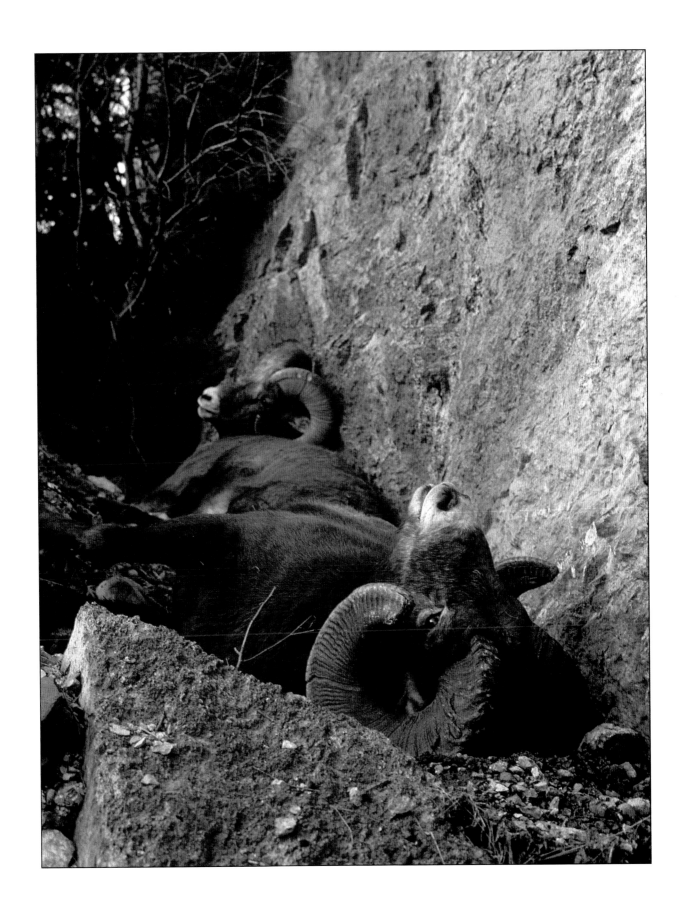

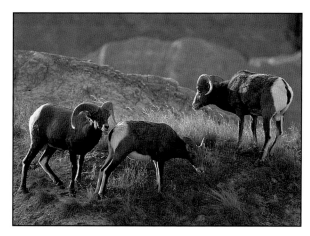

Rams roam about during the rut, testing females wherever they find them.

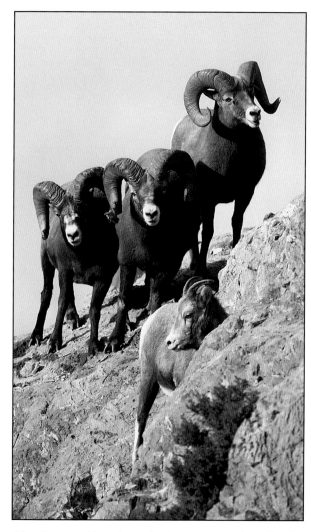

A female approaching estrous attracts many eager suitors. She tries to escape them in the cliffs.

singly or in very small groups to different female ranges, where rutting will take place. This happens about a fortnight before the first ewe is in heat. During that time, the rams meet strangers or other rams they have not seen for months, or even for a whole year. Dominance relationships need to be worked out, and the fights are likely to be serious. Canyons may literally ring with the clashing of horns.

The timing of the rut in mountain sheep, as in other north-temperate ruminants, appears to be set by the day-length regime and triggered by declining day-length. However, the date of rutting is a function of optimum birth timing minus the length of the pregnancy period of the female. Lambs need to be born close to the season of sprouting vegetation, so that the female sheep may convert a maximum amount of nutritious forage into rich milk for the small lamb. Over much of our mountain country, this optimum birth season is close to the end of May. The mountain sheep's gestation period of 175 days—a long one as far as sheep go—is nevertheless shorter than that of comparably sized deer. Due to the relatively short gestation period, the rut of mountain sheep happens late in the year; females are in heat from late

November to early December. As noted earlier, this does not apply to desert sheep, because populations births can occur during any month of the year in some bighorn populations.

When the rams appear on the female ranges, they scout out all localities that hold ewes. In the process they court ewes, in essence asking for a urine sample from each. Thereafter they test the urine via the lip-curl and move on. There is no competition among the rams for females not in

heat. Large and small rams all court freely.

About three days before a ewe comes into heat, one notices a change. A big ram seems to hang around one particular ewe. That's an indication that the ewe in question will soon be in heat, and the tolerance of the large ram guarding the ewe will soon come to an end. Only the estrous ewe is defended by mountain sheep. They do not defend harems as do the giant sheep, the argalis of Central Asia, including the Marco Polo sheep. Argalis are found in more open terrain and less frequently in cliffs than mountain sheep. In their habitat, argali rams can easily over-view, herd, and control a harem, something quite impossible in the steep, broken cliffs where female mountain sheep head when they are being pestered by rams. In short, visibility is a real problem in broken, steep terrain, and this mitigates against anything but keeping track of one female in heat.

As estrus approaches and the attention from rams becomes more persistent, the female flees into cliffs or forest or both, in an attempt to shed the pursuing rams. Here the ewe may perform a variety of maneuvers to discourage pursuit, including backing into a crevice or, in the absence of a handy crevice, pressing its rear against a cliff-wall. The ewe might also turn on a very narrow trail and, while confronting the pursuing ram, block its path.

When the ewe runs through the cliffs, it attracts the attention of rams, and soon there is a small group in pursuit. Now the largest-horned male not only follows the female and tries to court her, he also charges the pursuing rivals and may smash into them if successful. Every so often, one of the lesser rams succeeds in getting behind the ewe while the larger ram is occupied chasing off a rival. The smaller ram pursues the ewe and attempts hasty mountings. These mountings tend to be thwarted by the ewe's quick evasive actions, or by the returning big ram itself, which blasts the smaller one off the ewe. Rarely, the lesser male may succeed in chasing the ewe into a hidden spot where the large male has difficulty finding them. In that case, the young male may celebrate an orgy of successful mountings.

The very large testes of the rams appear to have an explanation. These are required in order to produce sperm in massive amounts, to allow for the many ejaculations that lesser rams have opportunities to perform when chasing and mounting contested ewes. Such chases are very frequent during the three to four weeks of the rut, and brief mountings by lesser rams—when they get the opportunity—may pay off reproductively. The lesser rams certainly contend for such. Rams of all age classes compete, though yearling rams are noticeably less engaged than the others. In total, about three-quarters of all mountings of estrous ewes are performed by the largest-horned rams.

If a very large ram defends an estrous ewe and only three to five rams are contesting, then the large male establishes control quickly and the scene is rather peaceful. The lesser rams hang about the mating pair, feeding, resting, looking on, but interfering little.

If the country is open, however, and a large number of rams are attracted to an estrous ewe, and the difference in horn size between the contestants is not great, then the situation is unstable. That is, the defending ram is often contested. While it is warding off one challenger, another ram may chase off the ewe, followed by the large string of rams. The next largest ram, however, will also have difficulty, and can lose the ewe to a subordinate while confronting a challenger. In the meantime, the first defender of the ewe returns and tries to catch up with the string and displace the lesser ram now running after the female. And so it goes. The ewe has little or no rest till her estrus period is over.

One year in Banff National Park, there were a

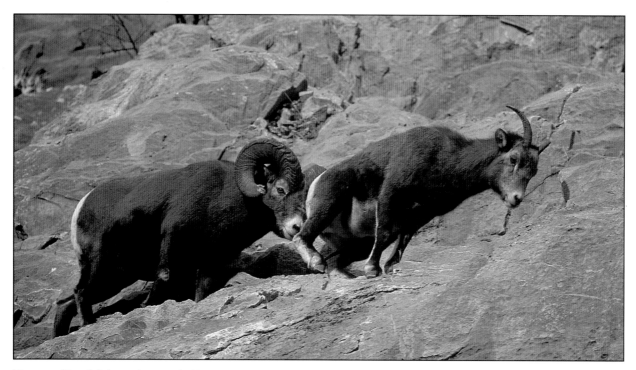

The courted female in heat urinates to the big ram.

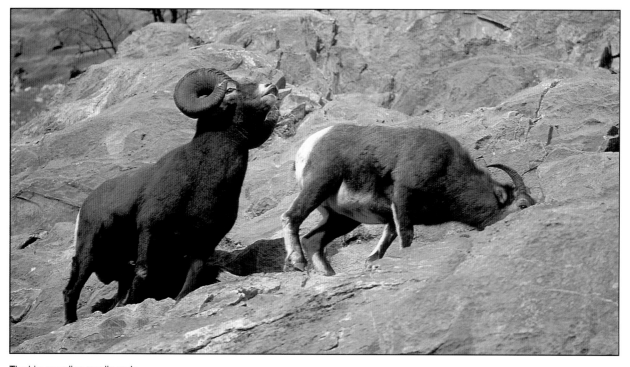

The big, guarding ram lip-curls.

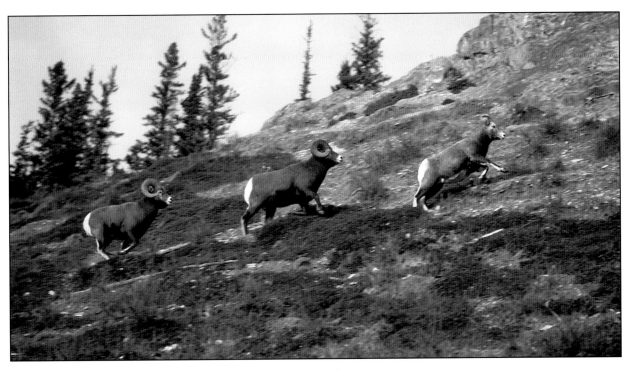

The estrous ewe flees into steep, broken rocks with her suitors in close pursuit.

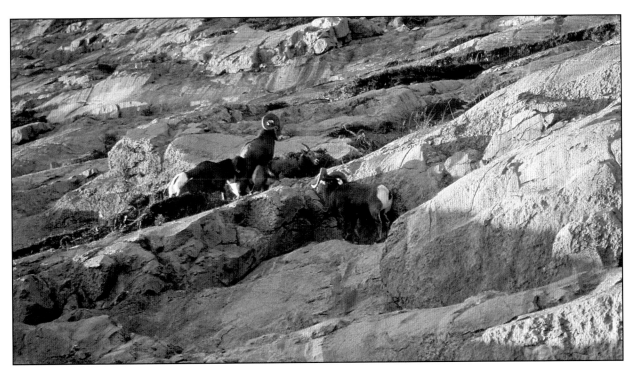

A smaller ram managed to mount, but the big one blasts it off the female. The bodies of rams must be able to withstand the severe punishment dished out when large rams protect "their" ewe.

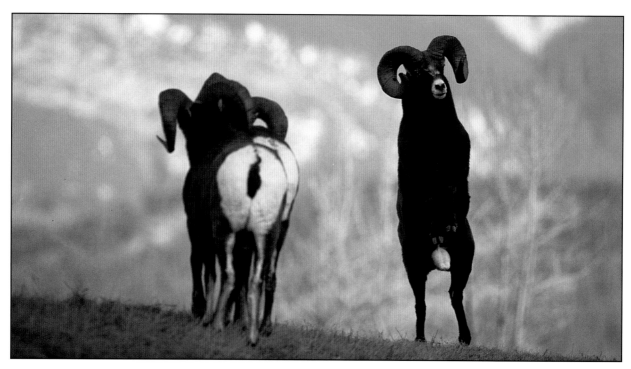

A clashing ram exposes the very large testes of mountain sheep. The testes evolve when many males compete for females and copulate frequently. Then it matters whose sperm meets the egg at fertilization. The more sperms that are ejaculated, the greater the chances of fathering an offspring.

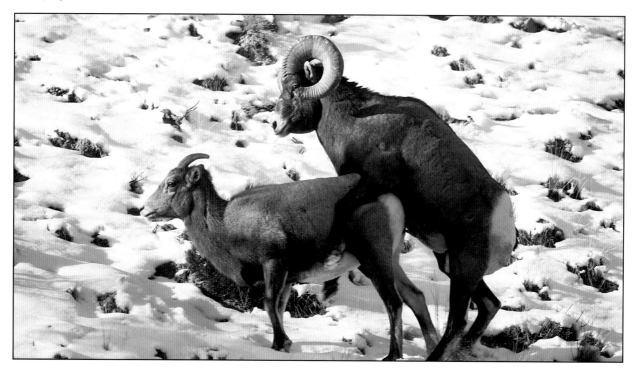

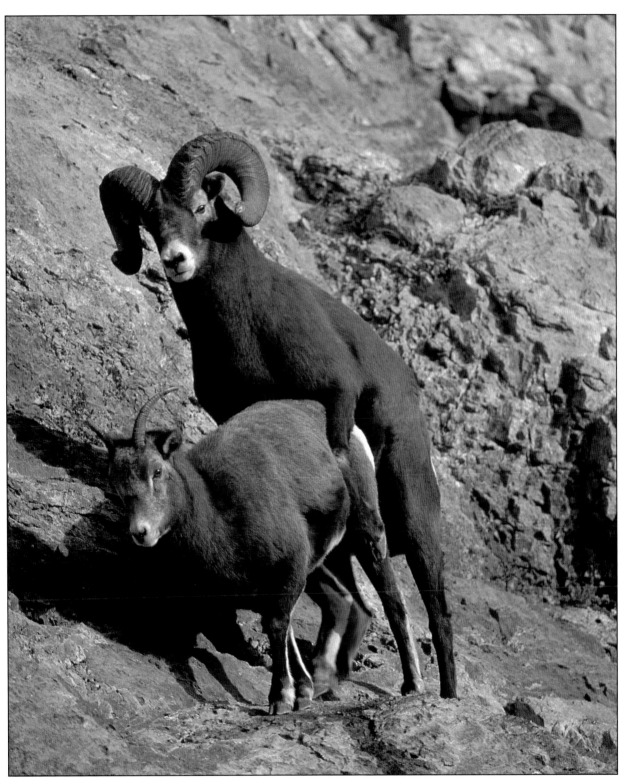

The estrous ewe is receptive for about a day, during which she copulates frequently and may even court the exhausted ram. A day later, she may fight the same ram off, along with other suitors.

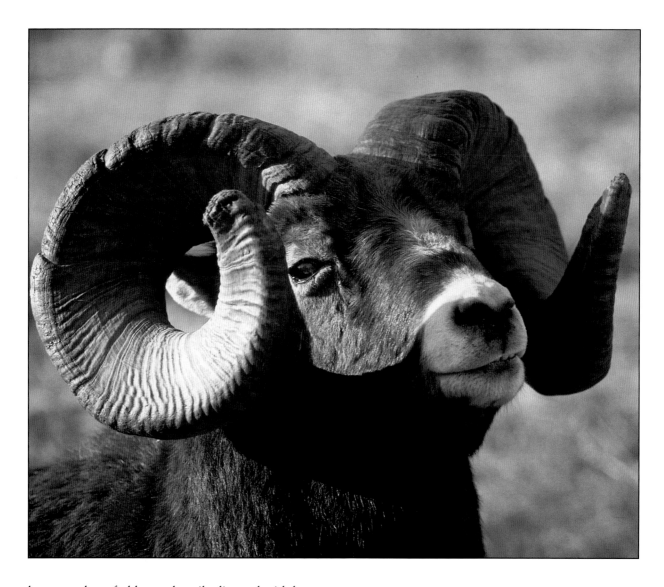

large number of old rams heavily diseased with lung worms. Rams become infected with these parasites early in life and defend themselves physiologically against the worms by walling them off within their lungs. Here the worms are trapped and die, encapsulated by thick layers of scar tissue. The cost of encapsulating the worms is, of course, loss of lung elasticity. Consequently, an old ram with a badly damaged lung may not be able to get much air, no matter how hard he breathes. He cannot exert himself because he'll quickly run out of breath.

Such rams, large-horned and massive in body, were present in Banff during one of the rutting seasons. They behaved very differently from normal rams, yet they acted with deadly logic. They were perfectly aware that they could not run far. They never tried to. While the young rams ran

Big rams are calm and deliberate, even when it comes to breeding. Here, an old fellow is surveying the scene before calmly moving in and taking an estrous ewe from a subordinate ram.

themselves to frazzles chasing near-estrous ewes, the old rams fed, rested, and watched. They chased no estrous ewes, but they watched closely. Only when a ewe had been chased to a standstill did they quit feeding, calmly walk over, and displace the small guarding ram. The old rams displaced the young ones without really trying, as the youngsters left upon their approach. Then these big rams proceeded to breed the estrous ewe again and again. The big rams, though short of breath, racked up almost as many copulations as did large rams in healthy populations. It was impressive to

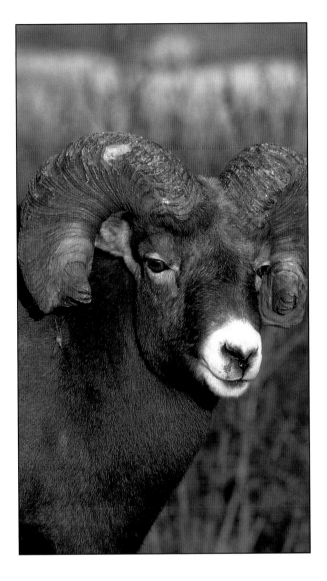

Ruffians may severely break their horns in combat, but the fighting habit dies hard: This old ram has a fresh chip knocked out of what is left of his horns.

They not only exert themselves, but they quit feeding while alertly guarding the ewes. In addition, they accumulate injuries during the many contests, injuries that have to heal during the winter. This must be an additional drain on the body resources. We do not know the precise cost to sheep, but the healing of internal bruises, large hematomas, and even broken bones is known to be costly. All this adds up to make rutting a costly event for dominant males—so costly, in fact, that it curtails their life expectancy. Thus, exceptionally well-developed rams that become dominant breeding rams early in life because of their large body and horn size also die early.

Small-horned, poorly developed rams, conversely, tend to live a long though rather frustrating life. Some begin to associate with and beat up small rams, as they are totally unsuccessful with rams their own age. They jealously watch for every opportunity to thwart small rams, and they were the first to confront us when we studied them. They were also quick to interfere in a dominance fight we witnessed between younger rams, smashing hard into the body of one of the contestants when it rose to clash. They are social and reproductive failures, and dangerous psychological cases to boot.

Large-horned, dominant rams are fairly calm individuals that have been forgiving toward myself or my students when we met them over the years. What troubles we had with rams overstepping the species boundary and attacking or displaying to us humans were from poorly developed, socially insecure males.

A spectacle that is not commonly observed is the ram's courtship by an estrous female sheep. It happens when a single ram guards the ewe somewhere in a secluded spot that roaming rams do not find. The large ram may then be so calm as to forgo courting, and the ewe takes over. Here the ewe's strategy is to excite the male into mounting. She uses diverse activities: rubbing her body along

see the rams make such well-calculated moves that effectively compensated for their disability.

Moreover, these rams with reduced lung capacity apparently lost little of their stored body fat during the rut and survived well in winter. They reached astonishing ages. The oldest I knew, tagged with a metal ear tag as a four-year-old, must have been 21 years old when I last encountered him. Rams as old as 16 years were common in this group.

Normally, breeding rams deplete their energy stores—that is, their fat deposits—during the rut.

Exhausted from the rut, a large bighorn ram takes a well-deserved break from it all, leaving the ewe to younger rams. After a snooze, he may reclaim her without a fight.

the ram's chest, butting him, horning his chest, neck, face, and horns, or even threat-jumping to him on two legs, as if attacking in a dominance fight. The strategies were, in all cases I observed, quite successful.

At the end of the rut the large rams are quite exhausted. They rest by themselves while the younger rams are still testing for estrous ewes. The young rams continue testing ewes in greater or lesser intensity throughout the year. I have even filmed a full-fledged copulation by a half-curl Stone's ram on a two-year-old ewe in May.

That female was a particularly attractive one to the rams, and was singled out for attention again and again. Time of year did not seem to matter. Whenever the rams saw "Bonny," they made a beeline for her, low-stretching all the way. The equal-aged ewe, "Blacky," which accompanied and dominated this sex-bomb among female sheep, was routinely bypassed by the rams. When I last saw Bonny on my final visit to the Stone's sheep study area, she and Blacky were still together, but Bonny, then five years old, had a handsome lamb in tow.

A frosty fall morning condenses the breath of a bighorn ram.

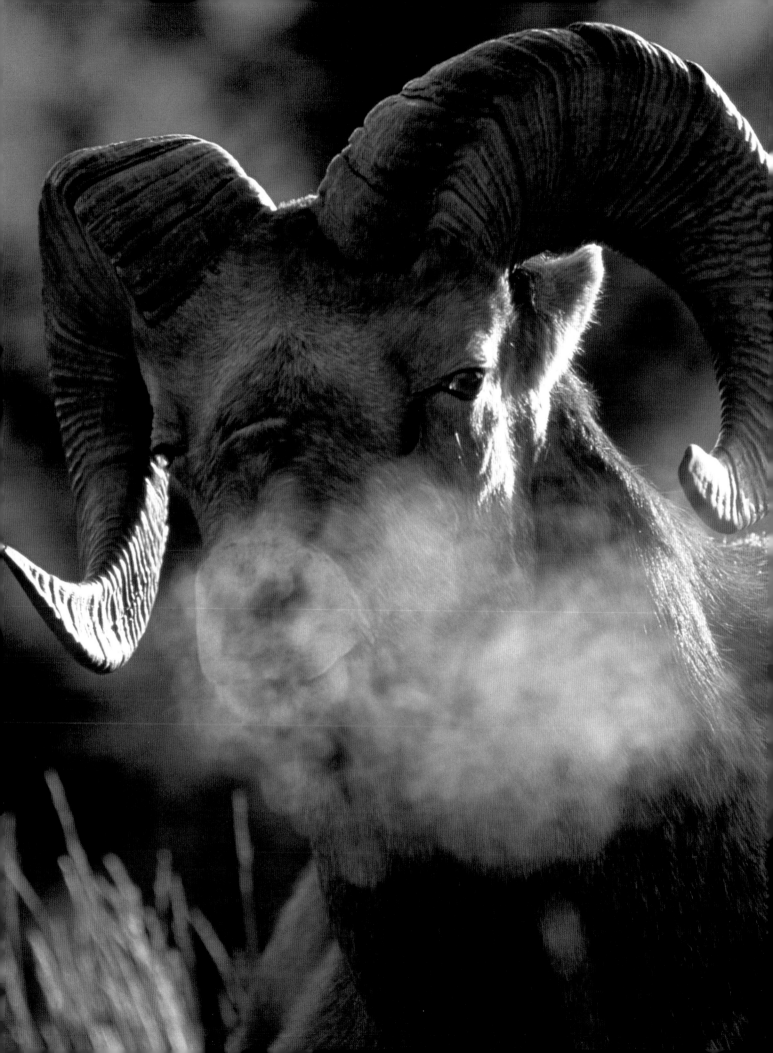

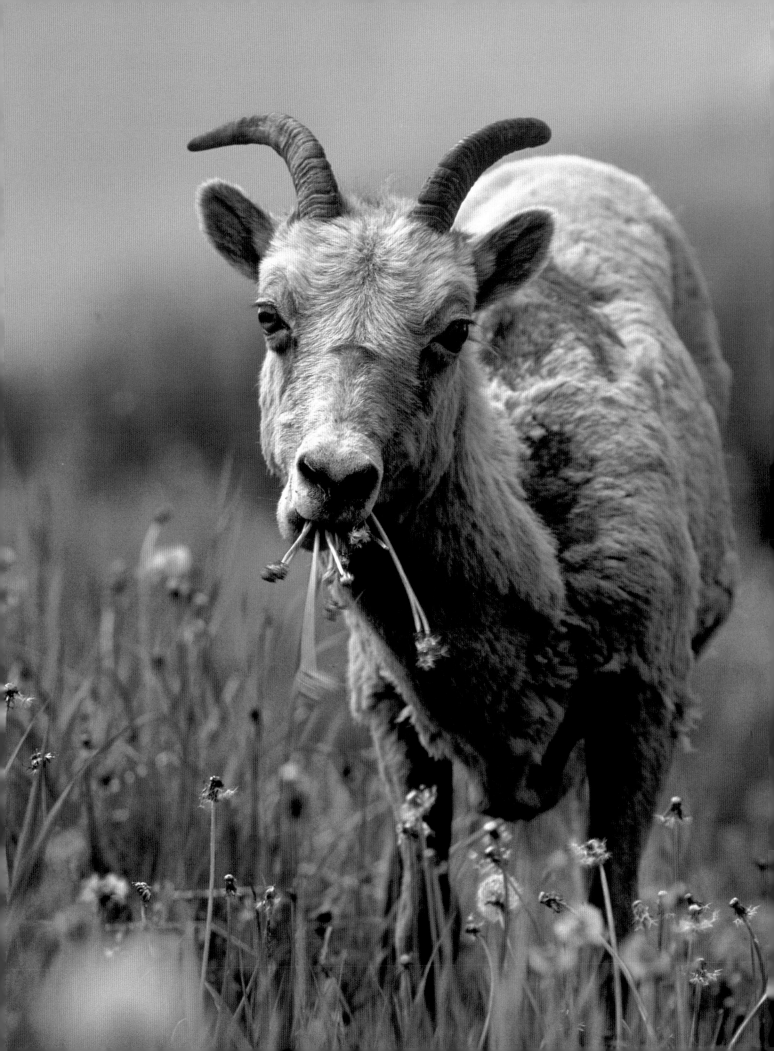

TAME MOUNTAIN SHEEP

Habituating wild mountain sheep to human presence, so that the animals fearlessly accept an observer in their midst, offers excellent opportunities for scientific research. It also opens a window for the student of sheep behavior to peer into the bighorn's "soul," and to begin to understand the way sheep see the world about them. From a research perspective, some operations that are normally difficult, costly, and upsetting to animals can be handled without much fuss with human-habituated sheep.

Tagging is a good example. Marking mountain sheep with small, numbered metal tags attached to their ears can be done without drugging, manhandling, or even upsetting the sheep. It can be done by letting the animal lick salt from one hand while your other hand maneuvers the tagging pliers and tag into position. When the tag is positioned over the ear, you clamp down and instantly release the pliers. The sheep, feeling the tag pierce the ear, jumps back—but returns right away to lick the salt. One must be prepared, of course, for the backward jump, and instantly release the tagging pliers. That way the sheep's ear is not torn.

Compare this procedure with chasing the animal by helicopter, shooting a net over it, wrestling it to the ground, tying it up, injecting it with drugs, and finally releasing it before it is competent and able to act normally. In addition to the risk of mortality from accidents and improper drugging, the animal may be damaged by what is called "capture myopathy" and die several days later. Capturing and handling wild animals is always risky. Often it cannot be done except by trapping, drugging, and use of physical force. But our bighorns taught us that there is an alternative.

Even small lambs can be picked up for tagging without causing them or their mothers any alarm. You hunch down beside the female while she licks salt in one hand, extending your other hand to gently rub the lamb. Then you place your extended hand under the lamb's chest and belly, and lift it gently into your arms. You can then place the tag in the lamb's ear. It does not struggle or bleat, and mom goes right on licking the salt, although she watches your every move. Tagging done, the lamb is gently placed on the ground, and the bighorn's trust in humans remains unclouded.

Sheep feed selectively. Here, a bighorn ewe eats dandelion flowering stalks with their nutrient-rich seed heads

The tags can be read by gently freeing the hairs from the ear tag after conditioning the sheep to having your hand on its face while it receives the salt it desires. This takes a bit of skill and tact, but the sheep soon understand that they can only lick salt if your hand is touching their face and, especially, their ears.

Sheep learn to accept as harmless the humans they see day in and day out just beyond their flight distance. As long as the human does not act like a coyote by trying to fixate them with a stare or by stalking them, they do not mind closer approaches. Eventually the sheep will get used to the observer and pass on to the next phase—investigating the human. A sheep so inclined suddenly steps up to the observer, sniffing and licking him and pulling on his boot laces, clothes, and equipment. A piece of salt extended to the sheep is sniffed at, then licked. Now the sheep is hooked. It can be that simple.

Little problems do arise. While sitting down and changing film in my camera, I've had a sheep's snout suddenly appear over my shoulder, the sheep then grabbing the film in its lips and pulling it out of the camera. And I've had several sheep crowd around to sniff, lick, and nibble my camera and hands while I try to safeguard the film. Elbowing the crowd away did not always work; once they're human-habituated, bighorns can be persistent and pesky. I finally began climbing into trees to change my film—and thumbed my nose at the horned crowd watching from below.

Once a young ram comedian gingerly lifted my camera out of my open backpack and dropped it down a scree slope. I watched it bounce downhill, then recovered the pieces nearly a quarter of a mile below. The culprit stood and watched.

One day a band of sheep I was studying followed me as I left the slope to return to my cabin. "That's okay," I thought. "They'll go back once we are in the timber." They did not go back.

Rather, they clustered about me and made body contact. I walked with a female sheep's face sticking out from under each arm. They went wherever I did, and made not the slightest attempt to return up the mountain. There was nothing else I could do but turn around and march them back to the open slope where they belonged. They were utterly and disarmingly trusting.

I learned to break away suddenly and run from the sheep. That startled them a little. They stood and watched me disappear into the timber below without following. This method of disengagement usually worked well. However, on a few occasions a ewe sprinted past me and, while running, turned in front of me, made body contact, and pushed me back. She was trying to prevent me from leaving! That's what lambs do when they are trying to stop their mothers in order to suckle milk. Here, adult female mountain sheep transferred this behavior to me, treating me as if I was their mother. No wonder sheep were the first mammal domesticated by Neolithic people—after the dog, that is.

I gained insights by playing an occasional game of hide and seek with the mountain sheep. If I ran from a band of rams into a strip of timber in a draw that extended up the slope, they usually would not follow me blindly. Rather, they would cross the strip of timber high above, stop, and look intently down the slope. They were trying to find me where I should have been had I continued in a straight line through the timber. They formed a perfectly logical spatial hypothesis about my whereabouts, then went and checked on it.

Is this an ability they have mastered in order to escape wolves and other predators?

I have seen rams follow wolves for long distances along mountain slopes and ridges, keeping the wolves under surveillance. When in the company of sheep, I've seen them visually track coyotes and wolves. When wolves disappeared

Bighorn sheep tracks in wet sand. Note that they are pinched in laterally, distinguishing them from deer tracks

into willow and dwarf birch flats, the sheep acted as if they were still tracking the predator visually, although I saw nothing of it even with my binoculars. The sheeps' noses told me of the wolf's position and—lo and behold—when it crossed a clearing, the sheeps' noses were always pointing to it. Did they see the wolf's movement through the shrubs, or did they track him mentally? I really don't know.

On a few occasions, I was skillfully tracked by the rams I played with. The rams retraced my tracks across dry slopes with cured grasses, step by step, nose to the ground, until they found me in my hiding place at the timber line. Their pace during tracking was fairly quick, which seems to indicate a good sense of smell. Yet I never saw bighorns track anyone but me. That is, unlike rutting buck deer, which routinely track does, rams did not appear to follow the tracks of females—at least not conspicuously so. A few times they found me by testing the wind currents; they could smell me from at least 200 yards away. Sometimes, when the rams failed to find me, they broke out into brief "frustration fights." They would search for me on occasion for close to half an hour.

To my surprise, sheep failed to see me if I sat in a tree, even when they passed only a couple of feet below me. A cougar, presumably, would also be missed in a tree. They could smell me, though,

A petroglyph from California. It appears to show a mountain lion attacking a desert bighorn.

and searched with determination, but looking up was not in their normal repertoire of behavior—the exception being when I climbed a tree to change the film in my camera.

My study sheep recognized me by my voice, even by my sneeze, and would rush in through timber to meet me. In the open, they would sometimes run to meet me from more than 500 paces away. That can be most impressive, especially if the group consists of big rams. After we were engulfed by a herd of big rams one sunny winter day, a good friend of mine who is a famous field ethologist confided to me that if his snowshoes had not been stuck under a downed log, he might have run away. The rams had come storming down on us in a cloud of flying snow, a grand spectacle for sure. They surrounded us, all eager, bright-eyed, and frisky. Such a cavalcade can be daunting when experienced for the first time, particularly when some of the rams whirl onto their hind legs to clash into the rams that follow—all in good sport. When reared up on its hind legs, a bighorn ram towers over any man.

The bighorns allowed me to inspect their bodies and even to remove ticks from their well-scarred withers. They were, however, ticklish, and a gentle dig with the finger behind the upper fore-leg made them jump. They did not cherish being touched. When I had no salt to give them, the

Cougars occasionally kill mountain sheep.

sweat on my arms would do. They have soft tongues, and while they nibbled my hand, they could press with their jaws without biting. They could, however, draw blood if they managed to pinch a bit of skin between the sharp incisor teeth in the lower jaw and the rubbery palate in the upper jaw.

Previously, while studying Stone's sheep, I had dressed myself in white overalls and wrapped a white towel about my head. It seemed to work, even with the spooky mountain goats, provided that I approached them, partially covered, from above. The goats would scrutinize me for some time, but they would soon settle down and ignore me, even when I was exposed at distances of under 20 paces. They also ignored the noise of my movie camera. In this attire, I also approached Stone's

sheep without difficulties. I suspect that my white attire, however, had little to do with their acceptance. The sheep had simply become habituated to my presence, and my attire was probably irrelevant. A clown's costume would have done as well.

Friends who have studied antelope in Africa have expressed surprise again and again at how very tame our bighorns, elk, moose, deer, and even mountain goats become in national parks when they are in frequent contact with humans. My friends were especially fascinated by the northern mammals' ability to adjust their behavior on the

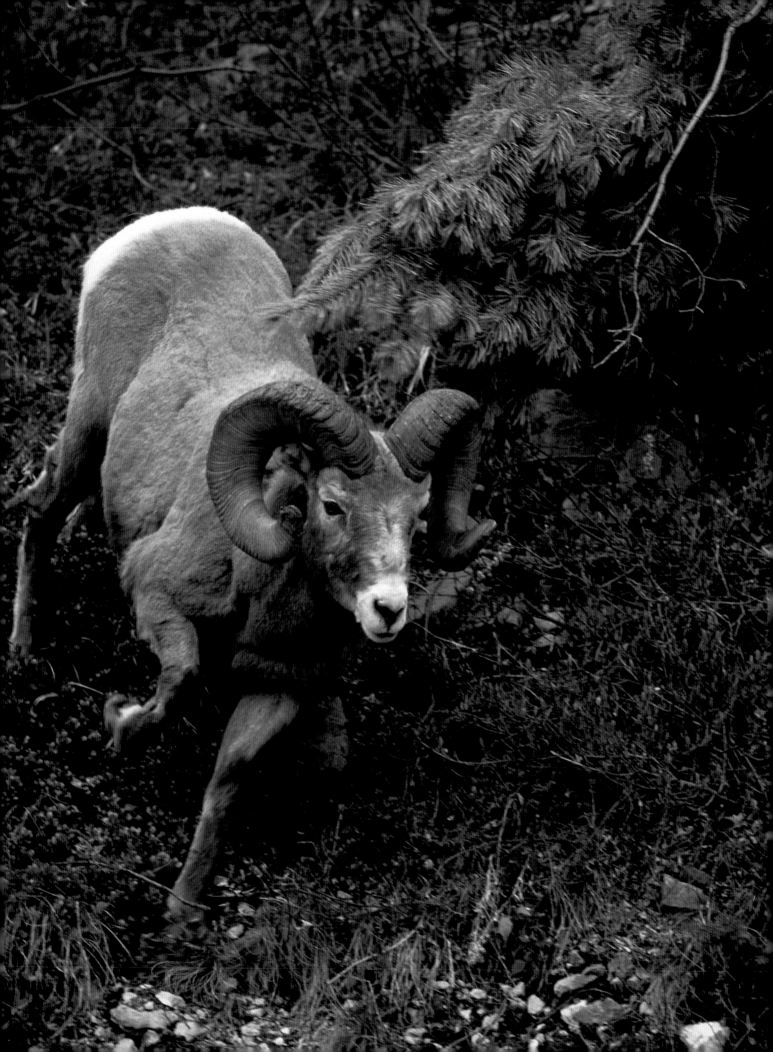

basis of experience. We take deer, elk, and black bear for granted in our North American national parks. But tropical and subtropical antelopes and deer tend to flee humans, even when the animals are carefully protected in national parks, as if they are incapable of putting experience to good use. They appear to be hard-wired in their security strategies. However, such African mammals as gorillas and chimps can be totally habituated in the wild, and African buffalo bulls are notoriously tame on the lawns around park warden stations.

There is, however, a risk associated with working with human-habituated animals in the wild. The risk is that the animal may "test" the human. This happens when an otherwise thoroughly tame animal suddenly decides to test whether the human being can be dominated. The

Mountain sheep have relatively large brains and learn the vital elements of their environment readily. They quickly discover when humans and their machines are harmless, and therefore quit running from them. They may even exploit humans to their advantage. This is why mountain sheep become totally tame where protected in national parks. For sheep to become tame is natural!

test is most likely to be performed by a large male that has, to this point, seemed to ignore the human.

I know of two cases in which humans were tested with dominance displays by mountain goat males. Both of the parties wound up in the hospital. With large animals such as elk, moose, or bison, there is no proven way a human can handle a "test" by a large male. The only safe approach is

to know what dominance displays look like and what they signal, and to stay far enough away to avoid any chance of being tested. In short, unless there is a way to handle an animal that may decide to test the human, it is best to never get too close, and to walk away when in doubt.

However, attacks may also be triggered when a person runs from an aggressive animal. Running simulates flight, and by charging and striking a running person from behind, the animal reinforces its dominance. By turning one's back and running, an observer may thus offer an invitation to attack that is simply too inviting to resist. Eventually, this happened to me: I was attacked by a big ram.

It happened in late November, at the height of the rutting season. I was on a small plateau, near a large, densely packed herd of ewes and rams that were rather excited. In the tumult, I had a very difficult time reading their ear tag numbers; try as I might, I could not identify two tagged ewes that were strange to me. I could not attract them with a lump of salt because other sheep, particularly some big rams, cut in and took over.

When I turned and ran away as I had done previously, I felt the horns of a large ram brushing down my back. Glancing back, I saw the ram dive headfirst into the scree behind me. I stopped and turned, but still held a piece of salt in my hand, which the ram instantly began to suck. With horror, I realized that I had rewarded him for the attack! He had now undoubtedly made the link between clashing and getting salt. Another try at running away led instantly to another attack. Fortunately, the ram was aiming downward blows at the trailing edge of my parka, and his clashes missed my body by inches. On the third try, however, he might clash through, wrapping me around his horns.

I turned to the ram. Standing above me on the hillside, it was now "taller" than I was. It was even displaying to me, as if gloating that it had me

dead to rights. There was no way I could handle the ram from below. To keep him occupied, I let him lick the salt while my mind feverishly worked at how to resolve this dangerous situation.

As we stood there, other sheep surged in and lifted their heads to lick at the salt. They snuggled between the ram and me. That was my chance. I slipped the salt piece into the ram's mouth and left. He was too preoccupied sucking his candy to notice my departure. Moreover, other sheep blocked his way as I safely reached the timber.

Fortunately, the ram who attacked me died not long after our encounter. However, for the remainder of his brief life he demonstrated only too well what he had learned. When I appeared on the mountain, he would run toward me from over half a mile away. Within 200 paces he would rise in spurts on his hind legs, telling me with these threat jumps what he intended to do with me.

I handled him by stepping behind a sheep that was grazing. He would then run around us and rise to clash below me. However, I was then taller than he was; I could look down on him even though he stood on his hind legs. I acted utterly unimpressed, for a ram cannot forcefully clash uphill. In my uphill position, I was in control, and he—standing on his hind legs—began to grow uncertain. He would drop down, still displaying, then turn and begin to graze. This is what I waited for. I stepped toward him forcefully. He evaded, stepped a few steps forward, and quickly grazed again. He was now psychologically defeated. It was perfectly safe to be around him again—for that day. The next day we had to repeat the process all over.

A friend of mine was not so lucky. He was walking along a sheep trail on a very high ridge. A large boulder protruded from the ridge, beyond which the ridge dropped off as steeply as a cliff. As he rounded the boulder, this very ram appeared. The ram rose instantly and clashed into

my friend. When he regained consciousness he lay at the edge of the abyss, with the ram nowhere in sight. Fortunately, this was the last time the ram was ever seen.

We had learned a bitter lesson. This big ram had become a touch too familiar, and an unfortunate circumstance had made him dangerous. Yet other rams continued in their trusting ways. Some followed me about or chose to rest close beside me when I sat down. They treated me as a familiar, useful something that wasn't too bad to be with. As I sat, they bedded down around me and ruminated or dozed off into little naps with their eyes half-shut. There was no indication that I was a member of a very predatory species. Their behavior simply illustrated that these wild animals are eminently capable of forming obvious, logical conclusions based on their experience. They treated me as I deserved to be treated.

With their wonderful ability to learn, it is no great wonder that mountain sheep become consummate experts in hiding when they are hunted. Not only do they flock to sanctuaries after the first shot of the hunting season, they also readily abandon their favorite mountain slopes and may even go into deep timber that is miles away from "sheep country," living there till the hunting season is over. Still, for all that, they are vulnerable to prices on their heads in illegal markets, and to poachers willing to turn a profit. A market in dead wildlife—one that pays handsomely for sheep horns and capes—may ultimately spell the demise of mountain sheep.

Wild mountain sheep are very different from domestic sheep. The latter, though they are achievements for the livestock industry that is interested in breeding tractable animals, are little more than caricatures of their wild counterparts. Sad, tragic caricatures, I may add. As is the fate of all domesticated animals—self-domesticated, 20th-century man included—domestic sheep have lost

much of their brain size in the process of domestication. Even the European mouflons from Corsica and Sardinia and the Cyprian mouflons which, as it turns out, are primitive domestic sheep released by Neolithic man on Mediterranean islands, have smaller brains than do their wild counterparts on mainland Turkey. Domestic sheep have acquired characteristics needed by their herders and owners, and these are not commensurate with life in the wild state, especially where surrounded by predators.

Some residues of the wild still remain in domestic sheep. Polled, or hornless, domestic rams still court as if they had horns on their heads, and domestic sheep studied in laboratories still prefer large-horned to small-horned or polled rams. However, the intensity of courtship in domestic sheep is low. It has little or no "drama" compared to the courting behavior of wild sheep in rut.

Even in culinary terms, domestic sheep are a distant second to the superlative meat of wild mountain sheep, which has no "muttony" or tallowy taste. In, fact, mountain sheep do not taste at all like sheep. However, mountain sheep rams close to the rut may develop a bit of an off-flavor compared to those taken in early fall, while mountain goat males turn completely inedible just before the rut in late October.

As runners and jumpers, domestic sheep are virtual cripples, and thus need protection against predators by man and his specialized sheep-herding and sheep-guarding dogs. However, these domestic morsels remain tasty prey for wild canids, as is wryly signalled by the bumper stickers displayed on cowboys' pickup trucks, which carry guns on racks inside the rear window.

"Eat more lamb," the bumper stickers advise. "A million coyotes can't be wrong!"

Bighorn ram in blizzard. Mountain sheep are glacier followers, and are very winter-hardy. During the ice ages, sheep flourished.

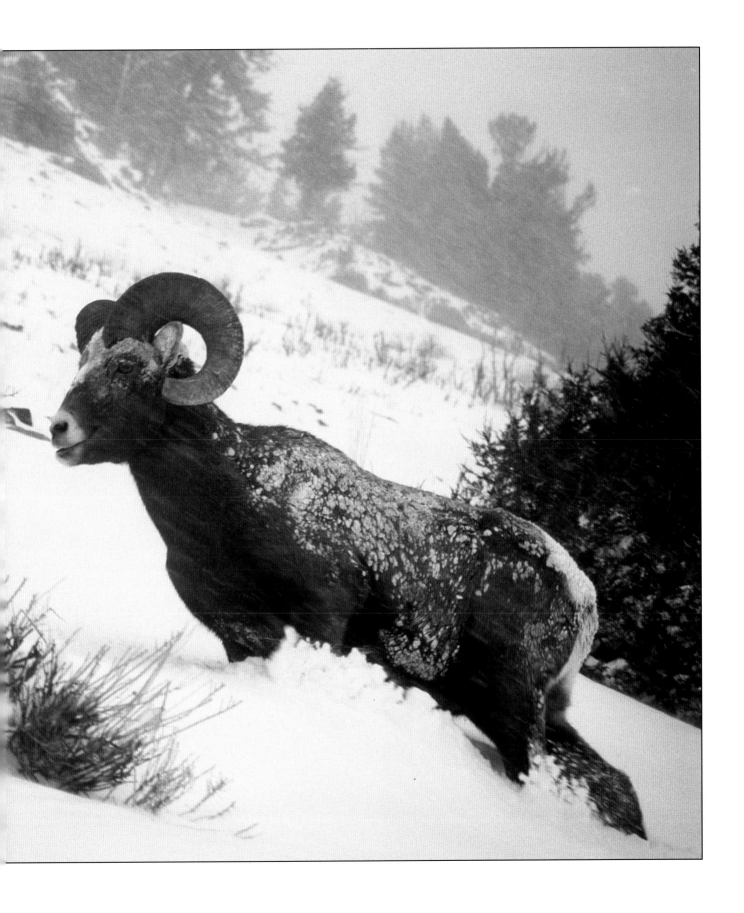

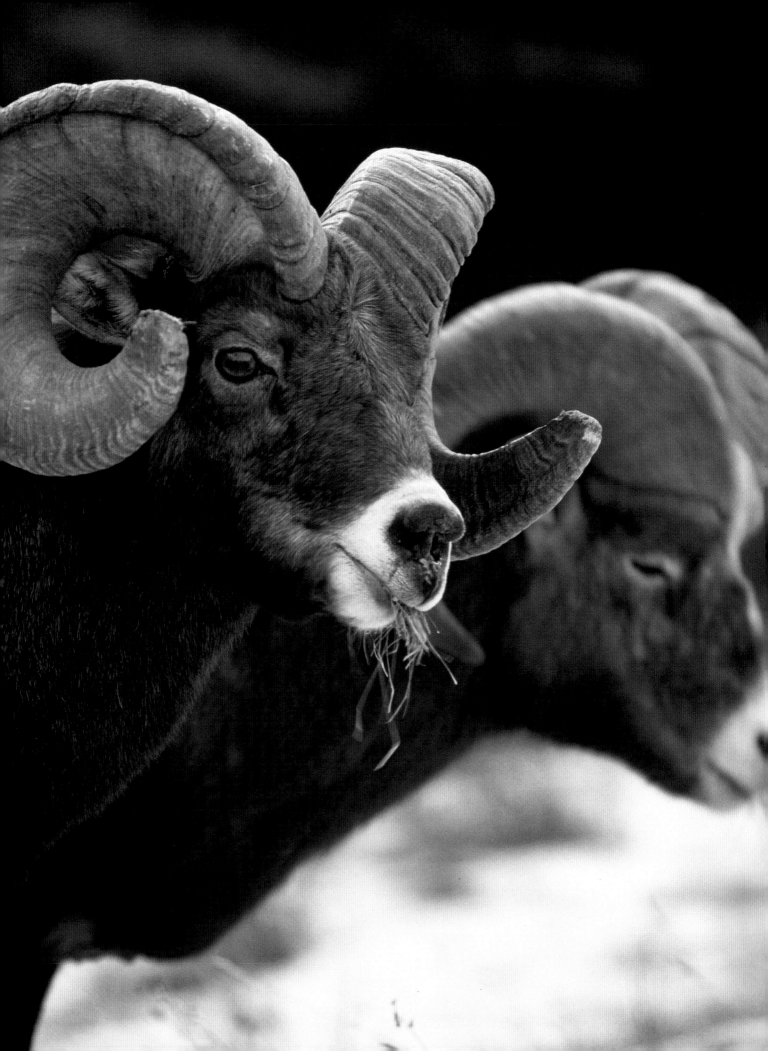

RENEWAL, SURVIVAL, DISPERSAL, DEATH

researcher returning year after year to the same populations of mountain sheep notices that they change little in terms of abundance and distribution. Despite the potential ability to fill their range with offspring, mountain sheep populations, like those of most living things, increase or decrease little.

That, at least, is the general picture as it pertains to populations that are large enough to remain stable. When sheep numbers are very small, unfortunately, decreases in a population may be significant enough to lead not only to severe in-breeding, but to the loss of the population. As Professor Joel Berger discovered when he examined the fate of small populations of bighorn sheep, it takes at least 100 bighorns to form a "survivable population." A smaller population is likely to go extinct within a century.

∘ ∘ ∘

It is sometimes useful to depart from conventional research and to reformulate matters using a different vision. Conventional research into

A ram with a damaged but healed nose. This was probably done by a wolf.

population biology is very much a numbers game. Instead, let's pursue reproduction from the perspective of the "selfish genes," the hereditary factors that contain the blueprints for the development of mountain sheep. Success here is measured not by the absolute number of sheep produced, but by the fraction of the population that a particular gene—an allele—has captured. In particular, let's assume that each sheep's goal is to maximize its genetic contribution to the next generation.

Mountain sheep live in what is essentially a "closed system" of resource availability, in which the gain of one is the loss of another—the death of an adult, for example, frees resources for reproduction for other sheep. The areas exploited by sheep bands are fixed in space by escape terrain, and in size by the mountain sheep's capacity to reach the adjacent escape terrain before a sprinting wolf reaches it. No matter how large a grassland favored by sheep happens to be, the amount of area actually exploited is governed primarily by the distance from escape terrain that a sheep can cross before it risks being caught by a swift wolf. Therefore, grassland some 300 paces beyond cliffs is of little interest to mountain sheep. It's just too dangerous to go farther than such a distance from the safety of cliffs.

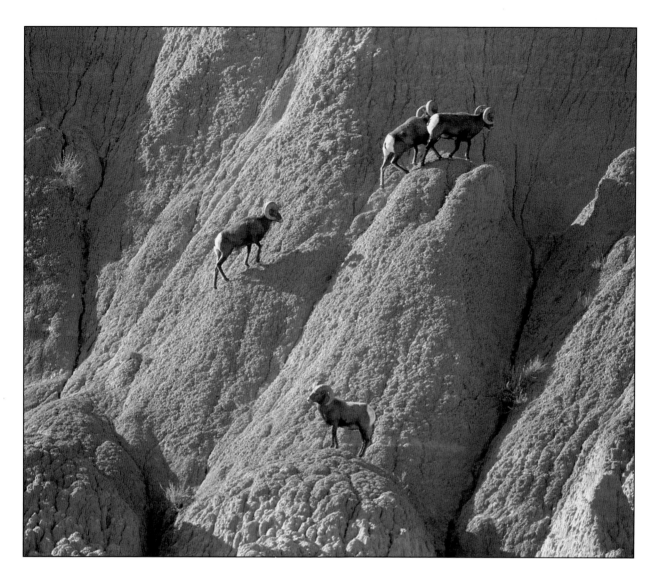

Escape terrain is central to mountain sheep ecology.

Herding, like confining activities to an area near escape terrain, is a form of behavior that protects sheep from predation. In this simple picture, a large herd size contributes to a statistical reduction of the chances that any one sheep will be singled out by a predator, for sheep in large herds can rely on the herd size itself as an anti-predator protection. As do other animals that live visibly in open country, sheep form "selfish herds," so called because animals benefit individually from herd affiliation. The herd, by its size and by a number of other factors, such as placing other sheep between an individual and attacking wolves, protects the majority of sheep from predation.

Increases in herd size, however, can also be detrimental to sheep. The areas exploited by sheep are essentially fixed and, as a population increases, more and more animals crowd into the same space. Thus the forage resources are shared by more and more sheep, and less and less is available per individual for growth, development, and reproduction.

When this happens, it places each female mountain sheep in a reproductive dilemma: If the female bears a daughter, then it raises a future competitor, because daughters stay on their mothers' home ranges and thus share the available resources with their mothers. If the female bears a son, then it does not produce a competitor because

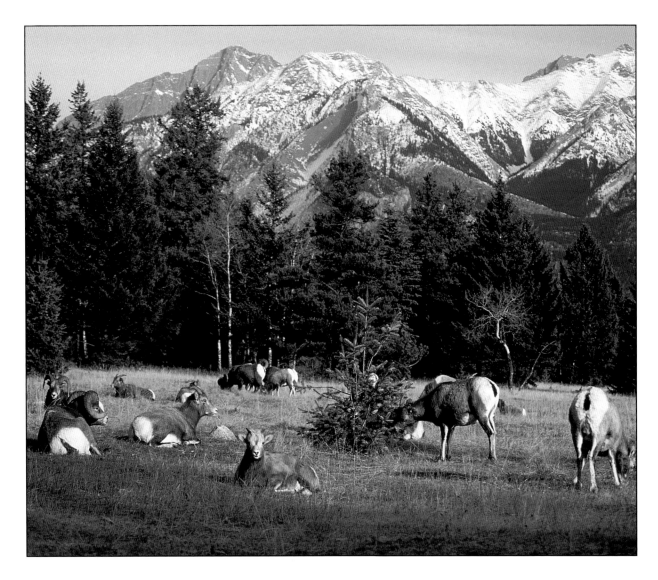

Like many herbivores that exploit open grasslands, mountain sheep congregate into "selfish" herds. In these groups, the sheer mathematics of numbers reduces the chances that any individual will be caught by a predator.

the son will leave the overgrazed female ranges for better foraging areas. However, if the son is born small and grows poorly in its first year, it may be too disadvantaged to grow to breeding ram size and status in later life, and thus it may be incapable of spreading the mother's genes.

From the female's perspective, that would be a waste of reproduction. The slim resources available for fetal growth could instead be invested by the female in its own body. It could skip a year's reproduction, then use its body stores to grow a big lamb. But that is risky, for the next lamb might be a normal daughter that stays with its mother and becomes a competitor. A son, though, would benefit from the gamble, because larger birth size and better growth in its first year increases its chances of becoming a breeding, dominant ram.

The female could avoid having a daughter as a competitor, however, if she were able to produce a "super daughter." This is a daughter so large and so demanding of food resources that it could not tolerate the starvation rations on its mother's home range. It would therefore be forced to leave, to follow rams, and, in the process, to colonize some of their home ranges.

In real life, mountain sheep do appear to follow

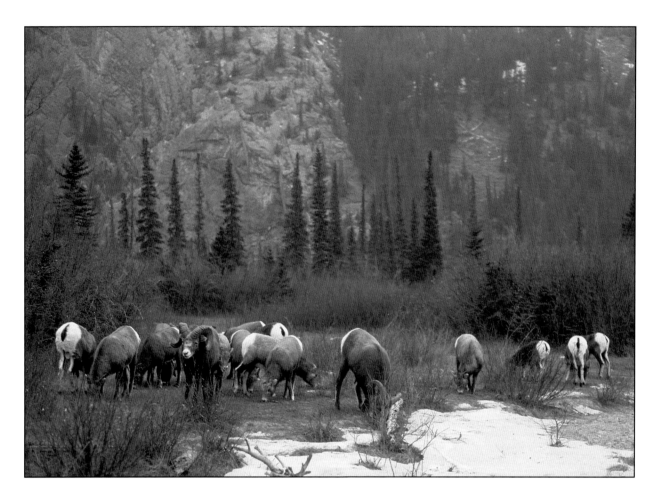

Occasionally, sheep leave the protection of cliffs and steep slopes and move into the valley to feed on particularly attractive forage. In winter, green forage is most attractive.

these expectations. At high population density, there is a preponderance of yearling males over yearling females. Many females do not reproduce annually, and a very few females rear exceptionally large female lambs. Also, careful removal of a few adult females from a dense population does lead to the expected increase in births, lamb survival, and size of the young. Annual fluctuations in food abundance, conversely, reflect themselves in the fecundity of the population as well as in the average size of horn segments grown by the rams. The better the summer's vegetation growth, the longer the horn segments of males and the more lambs that survive to yearling age.

Normally, mountain sheep exist under such "maintenance" or "efficiency" conditions. That is, all resources available for growth and reproduction are partitioned out, and the females grow only to a body size that, on average, ensures the fetal growth of the lamb to "survivable" size at birth. A female mountain sheep in northern environments needs to produce a lamb of slightly less than nine pounds in birth weight if the lamb is to survive; in warm deserts, the lamb can be smaller at birth, as the chances of hypothermia are small.

This idea, that birth-size is linked to adult size, explains the body size of Asiatic giant sheep, the

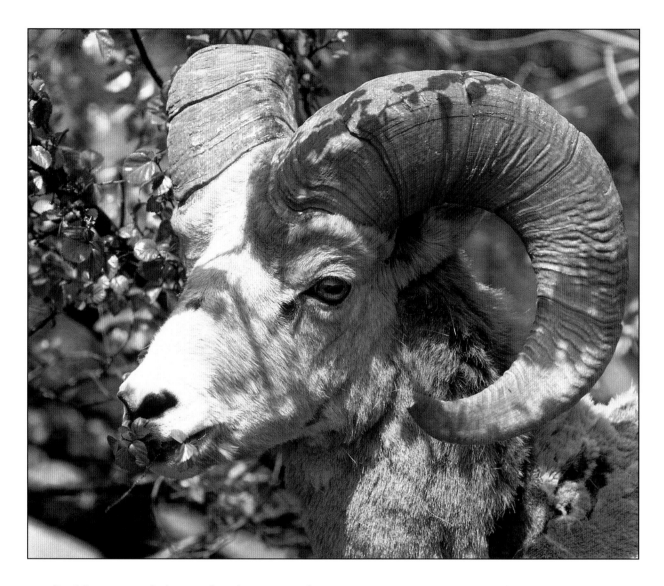

argalis. These animals live under climatic condi-
tions similar to those experienced by mountain
sheep, but they are much larger in size. However,
giant sheep bear twins and, rarely, triplets. That is,
the female giant sheep must be physiologically
capable of producing two young, each weighing
about nine pounds or more at birth. Therefore, a
female giant sheep, to achieve this, must be twice
the "physiological mass" of the female mountain
sheep.

However, under similar conditions of ecological
productivity, a female giant sheep has to exploit a
grazing area twice the size used by a female moun-
tain sheep in order to ingest twice the amount of
food. This means a giant sheep would need to
sprint farther than a female mountain sheep to
reach escape terrain. That's an impossible demand.

Diversity is the spice of life. More importantly, diversity in forage is
essential to proper rumen function in sheep, and necessary in maxi-
mizing precious nutrients for body maintenance and growth. This
ram is nibbling freshly sprouted foliage.

A giant sheep, two and a half times larger in mass
than a mountain sheep, does not have two and a
half times the muscular power to move its body to
successful escape speed. Consequently, giant sheep
cannot use the same anti-predator strategy as
mountain sheep, because they would have to
sprint farther to escape terrain, on average about
one and a half times farther, and, worse yet, they
have only 85 percent or less of the relative muscular

power of mountain sheep to push their larger mass.

Therefore, we expect for giant sheep a different anti-predator strategy than that employed by the smaller mountain sheep. In fact, giant sheep have evolved into cursors that escape predation primarily by speedy, enduring flight, not by sprinting into steep rock walls. This means that giant sheep have different body proportions than mountain sheep. In particular, they have longer legs.

The idea that sheep genetically gravitate to an adult body size required in order to produce lambs of minimum survivable size is quite useful. It predicts that with increased ambient temperature, sheep shrink in size. Thus sheep are smaller in the south than in the north.

A competing hypothesis says that sheep should reflect in body size the length of the good feeding period they experience in summer. That is, in summer, when the vegetation is growing most profusely, sheep are freed from shortages of good food and can indulge themselves on more food than they can handle. The sheep in summer have a "vacation from want."

This period of freely available good food shrinks as we move from mid-latitudes to high latitudes; that is, summers in the Arctic are much shorter than in the mid-latitudes. Thus we expect

In their cold environment, Dall's sheep need to produce lambs large enough to survive hypothermia at birth. This requires a birth weight of about eight pounds. Even this amount of neonatal mass can be grown in the long winters only because of an extended gestation period. On average, twins would be too small to survive the cold weather at birth. If Dall's sheep were to twin, they would have to grow to much larger size. To be precise: A female would have to be twice the "metabolic size" to bear viable twins. Twice metabolic mass means 2.54 times body mass. Clearly, such a large sheep could not live like a Dall's sheep. It would require more grazing area and, due to its large body size, it would be handicapped in acceleration and in jumping through cliffs.

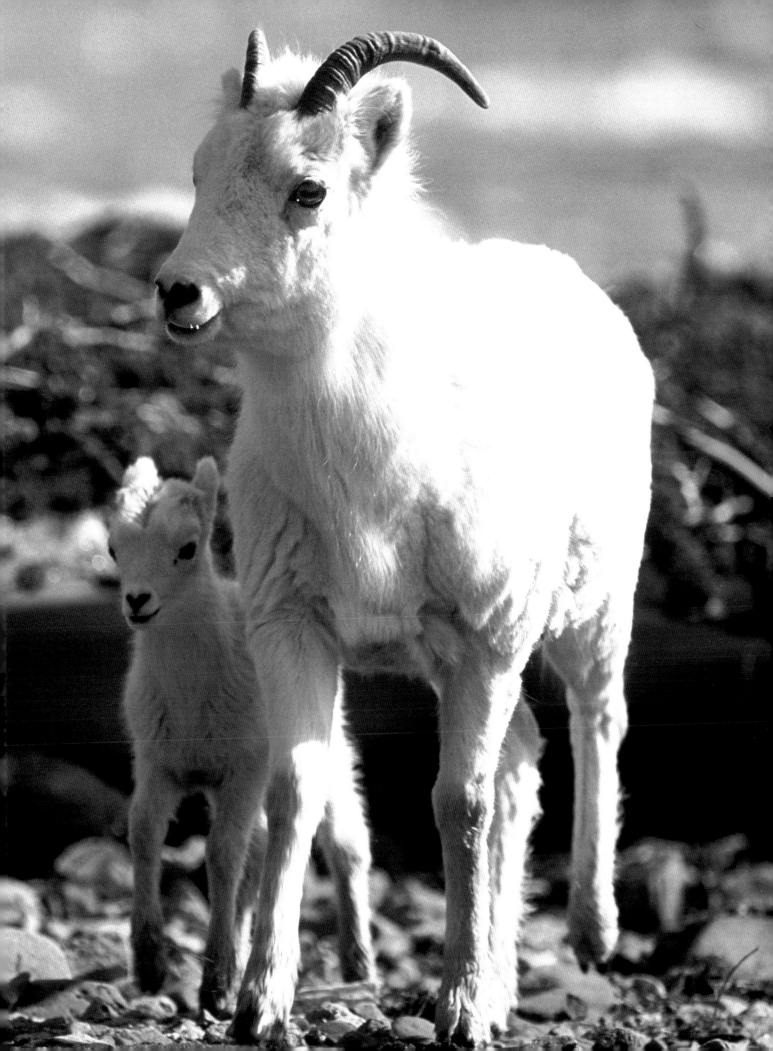

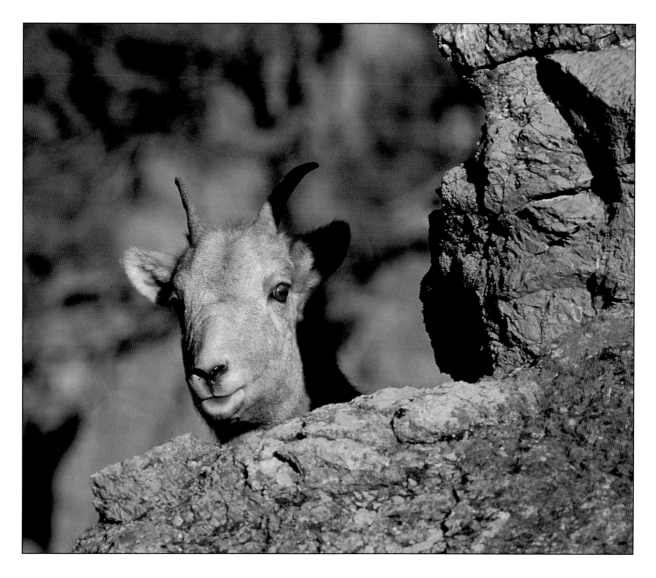

An unexpected encounter. Sheep make a point of inspecting harmless intruders, photographers included.

that sheep increase in size from south to north, but that this trend reverses and sheep become smaller again at high latitudes. This expectation is realized in nature, and not only in sheep. The reversal in body size of North American sheep occurs at about 50 to 55 degrees north latitude, and at 60 to 65 degrees for other large mammals such as caribou, wolves and moose; the difference is accounted for by the fact that sheep live at higher elevation, which compensates, of course, for latitude.

Also, sheep living at low elevations ought to be larger than sheep living in narrowly defined subalpine and alpine zones at high elevation. This, too, is found. And migratory sheep that exploit a large range of elevations ought to be large-bodied and large-horned. Such is the case.

○ ○ ○

The preceding theories address maintenance or efficiency conditions, when sheep have to be very frugal with the available energy and nutrients. Occasionally, under very rare conditions such as occur during the colonization of vacant habitat, sheep are faced with a superabundance of highly nutritious forage. Now the pregnant female can feed selectively, ingesting only the very best food. She selects protein-rich plants and plant parts. That triggers the growth of an exceptionally large and active lamb which, on the excellent forage,

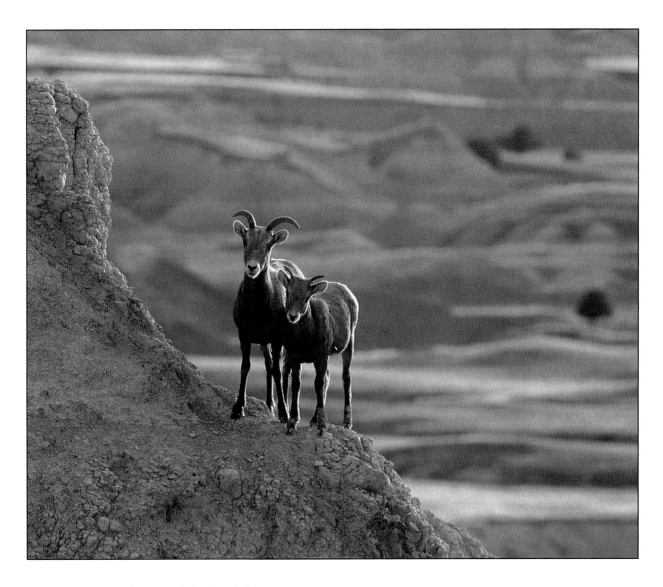

grows into a very large and lively adult.

This is the "dispersal form" of mountain sheep. It reaches about twice the body-mass of mountain sheep living today in mid latitudes. The dispersal form, freed from material want, abandons competition for scarce food resources and instead competes for mates to maximize reproduction. And that triggers intense selection for superior combat and display organs. These big sheep are roamers that explore and reproduce so vigorously that the male and female of the dispersal form have a short life expectancy.

Here we see the possibility for explosive evolution: Intense social competition selects for large size and very sturdy combat organs while generations replace themselves rapidly, each one sharply selected for social competence.

Bighorn ewe and lamb in the Dakota badlands

Consequently, a long dispersal phase, or many successive dispersal phases, should result in sheep with larger bodies and more elaborate social organs. Again, this prediction has proved fruitful.

The female sheep, then, adjusts her reproductive output on the basis of the available food supply. This is not merely a quantitative adjustment, but a qualitative one as well, in that she bears an "efficiency-type" lamb when forage availability is slim, and a "dispersal-type" when forage is superabundant. The efficiency and dispersal types, however, are not merely small and large sheep, but are

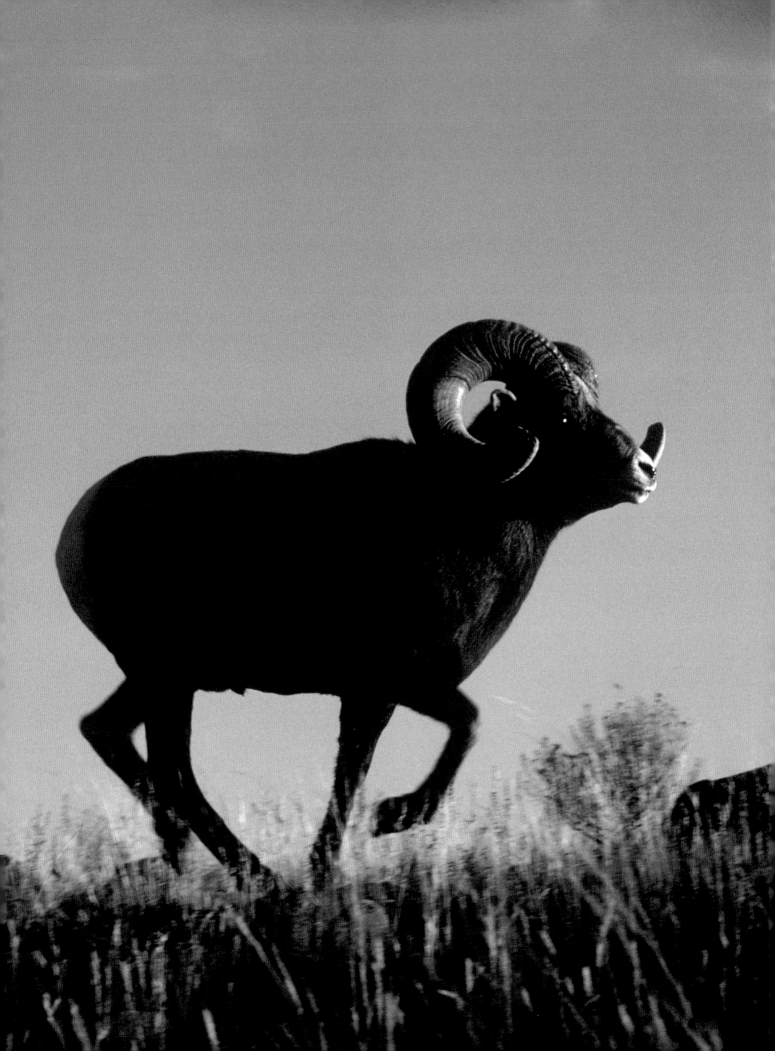

different sheep—different in adaptation.

The efficiency-type sheep is adapted to compete with others for forage; the dispersal-type sheep is adapted to compete with others for sexual partners. The efficiency-type is not very active, is a miser with energy; the dispersal-type is exuberant and wasteful of energy. The same hereditary material, depending on environment, can thus produce very different kinds of sheep. We now know, too, that it takes several generations to make the switch from efficiency to dispersal-types.

Efficiency-type sheep, in a manner of speaking, make a bet with nature that they will be able to reproduce successfully only occasionally. Therefore, the existence of these sheep depends on large numbers of long-lived adults that weather the difficulties of their environment and reproduce once in a while when conditions are good. Dispersal-type sheep, on the other hand, bet that their young will find high-quality forage in abundance and will need to be equipped to handle fellow sheep in brutal social competition. They invest everything into growing big, capable young that die young. These are two extreme strategies, but very real strategies nevertheless. Impose a high mortality on dispersal-type sheep and chances are they keep right on reproducing. Impose a high mortality on sheep in an efficiency regime and chances are they'll quickly go to extinction, without much of a compensatory reproductive response. That is, they fail to compensate for the loss of adults with a higher birth rate.

In short, population processes are more complex than simple numerical models of sheep

Dispersal is difficult for sheep. However, when sheep grow on excellent range to exceptionally large size, they show a propensity to roam, explore, and colonize unoccupied range.

Mountain sheep and livestock do not mix well. The trouble lies in the sheep's susceptibility to livestock diseases. However, bighorns accept other creatures in their domain. This young ram touched noses with these two horses before the photograph was taken.

demography would lead one to believe. Consequently, one needs to consider not only quantitative but also qualitative factors in sheep management.

 ° ° °

Perpetual concerns in mountain sheep management are diseases and parasites. Mountain sheep, as Siberian immigrants, are expected to have a lesser ability to deal with diseases than their Eurasian counterparts, domestic sheep included. The mere presence of domestic sheep is a hazard to our mountain sheep.

In an exemplifying experiment, Professor W. J. Foreyt of Washington State University placed six domestic sheep together with six bighorns. The first bighorn was dead in four days, the last in 71 days. Foreyt repeated the experiment. The results were essentially the same.

The crucial point here is that microorganisms harmless to domestic sheep can be deadly to mountain sheep. Epidemics have repeatedly wiped out large segments of mountain sheep populations, and recovery has been slow or absent; transfer of microorganisms from domestic to wild sheep is suspected to have caused these catastrophes.

Where they are in contact with livestock, mountain sheep have done poorly. On the other

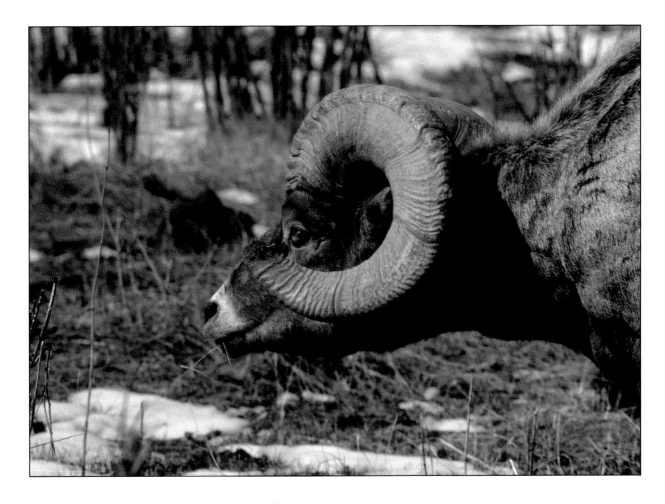

A bighorn ram blind with pink-eye in Yellowstone National Park. This condition spells certain doom.

hand, northern sheep populations that still live in wilderness areas are thriving. Lung worms, long suspected as the responsible disease agent in the southern epidemic of bighorns, are also present in northern sheep but do not appear to affect them. Even old, lung-worm-infected Stone's rams in my study area in the Spazisi ran with the speed and endurance of young rams. I never saw in them the liver-like deformations of the lungs that I repeatedly encountered in Alberta bighorns. It appears that microorganisms carried by livestock, in concert with lung worms, affect bighorns severely. In general, bighorn sheep across the United States currently live in moderate security, and one cannot be vigilant enough in ensuring that they have as little contact as possible with livestock.

Habitat loss that has forced mountain sheep into ever smaller ranges, and thus into the continual use of the same small areas, has also led to lung worm disease epidemics. Confining sheep year-round to the same places apparently generates good conditions for lung worm transmission, and the sheep suffer accordingly. Here, lung worms are even transmitted across the placenta from mother to young.

 o o o

For mountain sheep, old age is not always a chore. Old females that no longer reproduce are still vitally important to the population in spring,

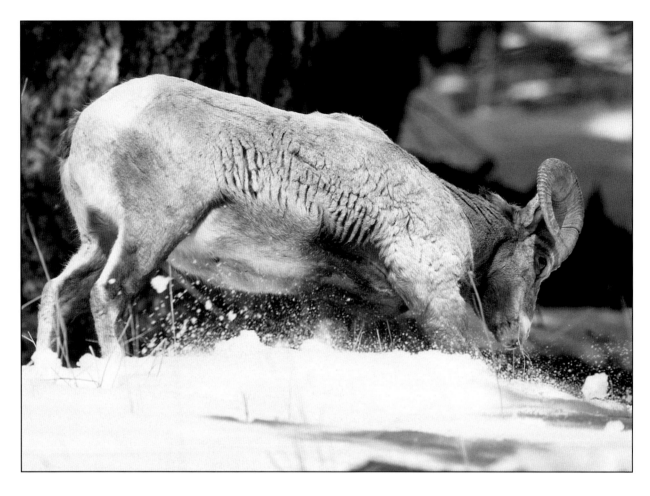

Ram pawing through snow for food.

at lambing time. They serve as a focus around which the year-old sheep cluster, to be securely led and cared for until the ewes return from lambing and once again form large, secure nursery bands. The old females clearly "cherish" their temporary role. The observation is anthropomorphic, but it's hard to put it another way.

Old females appear to be on a different hormonal regime, as they are more likely to join ram groups, feed on ram ranges, and occasionally bounce, frolic, and threat-jump with the rams on sunny spring mornings. The horns of such old females may begin to grow again significantly, and these aged ewes are clearly in good body shape. Whatever lifespan is left to them appears to be a good one.

Very old rams do not fare badly, either. They can be active, successful breeders at great age: The oldest I saw was 16 years old. It had lived almost twice the normal lifespan of a ram. The oldest ram I knew of grew to be 21 years of age. It carried thick, badly broomed horns, and other rams still rubbed on its head, impregnating themselves with the ram's preorbital gland scent and treating it as a dominant. Yet the ram moved with a little limp. Its front teeth had vanished years ago. It was feeding, essentially, by "gumming" the grass. This mattered little, as the ram was fat and had a good coat. I do not know where it went to rut, unfortunately, but

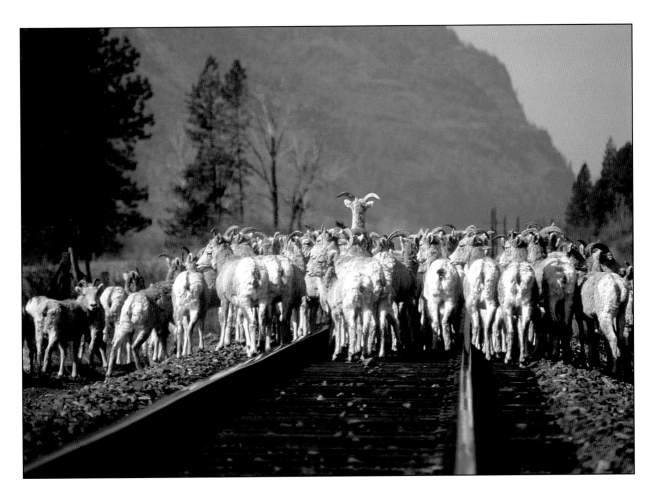

Ten percent of this bighorn population is killed by the railway or the adjacent highway each year.

I suspect that, due to lung worm infection, the ram did not exhaust itself. At the time, there were no wolves in Banff National Park—an important factor, I suspect, in the longevity of the bighorns I studied there.

I've observed old sheep with a blind eye or a crippled leg, and they did not fare too well. They were picked on by younger, healthy sheep, but they accepted this treatment and followed the band. When badly injured, though, they isolated themselves. Very old sheep I observed also tended to go where they had not gone previously. They appeared less alert than younger ones. I suspect this was fatal for the first old ewe I recovered as a wolf kill in the Spazisi. The ewe had moved low on the mountain slope into the dwarf birch bushes. Earlier in its life, the ewe might have

gotten away with such a foray. This time, though, two wolves surprised it and killed it. The ewe was 13 years old.

So was the old, black ram I had observed so frequently on this study area when the wolves chased it downhill into a patch of dwarf birch and killed it. This happened shortly after the rut, when the ram was exhausted and had probably also ventured into the rich feed of fescue grasses lower down on the slope, away from the protection of the cliffs.

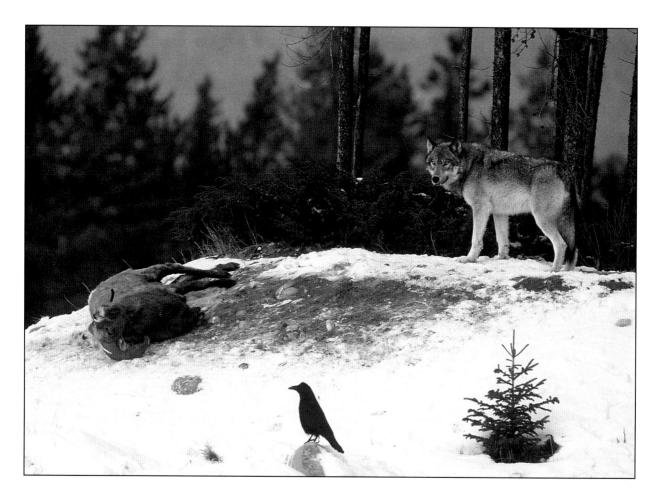

A sheep killed by the railway in Jasper National Park becomes food for a scavenging wolf.

But death does not always come swiftly. A large bighorn ram slipped one spring morning on a steep, glazed-over snowfield and tumbled a quarter mile before coming to rest on a bed of soft snow. I saw it lying there when I checked the slope, and I climbed up to see why it had died. It had not. It was merely paralyzed. Its back and neck were broken, but its eyes followed me. How I wished for a rifle. I plunged my knife into its heart and it died swiftly. It would soon have been eaten alive by coyotes.

Death gets a bit personal when it takes an animal that one knows, for my study animals were soon not merely sheep to me. Nor were they to my students. The students, too, experienced the emotional switch that happens when animals become personalities, when each ewe and ram assumes unique status by virtue of being unique. For us, each sheep had its very own story and its very own personality.

"Why, they are just like us!" a student blurted out, as he came to grips with the fact that identity and personality transgress species boundaries.

And so one gets a jolt when sad news arrives. Ram 316 had been found floating in Lake Minewanka, the park warden's office in Banff phoned me. Ram 316 was a mere number on a small aluminum ear tag, but I knew that number

Dead sheep become food for various predators and scavengers, such as these ravens.

well. Even in death, this ram revealed a secret. It had drowned while crossing the swollen Cascade River, and its carcass was swept into Lake Minewanka. Now I knew where the ram went in fall and where it mysteriously reappeared from in spring. Ram 316 was not large in body, but it was as beautiful a ram as one can find. It was also very shy, and I worked for many months to gain its confidence—one reason the ram was so memorable. I had watched this animal many times, and had become familiar with its ways. I had expected the ram to return that spring, right up to the time when the phone rang.

 o o o

 As I write this, each North American wild animal that lives north of the Rio Grande and is larger than a coyote is outnumbered 9 to 1 by humans. Our domestic livestock outnumber them by more than 120 to 1. The ranges of bighorns have been severely reduced, and developments in the name of tourism now threaten even more bighorns than before. We do not know how secure these magnificent creatures will be in the future.

 We have found ways to rehabilitate exhausted strip mines so that they become good homes for mountain sheep. That is a help. It is not a substitute, however, for the natural places in which mountain sheep normally live. Conservation

Bones emerge as the flesh is stripped from a dead bighorn. From fertile dust it arises; to fertile dust it returns.

groups, including many sport hunters, work on behalf of mountain sheep, raising money for research and land acquisition, donating time and effort to ensure that springs—vital watering holes for bighorns—flow in the deserts. Some groups help by lobbying legislators for sensible conservation policies, laws, and regulations. The scientists involved in research and management meet in conferences and disseminate their findings in journals. New bighorn populations are being established via reintroductions to vacant habitats. There are a good many events one can be cheerful about.

Yet many things cloud the horizon, especially the mindless trade in dead wildlife that goes on in urban centers, particularly in Japan, Korea, Germany, and in the many illegal markets within the U.S. These destructive luxury markets for the mindless, ignorant, or heedless minority have fueled an indigenous industry in game ranching that is legislatively incompatible with our successful conservation laws and policies. State by state, province by province, we see the dismantling of laws and policies that, in the last 70 years, have restored and protected our wildlife. Providing a commercial market for dead wildlife is a huge policy failure. It is one that our wildlife, let alone mountain sheep, may not survive.

Developments take their tolls. Heavy traffic on highways can be deadly to sheep.

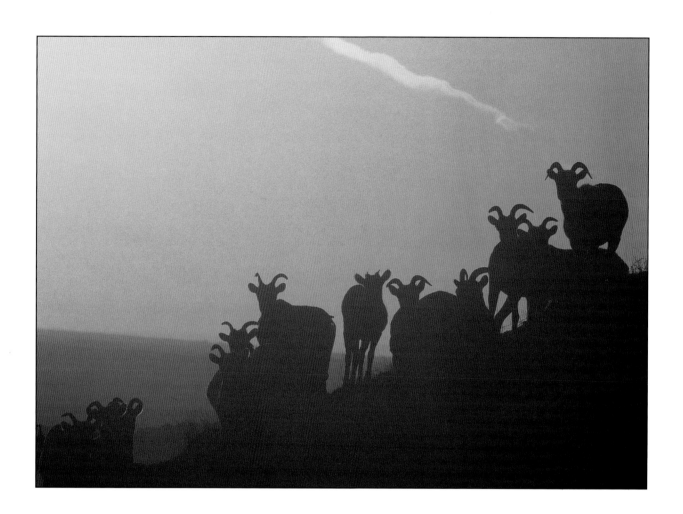